D1587368

watercolour CHALLENGE

TECHNIQUES IN PRACTICE

watercolour CHALLENGE

TECHNIQUES IN PRACTICE

First published in 2002 by Channel 4 Books,
an imprint of Pan Macmillan Ltd, Pan Macmillan,
20 New Wharf Road, London N1 9RR, Basingstoke and Oxford.

Associated companies throughout the world

www.panmacmillan.com

Designed and edited by Eaglemoss Publications,
based on the partwork *Watercolour Challenge*.
Copyright © Eaglemoss Publications 2002

10 9 8 7 6 5 4 3 2 1

All rights reserved. No part of this publication may be reproduced, stored
in or introduced into a retrieval system, or transmitted, in any form, or by
any means (electronic, mechanical, photocopying, recording or
otherwise) without the prior written permission of the publisher. Any
person who does any unauthorized act in relation to this publication
may be liable to criminal prosecution and civil claims for damage.

Front cover: Hazel Soan
Back cover: Adrian Smith (top), Polly Raynes (middle two),
Kay Ohsten (bottom)

A CIP catalogue record for this book is available from the British Library.

ISBN 0 7522 6211 4

Colour reproduction by Chroma Graphics (Overseas) Pte Ltd.
Printed and bound in Great Britain by Bath Press

This book is sold subject to the condition that it shall not, by way of
trade or otherwise, be lent, re-sold, hired out, or otherwise circulated
without the publisher's prior consent in any form of binding or cover
other than that in which it is published and without a similar condition
including this condition being imposed on the subsequent purchaser.

This book accompanies the television series *Watercolour Challenge*
made by Planet 24 for Channel 4.
Series Producer: Jill Robinson

Contents

Introduction

Watercolour is the most popular of all the painting media, and with good reason. Its spontaneity and versatility – and ability to render the transient effects of light – are unmatched by any other medium. It can be used for work in a wide range of styles from traditional landscapes built up from layers of subtle washes, to brightly coloured semi-abstract studies in which watercolour is mingled with other media.

The first chapter, **Techniques**, shows you how to tackle some of the most familiar and difficult watercolour subjects. You'll find techniques for handling all the elements of a landscape, from skies, water and weather to the components that can be found within it, including trees, animals and buildings. With watercolour there are limited opportunities for making amendments, so planning is essential for a successful painting. You need to consider where the lightest and darkest areas are, for instance, and in what order the washes will be applied. Each subject is thoroughly analyzed and a method of working described and illustrated. To master these techniques and start developing your own style, you should work through the mini step-by-step demonstrations, and reproduce the finished images.

The second chapter, **Mixing Colours**, suggests a working palette of twelve colours, which are all you need. You are encouraged to explore each of the colours in turn and to experiment with a range of mixes. Painting your own set of charts will help you get to know the paints in your palette, as well as providing a useful reference.

The final chapter, **Projects**, offers the opportunity to observe some of the best watercolour practitioners at work on a range of landscapes, and to see the techniques from Chapter 1 put into practice. Watching other artists is one of the best ways of learning and of picking up tips, shortcuts and tricks of the trade. You can either work through the step-by-step projects, or find similar subjects and paint them using the techniques described.

The projects have been selected to provide as diverse a range of landscapes, interpretations and styles as possible. Watercolour lends itself to creating atmospheric effects. In 'Country garden' (page 117), for example, a combination of watercolour and gouache achieves a study that shimmers with light. Buildings in a landscape provide other fascinating compositional possibilities, from a tumbling 'Mountain village' (page 127) built up from transparent wet-in-wet washes, to the exuberant study of Santa Maria della Salute hovering over the waters of 'The Grand Canal' (page 205). Water itself is a unique element in a landscape, reflecting and distorting the light. Its translucent quality may be captured by working from light to dark and using fluid brushmarks, as in 'Bustling harbour' (page 141).

Watercolour is a craft skill and a combination of instruction and practice is needed to acquire the deftness of touch and confidence that are essential to produce good paintings. This book not only provides a wealth of clear instruction but also a wide range of projects and images that will certainly inspire you to take up your brush and have a go.

CHAPTER 1
TECHNIQUES

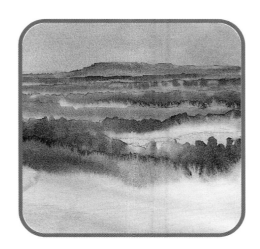

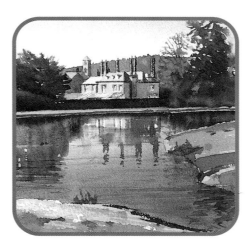

Much of watercolour's charm and a lot of its difficulty, comes from its inherent unpredictability. Many watercolour processes exploit wet washes and these behave in different ways depending on the amount of water, the nature of the surface and the pigment, and the prevailing temperature and humidity. A thorough understanding of the materials and techniques will give you the best chance of mastering this demanding, but highly rewarding, medium. Combine in-depth knowledge with regular practice, and you will see immense improvements in your pictures.

This chapter deals with some of the most challenging watercolour subjects and themes. If you have ever struggled with ways of rendering light, painting convincing shadows, sparkling water or the texture of fur and feathers, you will find the explanations, suggestions and tips here of enormous value. Techniques are illustrated in several ways – in simple four-step projects, in specially commissioned illustrations or by analyzing the work of well-known watercolour artists. Even if you already have your own method of tackling a misty or snowy landscape, it is always worth adding a new technique to your repertoire.

Planning washes

In traditional watercolour painting, the white of the paper is the only white used. One of your first challenges is planning your painting so that you reserve the areas that are to be white or light in colour.

Working from light to dark lets you build up colour and tones gradually. This is vital because with watercolour it is very difficult to correct mistakes. Most watercolour sets include a white paint that can be used for highlights and white objects. In the purist forms of watercolour, however, white paint is never used for the reason that washes lose some transparency when it is added. In what is known as transparent watercolour, it is the white paper shining through the paint layers that gives the medium its special luminosity. The white of the paper is the only white used and is the lightest tone. Highlights and light areas are created by leaving the paper unpainted. The white of the paper stands for the white of clouds, buildings, snow and white flowers, for instance, as well as for the highlights visible on reflective surfaces.

You need to plan white areas, then develop tones and colours gradually. The simplest way of doing this is to work around highlights and any areas that are white in colour. This means defining where these fall, then laying separate colour washes of deepening intensity around them (see overleaf).

Key points

- Plan white and highlight areas first before you start applying any colour.

- Plot white areas in an outline drawing and work carefully around them.

- Apply light tones first, building towards dark tones and intense colours.

- Use masking fluid to help you reserve white and lights.

- To render pale colours, dilute the paint with water instead of mixing it with white paint.

Taking a closer look

In this atmospheric painting, the artist has reserved selected areas of white paper to dramatic effect.

Mountain scene by Dennis Gilbert

An angry sky is created working from light to dark, leaving the white paper for the lightest clouds and adding progressively darker tones that overlap.

The nearest hill is painted with a light green wash leaving small white areas unpainted to express light on the rocky landscape.

The rough surface texture of the paper has caused small white areas to remain in the green wash. They convey a sense of dappled light.

White paper has been left to stand for the pale colour of the winding path and the stone of the wall.

The farthest hills recede with a mid-grey wash. A darker tone brings the next range closer, while the palest wash is used for low cloud.

The white of the paper gives bright highlights where the strongest light falls on the rocks in the foreground.

Reserving the whites

Try this simple exercise to get used to the light-to-dark approach. You will see how the layers of wash are slowly built up, leaving the white of the paper for the lightest areas.

In practice **Using layered washes**

Making a tonal strip

Mix a wash of Payne's gray and lay a 7.5cm (3in) band of colour. When dry, lay a slightly darker wash over the first, starting 2.5cm (1in) from the left. When this is dry, darken the wash and lay the final block on the right. These are the three tones you need.

Wash 1 **1 + 2** **1 + 2 + 3**

1 The simplest way to create areas of white colour and white highlights is to paint around them. Start by drawing the elements of the composition in outline, including the patterns of light and shade. Using your palest wash, paint carefully around the sharp-edged areas of the cottages and the fence posts, and apply the wash more loosely around the palest clouds. Allow the paint to dry.

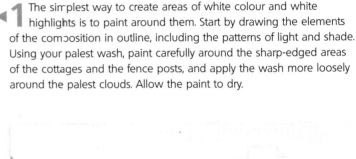

2 Using a slightly darker wash, fill in the mid-tone areas of the distant hills and the roof, door and window details on the buildings, again painting around the light areas of the cottage walls and the fence posts. Leave this second wash to dry before adding the darkest wash.

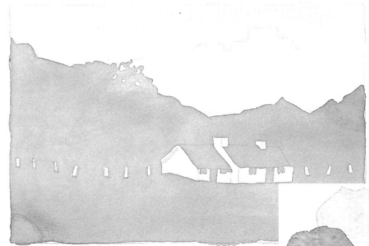

3 Add more Payne's gray to the wash and paint the areas of darkest tone and deepest shadow, thus bringing the tree and the foreground forward in the picture and picking out the rooftops.

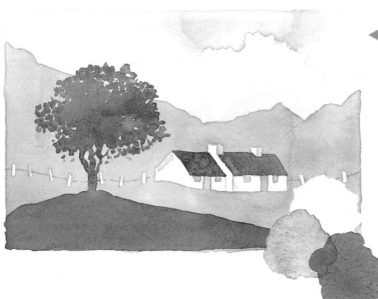

Tip

Make sure each wash is thoroughly dry before you apply the next. This will ensure the washes dry with crisp edges. A hair drier helps speed up the process, but do not hold it too close to the painting or you will blow rivulets of paint across the support.

Adding details

Watercolour is often thought of principally in terms of broad washes, but remember that details are important too. The trick is to find the right balance between the two.

Watercolour demands careful planning. Before you start painting, you need to think hard about what to include and what to omit. This is particularly important when it comes to details. If you are dealing with a complicated subject, for instance, it is better to start by applying light tones and generalized washes, adding the darker tones and the more precise details towards the end. This method of working gives you a considerable degree of control. Some subjects – including many landscapes – are most effective if reduced to a series of simple washes with a few key details put in at the end. In other cases, where there is more detail to consider (such as in a townscape), a more meticulous approach is required.

Key points

- Work from the general to the particular so the image evolves gradually.

- Work from light to dark – this gives more control and leaves room for changes.

- Pull a painting into sharper focus by adding some key details.

- Use selected details to create focal points and areas of interest.

- Shorthand marks can represent foliage or a roof – the eye fills in the rest.

- Details such as lettering give a sense of place.

- Easily recognizable features, such as figures, create a sense of scale.

Taking a closer look

In this evocative and economical watercolour, the artist has combined a series of delicate washes with touches of telling detail applied wet on dry with the tip of a small brush.

Mount Street, Diss
by *John Lidzey*

The thin branches have been painted using the tip of a small sable brush. The artist worked towards the tip of each branch.

Chimney pots silhouetted against the sky give a sense of scale.

Details in the foreground – such as the doorway here – bring this area forward and convey a sense of recession in the rest of the picture.

Grasses seen light against the dark trunk have been masked with pen and masking fluid.

Grasses seen dark against light have been painted with the tip of a fine brush.

Figures are easily distinguished even when small – here they lead the eye in and provide clues to recession.

Choosing key elements

Too much detail is fussy and confusing, but selected items can pull a picture together, lead the eye in and give clues to scale and recession.

An artist has complete freedom to select, edit, exaggerate and even invent. Decide what is important and avoid cluttering your composition with superfluous features. Every element in your painting should be there for a reason, contributing to the story you want to tell. Some subjects, such as wildlife and botanical studies, demand meticulous treatment, but mostly you need to include a certain amount of detail – not all of it.

Tip

A good way of introducing a sense of scale is to include a figure or two in your painting – an adult figure is a known quantity. The figure doesn't have to be laboured. A few flicked-in brushmarks will serve the purpose perfectly well.

In practice **Using specific features**

Although it's easy to see the sand, sea, headland and sky in this study (inset right), the spatial relationships are not clear, and without obvious focal points the eye wanders aimlessly. Adding details (below) makes the painting more focused and easier to read. The masts provide strong verticals, echoed in the foreground and balanced by the horizontals of the horizon and buildings. The figures, though sketchy, give a sense of scale.

POSTE DE SECOURS

Tiny details, such as this mast, are just as important as larger ones – if you can't get a fine enough line with a brush, draw it lightly with a sharp pencil.

Carefully rendered lettering gives a sense of place.

Crisp wet-on-dry brushstrokes make the brickwork stand out.

The definite shape and warm colour of the chimney pot pull this area to the front of the picture.

Figures help create a sense of scale.

Cast shadows establish the horizontal ground plane.

The mast in the centre of the picture provides a dynamic pivot for the whole painting.

Light fantastic

Light is often the real subject of a landscape painting. It can reveal and conceal forms, establish a mood, modify colours and change apparent spatial arrangements.

Light is insubstantial, elusive and transitory. You can see its effects, but you can't touch it or feel it. We depend on light to see, and it affects the way things look and even influences our mood. In many paintings, the landscape is merely a foil for the light, a screen on to which it is projected.

The aspects of light that concern the painter are intensity and luminosity.

Capture the intensity of bright sunlight by exaggerating the contrasts between the sunlit areas and the shadows, and use wet-on-dry techniques and masking to give them crisply defined edges. Suggest the luminosity of light by making the transitions between one tone and another as imperceptible as possible – the light should appear to emanate from the support.

Key points

● Light and tone allow you to model form and create the illusion of volume and three dimensions.

● Light affects appearances – a white cat becomes grey in certain lights.

● Light affects the mood of a painting.

● Paintings that are suffused with light can be cheerful and bright or soft and delicate.

● Use body colour, that is watercolour with white added, or gouache to touch in highlights.

Taking a closer look

In this subtle and luminous study, the artist has captured the warmth of the light splashing on to the pink, stuccoed façades lining a Venetian canal.

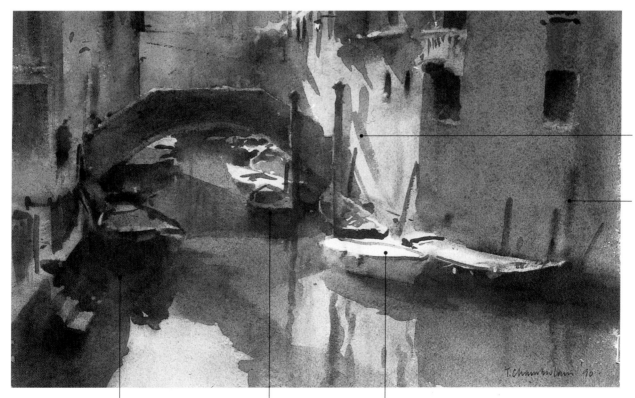

A quiet canal in Venice, 1990 by *Trevor Chamberlain* (Private collection/ Bridgeman Art Library)

Cool shadows contrast with the warmth of the sunlit areas.

A slight granulation of the wash makes this area shimmer.

Velvety dark shadows contrast dramatically with the pale reflection of the sky.

In deep shadow, the boats look blue – there is not enough light to show what colour the boat really is.

In very bright sunlight, the boats appear brilliant white, regardless of their actual colour.

How to depict light

Exp oit optical colour mixes and contrasts of tone and colour temperature to increase the impression of light in a painting.

Colour temperature is important when you are rendering light. Generally, an object bathed in sunlight appears warmer than the same object in shadow. Add blues or violets to the shaded areas in your painting – you can do this by using blue in the shadow mix, by overlaying a blue wash or by adding broken touches of blue or violet. Use warm versions of the local colour for objects in full sunlight, sap or a yellow green for foliage, and warm neutrals for stone surfaces.

Broken-colour techniques, such as stippling and spattering, are good for capturing the sheer luminosity of light. You can enhance the effect by limiting the tonal range in your painting and softening outlines so that the colours appear to shimmer on the support.

Expert advice

● Bright light is so dazzling that you can't see your subject clearly. If possible, find a place in the shade – for example, under an awning or a tree – and wear a broad-brimmed hat to shield your eyes.

● Light on a landscape can change rapidly, so make a quick sketch before you begin. Make a note of the direction of the light and the distribution of light and dark tones.

The effects of light are obvious on buildings. You get different effects in diffused light and in strong side light. Try this for yourself – find a façade and paint it in flat light and intense light.

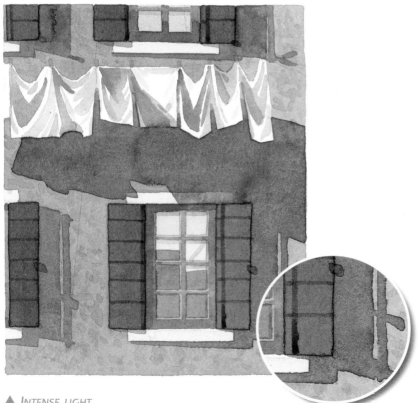

▲ INTENSE LIGHT
Strong, directional light casts dark shadows that emphasize the jutting sills, the space behind the shutters (inset) and the folds in the washing. Use a strong orange wash and spatter colour to suggest how the light picks up surface indentations. Apply the blue-violet shadows wet on dry for a crisp edge.

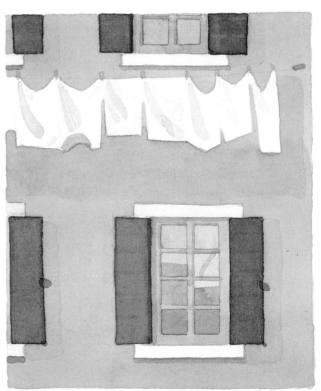

▲ DIFFUSED LIGHT
When sunlight is diffused by high clouds, shadows are barely discernible, colours are bleached and objects seem flatter than in stronger light. To paint this image, choose a relatively light palette and minimize the tonal differences. The resulting painting will have a fairly flat and uniform appearance.

Looking at shadows

Shadows add drama and pattern to a landscape – sometimes they are as important as the solid objects that cast them.

The most interesting shadow effects are seen early in the morning and in the afternoon on sunny days. In these conditions, shadows project a long way and make distinctive shapes which can become the main subject of a composition. Many artists choose to paint at these times of day because they like the interesting effects shadows produce in a landscape. Intense cast shadows have a special graphic quality – they can be highly decorative and by emphasizing them you can move an image towards abstraction.

Shadows also affect mood. Intense contrasts of light and dark evoke sunshine and warmth, while on an overcast day shadows will be soft and blurred at the edges, creating a more restrained atmosphere.

Key points

● Look for the light source and make your shadows consistent.

● Explore cast shadows and shaded areas in a quick tonal sketch. Note the way the blocks of light and dark relate to each other and to the edges of the picture.

● Shadows become paler and cooler the farther away they are (a rule of aerial perspective).

● Shadows become smaller and closer together as they move farther away (a rule of linear perspective).

Taking a closer look

In this vigorous landscape, the artist has captured a sense of bright sunlight, although most of the image is in shadow. The shadow areas create emphatic shapes and dappled patterns which enclose and enhance the sunlit areas.

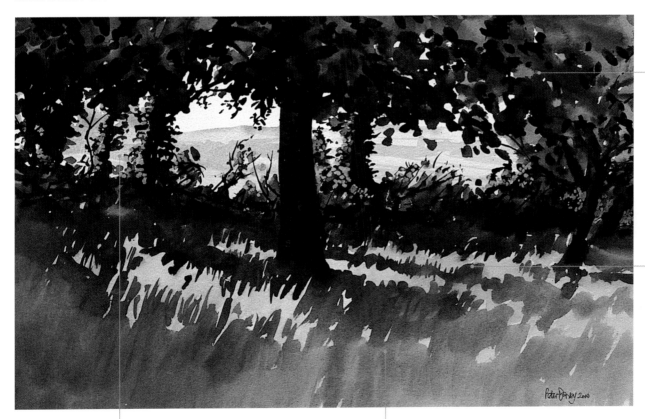

Sunset at La Grassiére *by Peter Davey*

The tree canopy has great luminosity and depth. The underwash was applied wet in wet, then the shaded foliage was dabbed on wet on dry.

Crisp wet-on-dry brushstrokes applied over a yellow wash suggest sunlight glinting on grass.

The contrast between the yellow sunlit foliage and the intense dark shadows creates a sense of the sunshine beyond the trees.

Layers of wet-on-dry washes describe the effects of light filtering through foliage.

Painting shadows

Watercolour offers a range of hard and soft edges, making it ideal for rendering shadows. Directly applied or subtly blended colour, or using a layering technique, helps you to capture light effects with precision.

Shadows are not solid. They have a luminosity and depth – don't overmix colours or they will appear flat and dead. Use wet-on-dry washes for the crisply defined shadows typical of a sunny day, and wet-in-wet or wet-on-damp washes for softer effects. Loose washes capture the vibrancy of the light. Allow colours to fuse and melt wet into wet, and lift out touches of colour to indicate reflected light.

You can also use a layered technique. Make sure each wash is dry before adding the next. Apply the paint cleanly and avoid disturbing the under layers so that the shadows stay fresh and luminous. If you are bold and confident, you can paint shadows directly, applying a single layer of colour. Be sure you have the right mix and remember that watercolour dries much lighter than when applied.

Expert advice

● In shadow areas look for: a darker shade of the local colour; colour reflected from the surroundings; blue reflected from the sky; the complementary of the object casting the shadow; and the complementary of sunlight.

● Shadows tend to be cooler than surrounding areas because they are away from the light.

● Shadows vary in tone depending on how near they are to the object casting them. The shadow of a lamp-post, for example, is sharper near the base and softer farther away because more light is reflected into it.

 In practice **Palm tree shadows**

Sea front in Turkey
by *Keith Noble*

Paint wet on dry to depict the neatly defined shadows on a sunny day. Introduce fresh colours wet in wet for the variegated effects within the shadow areas. This combination of techniques captures the luminosity of the light and the colour and intensity of the shadows.

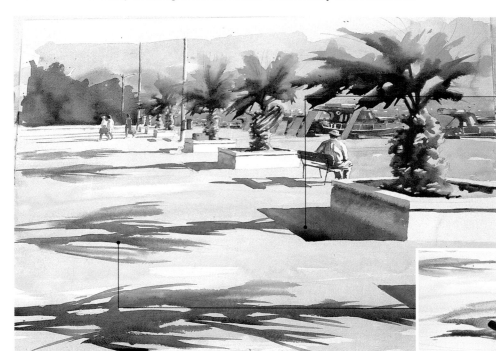

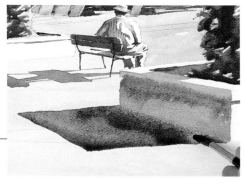

▲ *Apply a blue/lilac mix for the cast shadow, over raw sienna on the sides of the planters. Use the edge of the wash to define the neat edge of the shadow. While the wash is still wet, introduce touches of reflected colour with the tip of the brush.*

▲ CRISP AND DIFFUSED SHADOWS
The graceful shadows of palm trees falling across paving add decorative interest and colour to an otherwise empty part of the composition. They emphasize the flat, horizontal ground plane, and reinforce the sense of recession.

◄ *The shadow of the palm is diffused, so dampen the paper here and there with clean water. Use the tip of the brush to 'draw' the fronds in a mix of cobalt and cerulean blue. While the paint is still wet, introduce alizarin crimson for warmth.*

Painting night scenes

Subtle tones, muted colours and dramatic, theatrical light effects make night scenes a challenge. Careful observation is the key.

The more you look at a night scene, the more you will see. At twilight, outlines blur and appear softer, colours become subdued and details disappear. Once dark, forms are visible as vague silhouettes and shadowy half tones, but it's never uniformly dark even on the darkest night. As your night vision becomes attuned, subtle colours and tones and vague forms emerge.

Natural light from the moon and stars is surprisingly bright, creating an eerie or mysterious atmosphere, while street lights have quite a different mood.

There isn't usually enough light to paint night scenes on the spot. Make a few sketches, back these up with photos and – better still – hone your visual memory by looking long and hard at the scene.

Key points

● Even on the darkest night there is some light in the sky.

● Outlines are indistinct and details are lost at night, while subtle tones replace bright day-time colours.

● Twilight is often characterized by the orange-pink tones of sunset.

● Moonlight is cold and bluish, and creates bright highlights.

● Street lights cast a yellowish light.

Taking a closer look

In this painting, the artist has captured the luminosity of the street lights and their reflections in wet pavements. He used a limited palette and played transparent and opaque colours off against each other to enhance the atmosphere.

Piccadilly Circus, London
by Roy Hammond

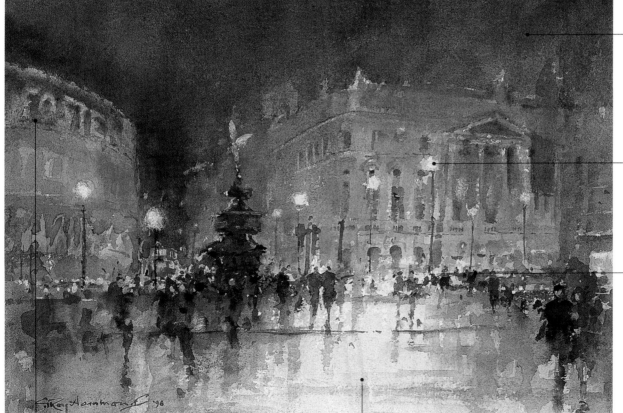

The inky depth of the night sky was captured with thin layers of transparent wash. These granulated slightly, which added to their luminous effect.

The artist reserved the white street lights before he started, then worked back into them with body colour.

The figures are loosely suggested in silhouette with no visible details and colours. Similarly, the details of the buildings are only hinted at.

Artificial light casts a yellowish glow, so the artist chose a limited palette of mostly warm colours, working in muted tones of browns and ochres. The red bus and blue advertising lights create bright accents of colour.

The bright foreground shimmers with reflected light, achieved with pale wet-in-wet and wet-on-dry washes in subtle tones.

Moonlight effects

Moonlight creates an eerie atmosphere that makes quite ordinary scenes mysterious. The absence of colour means you can use a limited palette to great effect.

Expert advice

● Use close tones and subtle gradations of tone rather than sharp contrasts.

● Apply very thin, semi-transparent body colour – use tiny brushstrokes or smear the paint lightly.

● Scrape out colour gently to create a range of softly diffused highlights.

In practice **Full moon over the sea**

This subject depicts available light only. The full moon creates crisp highlights on the ripples, and a diffused luminescence that glances off the water surface. Three colours have been used.

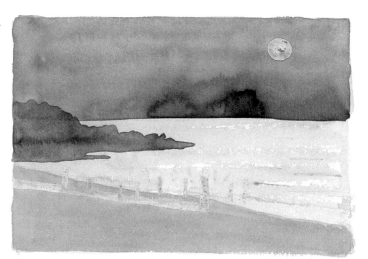

▲**2** Darken the sky with a stronger wash of Payne's gray and Prussian blue. Let it dry, then use a different mix of the same colours to paint the rocks wet on dry. Paint the beach with a wash of raw sienna and Payne's gray.

▲**1** Mask out the moon and the groynes, then apply a pale wash of Payne's gray and Prussian blue over the entire picture. Skim the brush lightly over the paper, leaving white areas for the reflections in the water. Let the wash dry.

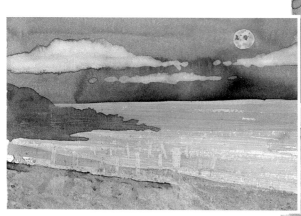

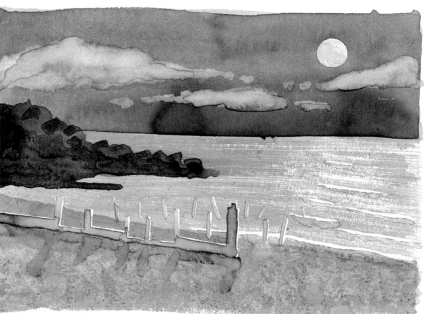

▲**3** Lift out clouds with clean water and blot with tissue. Darken the sea with a second, dry-brushed wash. Add texture to the beach by spattering with water and a toothbrush. Blot it, leave to dry, then spatter a darker wash of raw sienna and Payne's gray.

▲**4** Remove the masking fluid. Add depth to the clouds and rocks with a raw sienna/Prussian blue wash. Paint the moon and add the shadows and groynes with different strengths of the same wash. Scrape off some of the sea wash with a sharp knife or scalpel to depict the luminosity on the surface.

Painting skies

The sky, a constantly changing pageant of light and clouds, provides the backdrop for a landscape. For the artist, it is the most important element in a landscape painting.

A painter has to work very quickly to record the sky before the light and mood changes. Watercolour is ideal for creating fast, spontaneous and convincing sky effects. Its fluidity when used wet in wet is ideal for moody, amorphous sky effects, while wet on dry gives crisp edges for frothy white cumulus clouds. Watercolour is unpredictable so every sky you paint will be different – but that's one of the pleasures of the medium.

Key points

- The sky is not a flat wall behind the landscape. Allow colour and tone to fade towards the horizon to convey a sense of recession.

- Clouds are three-dimensional – the tops usually face the sun and are therefore lighter in tone than the sides and bottom.

- Make the foreground clouds larger than those near the horizon – this will enhance the sense of space.

In practice Summer sky

For fluffy summer clouds, use the white of the paper for the cloud shapes and wet-in-wet and wet-on-dry washes for soft and hard edges. Use a mop brush to wet the paper, then a squirrel mop to paint with.

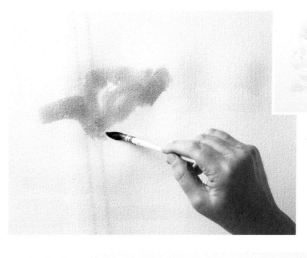

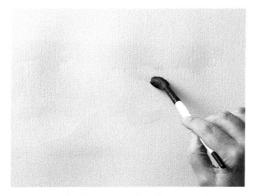

1 Use the large mop brush to wet the paper at random, leaving some cloud-shaped areas dry.

◄**2** Load the squirrel brush with cerulean and apply to the wet areas. Push and pull the paint around to create a variety of tones and cloud shapes. Take the brush over dry paper to create crisp edges (inset above). Leave to dry.

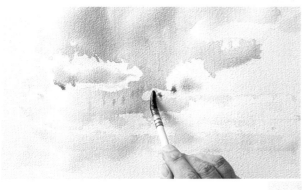

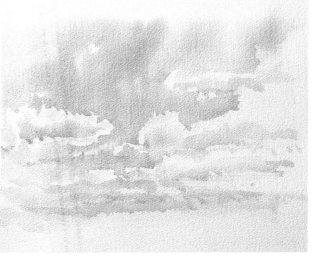

◄**4** Note that the sky is much lighter and softer when the paint has dried completely.

▲**3** Apply water here and there within the cloud shapes. Load the squirrel brush with a mix of ultramarine, alizarin and cobalt and use the tip of the brush to dot colour into the wet areas.

Change of mood

While wet-in-wet and wet-on-dry watercolour washes are excellent for sunny summer skies with white clouds, they also lend themselves to moody, rainy – even stormy – skies.

This is where wet-in-wet technique really comes into its own. Naturally, your palette takes on darker, more sombre tones. There is usually a touch of blue somewhere, but greys such as Payne's gray, or a mix of ultramarine and burnt sienna or Indian red, are ideal for brooding, rain-sodden skies. The trick is to let the watercolour do the work. Wet the paper first and allow the colour to flow into the wet areas – tilt the board if necessary.

Expert advice

As watercolour is unpredictable, constant practice will give you the confidence to exploit the medium's fluidity and accidental effects. Here is another rainy sky, painted in exactly the same way, but the effect is different.

In practice Painting a leaden sky

Wet-in-wet washes with their subtle blendings and transitions of colour are perfect for portraying rainy skies.

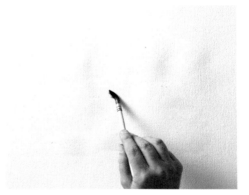

▲**1** Wet the paper, applying horizontal strokes of the squirrel mop brush. Don't worry about leaving dry areas – these all add variety to the effect.

▲**2** Apply dabs of cerulean to the top left of the sky area. Mix a wash of Payne's gray and ultramarine, and apply dots at random into the wet areas (inset above).

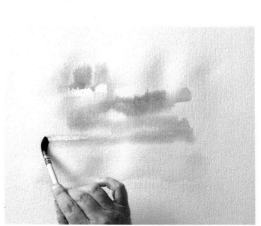

▲**3** Continue applying the dark wash, working freely and quickly with horizontal strokes of the brush.

▲**4** Place the bands of wash closer together near the horizon – this will create a sense of recession. The finished wash (right) captures the effect of a rain-laden sky.

Painting water

Water affects the mood of a landscape profoundly. It acts as a mirror to the sky and brings light into a painting. You can use a range of techniques to capture its depth, wetness and reflective qualities.

Water changes in response to light and the weather. The challenge for the artist is to capture these fleeting moments and convey water's fluidity and light-reflecting qualities. With streams and ponds, the sky is often partly obscured, with light filtering through the foliage. Light falling on water makes the water highly reflective. However, where the water is shaded, the surface becomes transparent and you can see the bed.

The key to painting water is keen observation. Look at the movement, colours and tones. A simple approach is best – don't overlay too many washes or the colours will become muddy and the sense of fluidity will be lost.

Key points

● Study water carefully and paint what you see, not what you know.

● Ripples fragment the reflected image.

● Shadows interrupt the reflections and allow you to see into the water's depth.

● Wet in wet and wet on dry can both be used for rendering water.

● Don't overwork your washes – the colours will become dull.

Taking a closer look

In this atmospheric painting, the artist has captured a powerful sense of bright sunlight and dappled shadows, at the same time conveying the wetness of the stream.

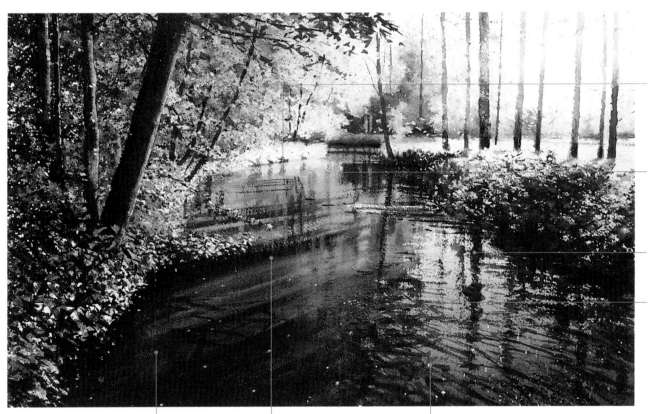

Albury Park by *Joe Francis Dowden*

Where the reflected light is strongest, you see no deeper than the glassy surface of the water.

A combination of transparent and semi-transparent colour suggests depth on the bend in the stream.

Vertical brushmarks suggest depth.

The strong contrasts of light and dark suggest reflected light on the surface of the water.

The shadows cast by the overhanging trees allow you to see the bed of the stream, which is rendered with a wash of burnt sienna.

Diagonal shadows emphasize the bed of the stream.

The sparkles of light are rendered with a variety of techniques, including spattered and dotted masking fluid and scratching out with a knife.

Calm, still water

The surface of still water mirrors almost exactly the colours of the sky and the features of the surrounding landscape. The reflections are sharp and clear.

Tip

Ripples break up and blur reflections. Keep vertical lines sharp in a distant reflection and soften the horizontal ones to mimic the rippling effect.

In practice Lake on a windless day

Follow the steps below to paint a scene with quiet water. The artist has used a number of techniques to give the reflections a sense of recession and depict the surface of the lake.

▲1 Apply the sky wash wet in wet, reserving the whites of the house. Turn the paper upside down and paint the water wet in wet with a strong graduated wash of phthalo blue/indigo. Darken it again while still wet, then add burnt sienna for the shallow, muddy bottom in the foreground. Leave the house reflection area white.

▲2 Paint the reflections of the trees. Wet this area with the tip of a round brush, leaving speckles of dry paper. Brush pigment vertically through the wet area – some strokes will diffuse with a soft edge. Gently drag some colour into horizontal ripples at the base of the reflection.

▶3 Wet the hard edge of the house reflection. Paint the house reflection with the same wash as the house, saving whites for the windows. While still damp, add a darker mix to the lower half of the reflection. Let it bleed into a soft edge.

▲4 Brush darker colours down into the house reflection. Re-wet the base of the reflection and darken it slightly. Streak the chimney reflections down into the water, wet on dry, with small horizontal strokes. Add the rest of the reflected house details. Re-wet and blend in darker colour at the lower edges of the tree reflections. Paint long ripples in the foreground.

Painting reflections

Reflections are a vital element in paintings of water. Their presence is a sure indication that water is present.

All water reflects, whether it is merely a surface film, a muddy puddle, a flowing river or the open sea. The beauty is that reflections not only provide attractive patterns in a painting, they also become important compositional elements. For example, reflections help you balance solid shapes with their watery images, and give the opportunity to repeat the colours in one area of a painting in another place, thus helping to create a sense of unity and harmony.

Although reflections are at their clearest in still water, the most interesting effects appear when movement creates ripples or swells that break up the reflections into separate shapes with jagged or wavering outlines. The ripples act like lots of tilted mirrors, reflecting the sky and the sun and making the surface sparkle with reflected light.

Key points

● If a building or any other object is right by the water's edge, the reflection must be exactly the same size.

● If a building or other object is set back from the water's edge, only the top part or parts are reflected.

● In moving or disturbed water, reflections are a mixture of the surrounding colours.

● Ripples or wavelets cause reflections to fragment and blur.

Taking a closer look

A thin layer of rainwater on the paving stones in St Mark's Square, Venice, reflects with perfect clarity the buildings, lamp-posts and figures. An underlying muted blue-grey wash is overlaid with precise darker washes, put in wet on dry, to stand for reflections. Minute flecks of red on the figures and umbrellas lead the eye into and around the painting.

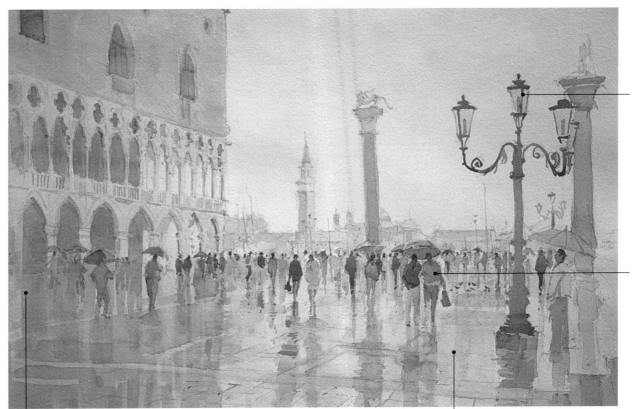

Rain and reflections, Venice by Paul Banning

The lamp-post is reflected solidly in the rainwater. The darkest tone at the base is actually shadow – not reflection. Seen straight on, this reflection should be exactly the same length as the post is tall. It therefore continues on, out of the picture area.

The figures are moving – so their reflections are wavy and blurred in the still water. The opposite would also apply – stationary figures would appear wavy in moving water.

The Doge's Palace is casting its own shadow, so its reflection is darker than the building itself. The palace appears to stand on its own reflection because it is right at the edge of the rainwater.

The water reflects all the colours of the sky and the buildings – a medley of soft watery blues, greys and warm neutrals.

Watery images

Look closely to see what is being reflected and how far the reflections extend – and what colours the water takes from its surroundings.

The position of the items reflected relative to the water affects just how much of them you see – for example, a house right by the water's edge is reflected in its entirety, while one set farther back is reflected in part only. The wet-on-dry technique is excellent for painting reflections – you can create crisp details and precise colours on top of underlying washes.

Expert advice

Proof that the building below is right at the water's edge lies in the fact that its reflection stretches exactly as far into the water as the building is high. Use a pencil to check these proportions in the field. Line up your pencil with the building or other object in question and slide your thumb down to the measurement you see. Then, keeping your thumb in position, check the measurement of the reflection in the water.

In practice Reflections in still and rippling water

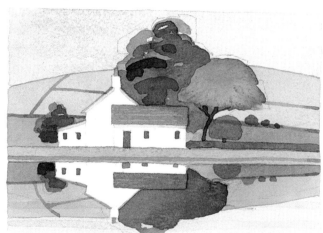

◀ STILL WATER
Here the reflections are not affected by the direction of the light and they appear directly beneath the object. This house is quite close to the water's edge so it measures nearly the same below the water as it does above.

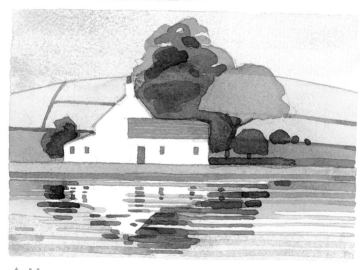

▲ MOVING WATER
When water is moving – as with the ripples in the river here – the reflection becomes fragmented and blurred. The surface of the water becomes faceted, so that each ripple or wavelet acts as a separate, tilted, curved mirror.

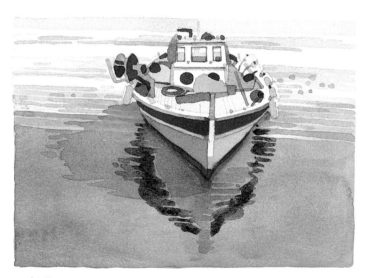

▲ REFLECTIONS AND SHADOWS
Shadows are affected by the position of the sun or other light source – here the boat is casting a distinct shadow to the left, indicating that the source of light is coming from the right. The reflection, on the other hand, is not affected by the light source. Both sides of the boat's hull are reflected in the water directly under the boat itself.

Painting seas

Capturing the changing sea is a great challenge. Using wet-on-dry washes is a key technique for portraying the sea convincingly – whether it's calm and rippling or has breakers crashing on the shore.

A s with skies, painting the sea requires quick work because the water is never still – and no two ripples or breakers are exactly the same. The secret is to convey a sense of movement by laying in an initial broad, flat, pale wash that is then broken up with a series of irregular darker bands, laid down wet on dry.

For a calm, rippling sea this need be no more than one darker wash laid over a lighter one. You can introduce a sense of recession very effectively by ensuring that the ripples become smaller and closer together the farther away they are, and that the ripples nearest to you are darker than those farther back.

For waves rising, peaking and then breaking on the shore, areas of darker shadow are vital for giving form and substance to the water.

Key points

- Plan and reserve your whites before you start (see pages 11–12).

- Use the wet-on-dry technique to give a sense of movement.

- Make sure the waves are smaller and closer together, and the colours lighter, in the distance than in the foreground to create a sense of recession (see below).

- Paint waves with fluid brushstrokes, in the direction the wave is flowing, to capture their complex shapes.

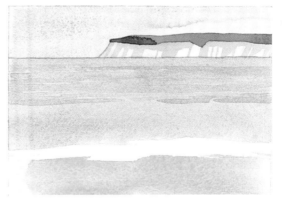

In practice — Calm sea – gentle waves

These studies show you how to capture the qualities of a calm sea. Here the artist used a mix of cerulean and Payne's gray for his basic wash, starting from a very light mix and gradually darkening it for the nearest rippling waves.

1 Paint the sky first, then lay in a flat wash of colour for the sea, using a mix of cerulean and Payne's gray and working downwards from the horizon. Leave the white of the paper for the foam on the shore. Paint in the cliffs, the beach and the green clifftops. Leave to dry.

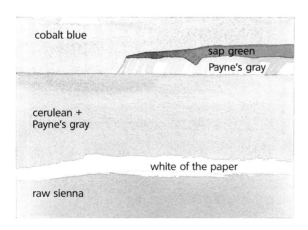

cobalt blue

sap green

Payne's gray

cerulean + Payne's gray

white of the paper

raw sienna

2 Mix a slightly darker version of the wash you used to paint the sea in Step 1. Lay long, flat parallel bands of colour, working from the horizon downwards as you did before. Leave gaps between your bands to create the effect of ripples in the water. Leave to dry again.

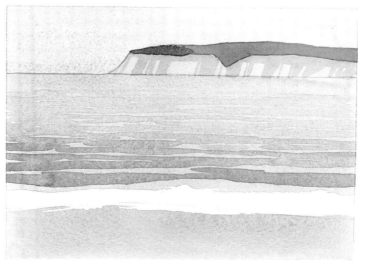

3 Darken your wash again and continue laying bands of colour in the foreground. Make these broader and more widely spaced than the previous ones. This helps you create that vital sense of recession in the picture.

Making waves

Find out how waves work and you'll be able to capture all their drama and restless energy.

Understanding how the sea swells to form waves helps you to paint them with assurance. Watch and you will see that they rise to a peak, then curve over and under before breaking into foam. The secret is not to attempt to draw a wave. Instead, use fluid brushstrokes to paint curving, swelling shapes that capture its complex form. Work in the direction the wave is flowing – this helps to give momentum and energy to the image.

In the exercise below, the white of the paper stands for the breakers at the shoreline and the whitecaps farther out to sea. Plan the whites at the start.

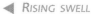

Try this!

Waves rise and break in a continuous rhythm. Use these studies to help you follow how waves are formed.

◀ RISING SWELL
A wave moves towards the shore from afar, starting as a gentle rising swell that gradually builds to a rolling movement.

▶ PEAKING
A breaker forms as the sea becomes shallower and interrupts the wave's circular motion. The wave begins to rise to a peak.

◀ BREAKING
As the wave reaches the beach (where the sea floor is at its shallowest) it passes its peak, curls over and crashes down, creating a mass of spray and foam.

In practice **Breakers on the shore**

Waves breaking on a shore are forcible and vibrant. To capture this, you need the pure white of your paper to contrast with indigo blue under the waves.

cobalt blue

sap green
Payne's gray

cerulean + Payne's gray

white of the paper

raw sienna

◀ **1** Paint the sky, leaving patches of white for the clouds, then start on the sea. Lay long bands of colour across the paper, allowing white areas to stand for the whitecaps and the breakers at the foot of the cliff.

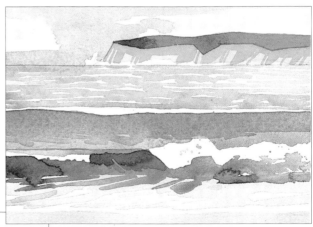

▶ **2** Darken your wash and, using a larger brush than before, apply more colour loosely across the sea area, using the brush to 'draw' around the wave shapes as you go. Take the wash carefully around the white of the paper in the foreground. This will become the breaker of the wave as it falls on to the beach.

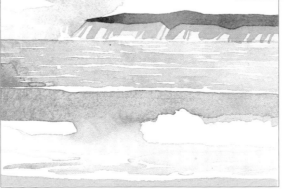

▲ **3** Mix an intense indigo blue wash from a mix of cerulean and Payne's gray and use it to put in the darkest shaded area under the wave. This helps to convey the impression of the curving wave just starting to break.

Painting sparkling water

Sunlight on water causes brilliant reflections. The aim is to capture the intensity of the light and convey the translucency of the water.

Light reflected on still water creates a flat, dazzling sheet. If the surface is rippled this is broken into tiny pinpoints of light. The white of the paper is the brightest tone – make it dazzle by surrounding it with darker tones that set up strong contrasts. Paint around the bright areas first or use masking fluid – spatter or stipple it to capture the effect of sunlight glistening on broken water, or use wax resist.

Combine a Rough, highly textured paper with dry-brush work, that is drag the paint across the surface with the bristles of a dry brush – the wash fragments to suggest sparkle. At a later stage, try scraping out to lift the paint – rub with glasspaper for a shimmering surface or scrape linear marks with a blade for light glancing off ripples. Pick out tiny specks of paint with the tip of a blade to create minute highlights.

Key points

● Reserve the white of the paper at the outset for the brightest reflected lights.

● Use masking fluid or wax resist for broad highlights and broken, sparkling effects.

● Exploit the texture of Rough paper and combine with dry-brush techniques to suggest sparkle.

● Score lines through to the white paper while the paint is wet to suggest light reflected on ripples.

● Pick off specks of dry paint with the tip of a blade for bright pinpoints of light.

● Use white gouache or soft pastel to add final highlights.

Taking a closer look

The artist has combined delicate nuances of colour and darker contrasting tones with whites to create a dazzling sense of intense reflected light bouncing off the water.

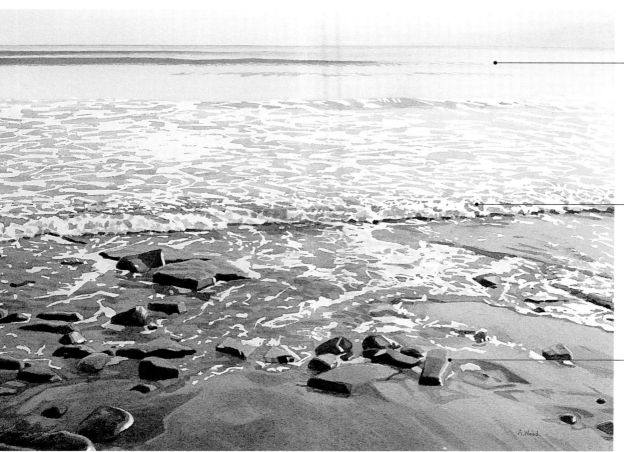

Seascape by Andy Wood

Subtle gradations of tone on the calm sea create a sense of recession. The still surface reflects a sheet of light so bright you almost have to close your eyes against the glare.

The artist used masking fluid to create the complex pattern of light reflected on the water and the wet sand.

Bright highlights on the stones make them glisten wetly.

Capturing light on water

A combination of techniques is often effective for depicting the transient effects of light reflected on water. Keep your painting simple so you retain the freshness and clarity of the subject.

Expert advice

● Look for the direction and the height of the sun which dictate the position and shapes of the bright reflections. See where the bright highlights occur.

● Lay a loose bright yellow wash first to establish the overall high key of the painting. Retain areas of this colour in the finished painting.

In practice **Sun on a woodland stream**

Masking fluid, wet-in-wet and dry-brush techniques combine to create this painting of a sparkling woodland stream.

◀**1** Mask a few river stones. Run cadmium yellow into wetted parts of the woodland. Leave white areas for sky. Wet the river, leaving a dry swathe on the right. Run cadmium yellow into the wet. Add phthalo blue from the bottom and drag some to the right for ripples. Leave to dry.

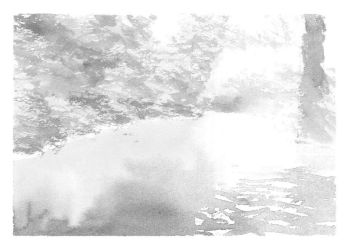

▲**2** Drag strands of water across the woodland area and use a phthalo green/cadmium yellow mix to create a dry-brush effect for leaf textures. These diffuse into the wet areas. Add green to the distant bank and the large tree trunk.

▲**3** Wash in the darkest foliage in phthalo green/indigo – also the tree trunks, bank, the dark water under the bank and the big tree trunk. Wet foreground reflections and ripples and run in dark green/yellow and Payne's gray/indigo mixes. Add the fence.

▶**4** Darken the ripples – add a few in the sky reflection area. Darken the tree trunk reflection on the right. Leave to dry. Remove the masking fluid and scratch with the point of a knife to create sparkles in the water.

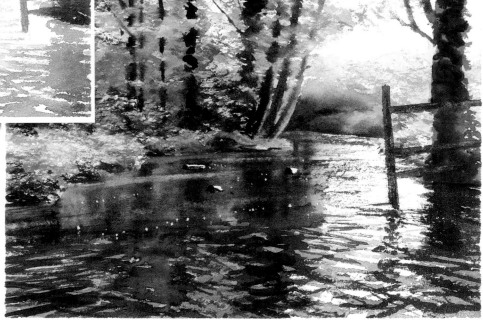

Misty landscapes

The soft lucidity of watercolour is ideal for capturing the veiled light, blurry shapes and muted colours of misty landscapes.

Mist is made up of microscopic droplets of water suspended in the air, creating a fine, grey veil that subdues colours and softens tones. Misty skies and landscapes have a damp luminosity – light is diffused and reflected back, with the mist echoing the colours of the sky.

Mists usually occur in the morning and evening, and over low ground by streams and rivers. Often, on misty days, hills may be seen peeping above vaporous clouds that obscure the valleys beneath them.

Capture the soft light with closely related tones and a limited palette. Use granulation (that is the tendency of some pigments to separate and settle in the indents of the paper) and a variety of brushstrokes. Apply a wash to wet or partially dry paint, creating runs (called backruns) that evoke dampness and suggest the undefined forms of objects seen through a haze.

Key points

● To capture a mist, you need to be equipped to start painting early in the morning or later in the evening.

● For the best results, paint wet in wet and exploit backruns; and use the mottled effect of granulation.

● Build up colour with transparent washes to suggest veils of mist.

● Use a limited palette of delicate colours and subtle tonal gradations.

● Use complementary mixes to create a range of pearly coloured neutrals.

Taking a closer look

In this painting, the artist worked wet in wet and exploited granulation effects on rough-textured paper to suggest the soft light of early morning mist over a river.

Early morning, Zayandeh-Rood River, Isfahan, Iran
by *Trevor Chamberlain*

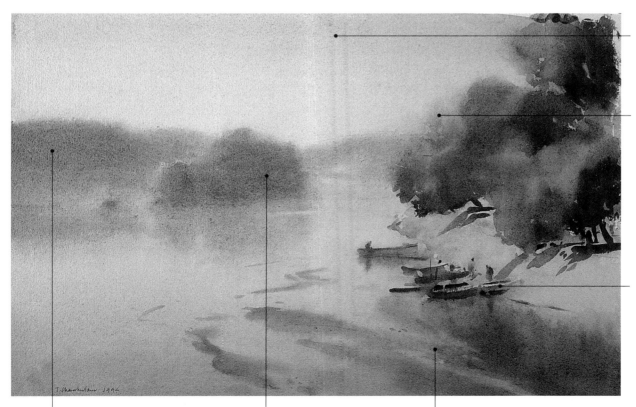

The granulation of the sky suggests the soft glow of misty early morning light.

The artist has applied the washes loosely in one or two layers, keeping the colour fresh and light to maintain a luminous quality.

Although the boats have been fairly crisply defined to bring them forward, just one or two brushstrokes are used to suggest their forms.

Features become more indistinct as distance increases – soft-edged areas of tone hint at clumps of trees on the far side of the river.

Tonal contrast has been kept to a minimum, enhancing the sense of diffused light.

Colour has been applied using very wet washes. The artist used rough-textured paper, held flat, for extra control and granulation.

Depicting mist

*Painting wet in wet and creating deliberate backruns are
excellent techniques for achieving an ethereal look.*

 Mist over trees

*In this misty landscape, the ridges are marked in pencil over a pinky grey
wash, then strengthened with a series of wet washes.*

▶ **1** Cover the paper
with a wash of
Naples yellow/cobalt
blue/burnt sienna/
alizarin crimson. Pencil
in the ridges. Wet the
horizon and run in
ultramarine/burnt
sienna/alizarin crimson.
Wet the far ridge, then
bleed in more of the
horizon wash. Add
water to create
backruns.

▲ **2** Work downwards, wet in wet, painting one
ridge at a time, as in Step 1. When each wash
is almost dry, brush water just beneath to create
feathery backruns, tilting the support if necessary.
Allow each ridge to dry before starting the next
and vary the colour and tone of the blue-grey mix.

▶ **3** Darken the blue-grey mix with burnt umber and
ultramarine. Continue painting the ridges,
making them bigger, more widely spaced and looser
towards the foreground. For the last ridge, add a little
cadmium yellow to the wash. When still damp, drop
in water and a little burnt sienna to create a backrun.

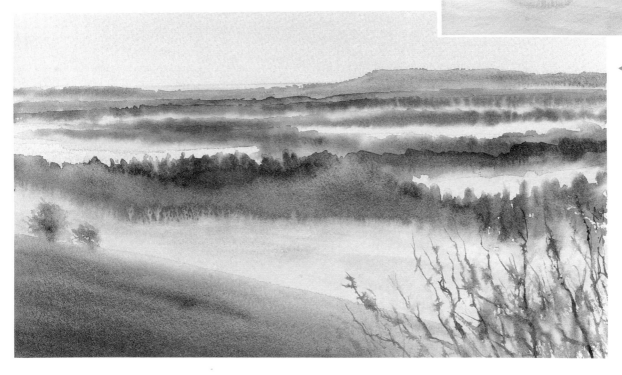

◀ **4** Darken the pinky
grey wash with sap
green and use this to
paint the foreground
field and the small
trees, working wet in
wet from the bottom
up. Allow to dry.
Feather a damp brush
across the foreground
on the right. Run a
burnt sienna-based
grey-brown across,
then run in dark
branches using the
point of the brush
loaded with burnt
umber/ultramarine.

Painting rain

Rain alters the appearance and mood of a landscape dramatically, presenting different challenges to inspire the landscape painter.

For the artist, rain isn't 'bad' weather. Rather, it offers an opportunity to study the landscape in a different mood. Rain has many aspects, from the light veil of a summer shower to the drama of a thundery cloudburst. Sometimes the landscape is shrouded in gloom. At other times, rain and sun alternate rapidly. Rain can blur outlines, obscure details and horizons, and create muted colours, or it can bring things into sharp focus and intensify colours in the subdued surroundings. Watch rainstorms and make rapid tonal thumbnail sketches. Take photographs to supplement them.

Key points

● Make lots of sketches of the fleeting effects of rain.

● Note the tonal range and look for areas of contrast.

● Control your palette. On an overcast day, use neutrals and muted colours.

● Imply rain with threatening skies and wet ground.

● Use dragging or dry-brush techniques to depict falling rain.

Taking a closer look

In this evocative painting, the artist used several devices to convey the inclement weather conditions. The viewer is left in no doubt about the gloom and utter wetness of the day.

Wrapped boat
by *Michael Whittlesea*

The artist suggested the driving rain with slanting strokes of darker colour dragged lightly over the dry background washes with a dry brush.

The highlight on the top of the tarpaulin shines out wetly in the muted surroundings – you can almost see the pelting rain bouncing off it.

Sky and background blend murkily in wet-in-wet washes, while the foreground merges into the middle distance in one sodden mass.

Directional brushmarks add texture to the long grass. They seem to follow the trajectory of the rain and increase the impression of a downpour.

Depicting a rainstorm

With watercolour, you can capture the menacing atmosphere of an overcast day and a heavy downpour of rain.

A rainy landscape is never just grey. Colours may be subtle or there may be areas of heightened colour. Note the intensity and direction of the light, and find the lightest and darkest areas. Use your palette carefully – a strong colour can destroy the effect. Stroke wet paint downwards with a dry brush to suggest falling rain and use directional strokes for added movement.

Tip

You don't need to paint falling rain to suggest a rainy day. You can imply rain with blurred outlines, dark, threatening clouds and puddles on wet ground.

 In practice Countryside in rain

Wet-in-wet washes are excellent for portraying turbulent clouds and pouring rain, and granulation, i.e. pigment settling in the indents of the paper, adds to the stormy effect.

▶ **1** Wet the entire paper except for the white buildings and streak in an indigo wash to establish a general background tone. Use vertical brushstrokes in the sky and leave a white area on the horizon.

▶ **2** While the first wash is still wet, increase the intensity of the sky with a second wash of phthalo blue, taking it down as far as the top of the bridge and painting around the buildings.

▲ **3** Working wet in wet, depict the storm cloud with more indigo. When it's dry, paint the land with yellow ochre, then add cobalt blue to the wash and paint all except the lighter areas of land again.

▶ **4** Depict the shadows that the cloud casts on the land with streaks of cobalt blue. Paint landscape details with mixes of cobalt blue, burnt sienna and yellow ochre. Use Payne's gray for shadows and reflections, and light red for the roof. Finally, use a fan brush to stroke water down through the sky. Brush cobalt blue/burnt sienna horizontally for clouds, tilting so that some colour bleeds into the hills.

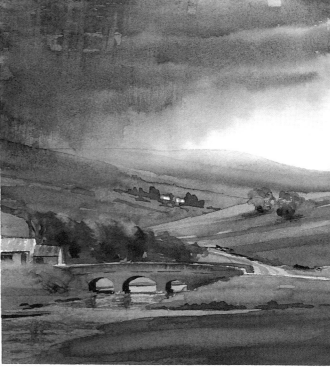

Looking at rainbows

Lifting out and painting wet in wet are useful techniques for portraying rainbows – the most spectacular light shows on earth.

The translucency of watercolour makes it the perfect medium for painting rainbows. These natural phenomena appear in the sky when there is both rain and sunshine. When you are lucky enough to see one, the sun is always behind you, and the rain is in the direction of the rainbow. When the sun is low, the rainbow forms a steep, dramatic arc. When the sun is higher, the arc is wider and shallower. Rainbows are not seen when the sun is at its highest around midday.

Look carefully next time you see a rainbow – observe how its seven colours start with red at the top and finish with violet at the base. The sky shimmers, because of the rain, and parts may be quite dark. Inside the rainbow, the sky is at its brightest.

Key points

● Rainbows have seven colours, starting with red at the top, then orange, yellow, green, blue, indigo and violet.

● The sun is behind you and the rain in front when you look at a rainbow.

● Rainbows have different arc shapes depending on the position of the sun.

● Mix all the colours before starting to paint a rainbow.

Taking a closer look

In this atmospheric painting, the artist has captured the luminous quality of a rainbow set against a dark and stormy sky. The silvery quality of the light suggests a departing rainstorm.

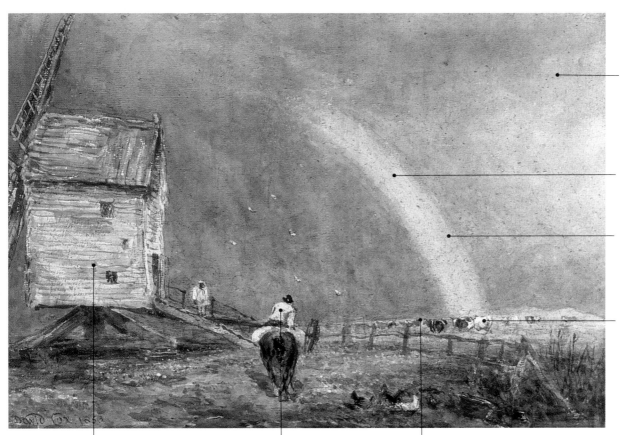

**The mill
by David Cox**

The dark, stormy sky was captured with layers of transparent wash. The effect is uneven, creating a luminous quality.

Only a few light colours are included in the rainbow – the eye fills in the rest.

The artist lifted out an arc of the sky colour, and worked the rainbow on the scrubbed white paper beneath.

Touches of body colour on the cattle and the rider suggest the intensity of the light, shining from somewhere behind the viewer.

The mill creates a sense of place, adding to the drama of the setting.

The pale clothing of the rider is brilliantly lit by the sun.

The low horizon gives the picture an open composition and an optimistic mood.

How to paint rainbows

Wet-in-wet techniques and an arc of light colours against a dark sky help to capture the fleeting brilliance of a rainbow.

Keep your rainbow mixes light, with the lightest possible yellow in the middle. Mix the colours when you have completed the sky and land, so that you can work quickly. Don't use all seven colours, as you risk a muddy result. Instead, use just a few – the eye will fill in the rest. Paint the rainbow wet in wet, so that the colours blend slightly. Aim for soft edges and a luminous effect, so that the rainbow seems to melt into the sky.

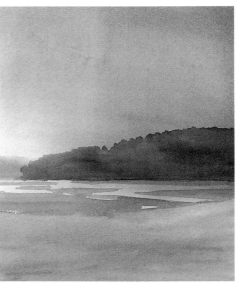

Tip

If you are painting a double rainbow, note that the primary (top) rainbow has the usual order of colours, but in the secondary rainbow, the colours are reversed, with violet at the top, and red at the bottom. The sky between the two rainbows is darker than the surrounding sky.

Try this!

Work wet in wet and lift out an arc of colour before running in the rainbow mixes. Use gamboge, which is a highly transparent, warm yellow, available only as a watercolour.

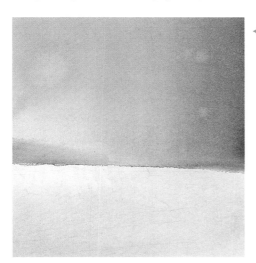

◀ **1** Apply a gamboge wash to wet paper, keeping it very light for the bright sky patch, light in the sky and denser over the foreground grass. Drop phthalo blue wet in wet into the bright patch of sky. Leave to dry. Re-wet the sky and, working from right to left, wash on a cool grey mix of neutral tint/phthalo blue, keeping it paler on the left.

▲ **2** Paint the far hill with neutral tint. Darken with phthalo green/phthalo blue for the nearer hill. Use gamboge/phthalo green/burnt umber for the grass and neutral tint for the flooded meadow.

◀ **3** Use neutral tint for the grass tufts and the field edge. Add form to the far meadow and paint the tree on the right. Mix the rainbow colours, using alizarin crimson, cadmium red, cadmium lemon, cobalt turquoise and phthalo blue. Wet the sky vertically and lift out an arc of colour for the rainbow.

◀ **4** Lightly run in the rainbow colours, retaining their translucence. Use the reds at the top and the blues underneath, and keep the yellow in the middle almost white. Add a pool of orange where the rainbow strikes the ground. Lift out a couple of fence posts.

Stormy seas

A raging sea is a compelling sight. Turbulent water, breaking waves and flying spray offer an exciting subject for a painting.

The fascination of a stormy sea lies in the fury of the crashing waves, the exhilarating freshness of the spray-filled air, and the rhythm of the surging swell. In the best seascapes, the artist manages to depict all these aspects, and to imply the awesome power and energy that create them. As always, objective observation is the key. The sea reflects the colour of the sky, modified by reflections from the surroundings. Foam and spray are basically white, but they too are affected by the prevailing light. Watch waves as they surge and break – the back of the wave reflects the colour of the sky, but as it curls over, it casts a shadow beneath the crest. The constant movement makes this difficult to see, but patterns emerge as you watch. Use whatever techniques work for you – but maintain a light touch or the image will lose its impact. (See page 28 for more details on waves.)

(See page 28 for more details on waves.)

Key points

● Rough seas reflect the colour of the sky, modified by debris in the water.

● Foam and spray are mainly white, but they are modified by the prevailing light.

● Create white areas by reserving the white of the paper, or using masking fluid.

● Use wax resist or body colour for highlights and broken water textures.

● Use soft pastel or gouache, or scrape back with a scalpel or sandpaper to depict a choppy sea (see page 38).

Taking a closer look

In this painting, the artist used several techniques to depict the movement of the surging water and the rising spray.

Stormy sea and spray, West coast by *Charles Knight, RWS, ROI*

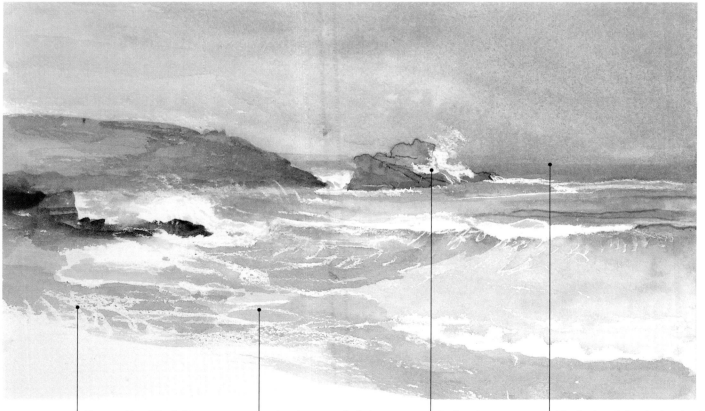

The sparkle of the light on the swirling foam is created with wax resist. The texture of the Rough paper enhances the effect.

White linear marks help to express the swirling movement of the water. This effect can be achieved with masking fluid or wax resist.

Body colour applied over dry washes depicts the foam and flying spray.

The horizon is lost in the clouds as the sea and sky merge into one glowering element. Granulation (see page 31) enhances the moody scene.

Convincing breakers

Key aspects of a violent sea can be successfully portrayed with the help of various techniques and special effects.

When you paint a stormy sea, the water must look as if it is moving – blurred edges and marks that echo the motion of the water help to make a successful painting. You can create the white areas in several ways – reserve the white of the paper using masking fluid or wax resist; spatter or stipple with Chinese white or gouache; use soft pastel; or try scratching the dry paint film with the tip of a scalpel or craft knife.

Tip

First-hand observation gives the best painting results, but looking at photographs in books and magazines will also help. Learn from other artists too – study their work in galleries and examine their techniques to see how they have edited and simplified the subject.

In practice Crashing waves

Use grey masking fluid and scraping-back techniques to depict waves crashing on a jetty. A tinted masking fluid is easier to see.

1 Draw the subject lightly, then apply grey masking fluid for the spray. When it's dry, paint the sea with a wash of primary yellow, shaded with cobalt blue at the horizon and foreground. For the sky, drop cobalt into a wet surface.

2 Paint the jetty and rocks with a stronger cobalt wash, adding a little burnt sienna to make greys in some areas. Keep the tones uneven to add texture to the rough stone surface.

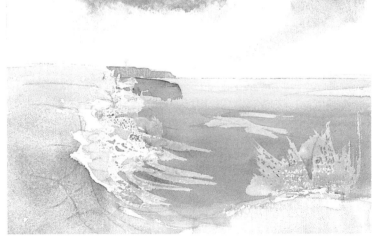

3 Re-wet the sea with a clean damp brush and blend a viridian/raw sienna wash into the foreground. Define the distant coastline with cobalt and a touch of burnt sienna. Paint the end of the jetty with a mix of French ultramarine and burnt sienna. Note how the movement of the sea is beginning to come into focus.

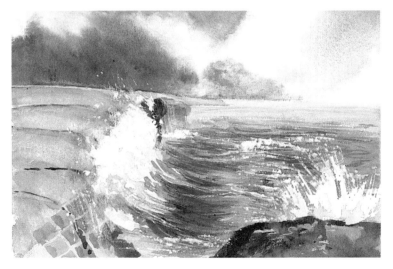

4 Paint storm clouds with a French ultramarine/burnt sienna mix. Add viridian to the same wash for the darkest part of the waves and the foreground wall. Use cobalt/burnt sienna for the top of the wall. Finally, remove the masking fluid and add cobalt blue shadows to the spray. Scrape out flecks of foam with a sharp craft knife.

Painting snowscapes

A snowy, wintery landscape is not an easy option to choose for a watercolour. Planning the picture before you start is essential in order to capture the distinctive brilliance of the scene.

Snow changes the landscape by softening its contours and masking detail. It also makes the land much brighter in tone than the sky – the opposite of the usual situation.

Allow the white of the paper to stand for snow. Make a quick tonal sketch before you start, roughly indicating where you want the white areas to be. Think of them as positive shapes, not negative spaces. When you paint the surrounding darks, you're giving the whites form and shape at the same time. Don't forget the shadows – these indicate a horizontal surface and are vital in snow scenes. Use blues and lilacs for the shadows.

The sky completes the composition and sets the mood for the picture. It can be clear, crisp, cold and sunny, or heavy and brooding, threatening more snowfalls.

Key points

● Use the white of the paper to stand for the snow – plan these areas first.

● Positive shapes are the obects you have painted; negative shapes describe the area between the objects and the edge of the paper.

● A heavy snowfall will make the snow settle in most areas – don't forget the roofs, tops of fence posts and the top side of branches and twigs.

● Use darker surrounding tones to show up the brilliant white of the paper wherever you want to indicate snow.

Taking a closer look

In a snowscape like this, you can see how important it is to plan your whites extremely carefully. Doing this correctly means the sparkling white complements the natural translucency of the paint, giving your rendering extra life and brightness.

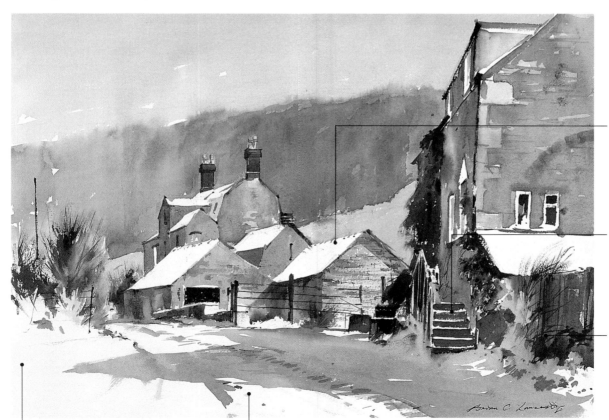

Winter's mantle, farm at Uley, Gloucestershire by *Brian Lancaster*

Crisp straight edges – planned in right at the start – show where the snow has settled on the roofs.

Snow piled up on the treads of the steps has been observed by the artist – again this is represented by the white of the paper.

The artist has used a limited palette of violets, blues and earth colours. You can see how these allow the whites to stand out boldly.

The snow on the ground is much lighter in tone than the sky, which looks as though another snowfall is imminent.

The snow on the road is indicated by the white of the paper. A blue wash indicates deep shadow and a few dry strokes of colour represent the tracks of a vehicle.

Leaving whites for snow

Keeping the white of the paper untouched is the classic way to paint snowscapes. The stark brilliance of the white is ideal for this effect.

Imagine the white of the paper to be a colour on your palette. Consider what areas you would make white if you were painting with it, and create that shape as you paint around it. This means careful planning in advance before starting to paint – once you've applied a wash, there's no turning back. Try to be aware of all the shapes you're making with your brushstrokes.

The ultimate aim in any snowscape is to ensure that the all-important whites are an integral part of the whole composition.

Tip

White has a strong visual impact – a certain sparkle – that makes it appear to expand. By contrast, because they absorb light, darker tones seem to contract. The brilliance of white areas placed next to deeper tones is even more striking by comparison. This is what makes snowscapes so dramatic.

In practice Mountain snow scene

Plan your composition carefully and stick to your decisions. Use a limited palette of colours for the best results.

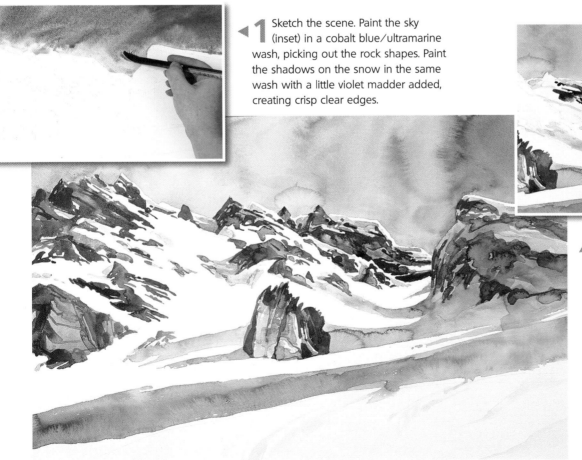

◀**1** Sketch the scene. Paint the sky (inset) in a cobalt blue/ultramarine wash, picking out the rock shapes. Paint the shadows on the snow in the same wash with a little violet madder added, creating crisp clear edges.

▲**2** Mix three washes for the rocks: raw sienna/burnt umber; the same two colours plus Vandyke brown and burnt sienna; and violet madder/indigo. Work wet in wet first, then wet on dry.

▲**3** The white of the paper sings out as bright white snow, while the crisp dark tones against the white establish a pleasing contrast. The limited palette of blues, browns and purples gives the painting inherent harmony.

Trees in summer

Before you can paint convincing trees, you need to learn to look at them and note their different shapes, forms and textures.

The more you observe trees, the better you will paint them. Make sketchbook studies of various types of trees, noting their differences and similarities, and breaking them down into simple shapes.

The crowns of trees vary according to species. They can be rounded, narrow or columnar, with a smooth or ragged outline. The leaves can be small or large, and they may be very dense, sparse or arranged in gappy clumps.

The proportions and structure are important, too – use a pencil to work out the height-to-width ratio, and note how far up the trunk the crown starts.

Examine the different kinds of trees and learn to recognize their forms and structures. Notice the similarities and the differences.

Key points

● Study the shapes and forms of different types of trees around you.

● A field guide is a helpful aid to find out more about trees.

● Keep your sketchbook handy so you can make studies.

● Observe how the branches grow out from the trunk.

● Use a pencil to compare the height and width of the tree.

● Suggest foliage textures with light and dark tones.

● Use wet-on-dry techniques for details on nearer trees.

▲ LARCH
The larch has a sparse, conical crown. The needles hang from the regular horizontal branches in stiff fringes.

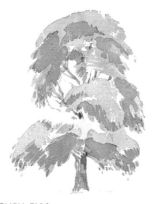

▲ ENGLISH ELM
The elm has a tall, narrow crown with billowing clumps of dull green foliage. The rough, dark bark has long fissures.

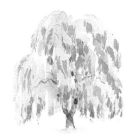

▲ WEEPING WILLOW
The broad, rounded crown has drooping branches with flexible twigs reaching to the ground. The leaves are narrow and the ridges on the bark form a criss-cross pattern.

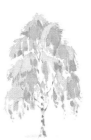

▲ SILVER BIRCH
This graceful tree has a long slender trunk and a tall domed crown with drooping branches and small, pale green leaves.

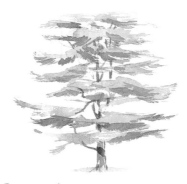

▲ CEDAR OF LEBANON
The cedar has a short trunk with horizontal branches. The foliage forms horizontal, plate-like shapes at the ends of the branches.

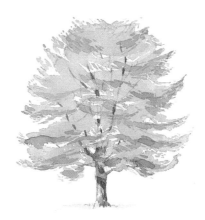

▲ COMMON BEECH
The massive rounded crown of the beech tree casts a deep shadow. The foliage is bright green and the smooth bark is grey.

Summer trees near and far

When including trees in a landscape, take account of distance.
The closer the tree, the more detail you can see.

When you paint trees, the amount of detail you include gives important clues about distance. Show distant trees as soft patches of tone and colour. Convey texture and the direction of growth in the middle distance, and pick out leaves and individual twigs close-up.

The simplest way to paint a tree is the traditional layered technique, working from light to dark and from the general to the particular. Start by blocking in the silhouette of the tree using your palest wash, then use gradually darker washes, either working wet in wet or wet on dry, to add form, tone and generalized detail. Continue adding layers of colour to pull the tree into focus and to suggest texture. Paint specific details, such as leaves, last.

Expert advice

● Broken-colour effects, such as stippling, sponging, dabbed marks and scumbling, are ideal for capturing the texture of foliage without making it look too solid.

● Try including some tiny touches of complementary reds and ochres to your broken colour to enliven the green.

In practice Elm tree in summer

Practise painting an elm tree in the middle distance, starting with the silhouette and then adding deeper washes to give form and texture.

◄1 Draw the outline of the tree, picking out some paler patches of bark. Block in the foliage with a mix of ultramarine, gamboge yellow and raw sienna, and paint the shadow at the base of the trunk. Leave to dry.

◄2 Darken the green mix to add form to the base of the foliage clumps. Working wet on dry, paint the darker areas of bark with a pale wash of raw sienna.

▶3 Working wet on dry, darken the base of the foliage clumps with a mix of ultramarine, gamboge and Payne's gray. Strengthen the trunk with a slightly darker wash of raw sienna.

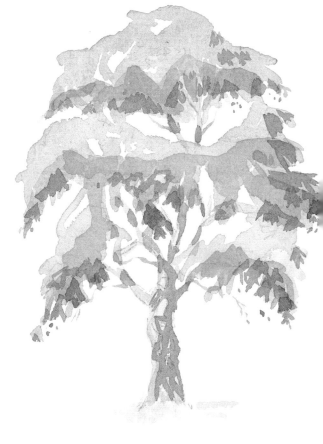

▲4 Add spots to represent a few individual leaves and paint foliage clumps with a mix of ultramarine, gamboge and Payne's gray. Strengthen the mix and add more foliage detail. Add shadow to the trunk and branches with raw umber and Payne's gray.

Trees in winter

Painting winter trees is easy if you abandon your preconceptions about shape and colour and rely on direct observation.

A painting of a winter scene in which all the trees look the same is unconvincing, inaccurate and lacks visual interest. Your trees should look as though they are alive and growing, capable of swaying in the wind, but firmly rooted in the ground. It is important to get the feeling of size – the girth of the trunk and the shape and volume of the crown. Look for the basic shapes and volumes – the domes, spheres, cylinders – that make up the crown. Every tree has a natural and individual way of growing – an obvious example is the weeping willow with its gracefully drooping branches.

Key points

● Buds occur along the twigs and each twig ends with a terminal bud. The colour, shape and distribution of the buds help identify the tree in winter.

● Winter trees are rarely grey – use a palette of warm and cool neutrals.

● A tree in the middle of a field will be upright, shapely and symmetrical.

● In parkland grazed by cattle or deer, trees have straight, neatly trimmed bases.

Try this!

Trees in winter are just as individual as trees in summer. Use your sketchbook to make detailed studies of trees.

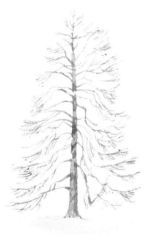

▲ LARCH
The larch has long, slender, tawny brown branches with small round buds along the entire length – from a distance the branches have a wiry appearance.

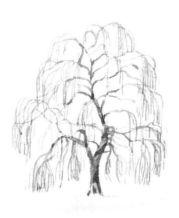

▲ WEEPING WILLOW
The dome-shaped silhouette of this graceful tree with its cascades of pinkish twigs is unmistakable. The buds give it a greenish cast.

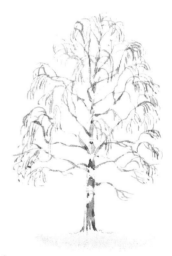

▲ SILVER BIRCH
The silver birch has a mottled silver and black trunk, and shiny red-brown twigs which curve down in clusters.

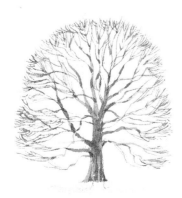

◄ COMMON BEECH
The beech has slender buds which give the twigs and smaller branches a gracefully tapering appearance. From a distance and in certain lights the tree appears to be enveloped in a golden-brown mesh.

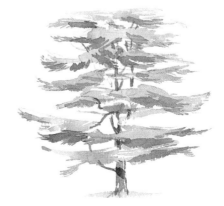

◄ CEDAR OF LEBANON
Coniferous trees such as the cedar of Lebanon, which retain their needle-like leaves during the winter months, provide year-round colour in the landscape.

Painting leafless trees

Select an approach and a technique that suits the subject and captures the tree's characteristics.

As a general rule all tree limbs taper – the main branches are thinner than the trunk, while the subsidiary branches are thinner still. Draw with a round brush, working from the main trunk outwards. Express the character of the branch with your line: a rugged, twisting line for the sturdy oak and a longer, freer line for the supple ash. The branches on the nearside of the crown will be darker and more emphatic than those farther away. The terminal buds may give the branch a blunt appearance and this can be suggested with some flicked and dotted brushmarks. A network of finer branches can be stippled with the tip of the brush, or drag the paint with a dry brush to produce a haze of delicate colour around the crown.

Expert advice

● Use graphite or coloured pencil to add details such as small twigs and buds. Water-soluble coloured pencil can be softened with a brush or smeared with a moist finger.

● Make detailed studies of winter twigs – these will help you to understand the structure and growth pattern of the tree.

In practice **Ash in winter**

Use a range of different techniques to capture the character of this tall, domed ash tree.

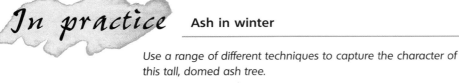
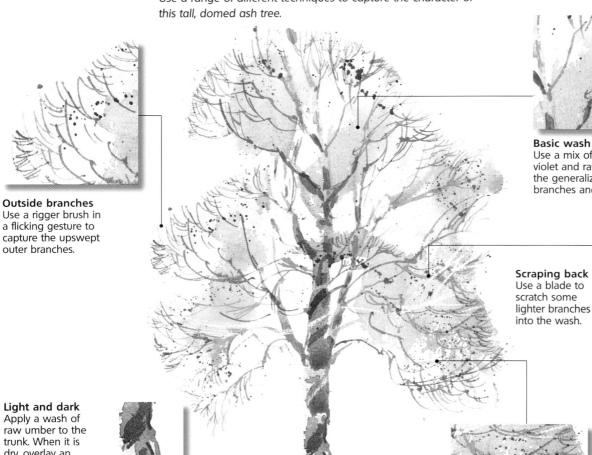
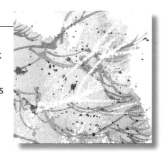
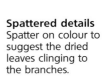

Basic wash
Use a mix of ultramarine violet and raw umber for the generalized haze of branches and dry leaves.

Outside branches
Use a rigger brush in a flicking gesture to capture the upswept outer branches.

Scraping back
Use a blade to scratch some lighter branches into the wash.

Light and dark
Apply a wash of raw umber to the trunk. When it is dry, overlay an ultramarine violet/raw umber wash on the shaded side.

Spattered details
Spatter on colour to suggest the dried leaves clinging to the branches.

Painting foliage

The soft textures of foliage and grass are a vital source of colour, tone and pattern in a landscape.

Trees and their foliage, plants and grass provide a multitude of forms and textures. They introduce lively visual interest in a painting, and create a contrast with the hardness of bricks and stone. Use your sketchbook to explore the way vegetation grows. Don't attempt to include every detail. Instead, look for shorthand ways to express the textures. The way you do this depends on your style of painting.

If you like to work loosely, use fluid, sweeping gestures to suggest leaf shapes and foliage masses. If your style is tighter and more precise, build up depth and detail with a variety of small and descriptive brushmarks.

Remember that in nature there are few harsh lines and angles. Work in the direction of the growth, so that all your brushstrokes follow the natural flow of the plant or tree.

Key points

● Use a variety of brushmarks to express different kinds of foliage.

● Use generalized washes for distant foliage.

● Overlay transparent washes to create a sense of depth and volume.

● Follow the direction of growth with your brushstrokes.

● Don't paint every leaf or your painting will be too busy and confuse the eye.

Taking a closer look

This picture of a riverside on a sunny spring day was painted on the spot. The artist used gouache, which is an opaque form of watercolour, working loosely and quickly, and employed a variety of brushmarks to suggest the different kinds of foliage present in the scene.

Ashridge Farm, Sandford, Devon by Robert Jennings

The sky was painted first, with a loose background wash. In gouache, which is opaque, you can work from dark to light as well as light to dark.

The haze of smaller twigs on the distant trees was painted lightly with a dryish brush, allowing the sky wash to show through.

The artist built up a sense of depth in the foliage with layers of washes scrubbed one on top of another. This technique perfectly conveys a sense of depth and volume.

The dark washes of the distant trees were overlaid with bright green areas of colour to depict the delicate spring foliage.

The tracery of bare branches was painted with fluid brushmarks on top of dry washes.

The artist used a rigger (a soft brush with long tapering bristles) to paint the fine lines of the reeds and the thin branches.

Rendering natural textures

When you paint the textures of foliage you must find a way to convey a sense of depth and volume without solidity.

Foliage consists of layer upon layer of leaf forms of different sizes, colours and tones. Since you can't possibly paint every single leaf, you need to find ways to express the depth and volume of the foliage without producing lifeless, solid-looking shapes.

The transparency of watercolour lets you build up an optical effect of depth and texture by overlaying washes. Try using both warm and cool versions of a colour – they mix visually, producing a third tone. If you are painting a detailed study, you can use a variety of appropriate brushmarks – small leaf-shaped flicks or dots for little leaves, and long, quick strokes to express waving grass, for example.

For a quick sketch, use broader, more generalized gestures to describe the form and mass of the foliage, and to give clues to the species of plant. Remember that the farther away you are, the less detail you are able to see.

Expert advice

● When you paint natural textures of one main colour, such as a woodland or a meadow, try introducing touches of complementary colours that resonate with each other. This helps to keep your painting alive and vibrant.

● Work from the general to the particular, from broad washes to crisp details applied wet on dry.

● Each plant, shrub or tree requires a particular set of marks – practise your brushmarks on scrap paper and work rhythmically.

● The long fibres of a rigger are ideal for the smooth, sweeping lines of pampas grass and palm fronds.

In practice — Botanical garden

The gardens in this study contain a variety of exotic shrubs and trees. The varied shapes and textures of the foliage are rendered with different kinds of brushmarks.

Inverewe Gardens, near Poolewe, Scotland by *Albany Wiseman*

The majestic Scots pines are suggested with horizontal brushstrokes painted outwards from the tall trunks in the direction of growth.

The near hedge is painted with a broad, pale wash, its texture hinted at with a few individual leaf outlines.

The snaking curve of the wall draws the eye into the composition. A series of receding curved lines help to express its rigid form.

Spiky pampas grass is depicted with curved lines painted with a dryish brush. The brushmarks start at the base of the plant and work out to the tip.

Curving brushstrokes are used for the elegant palm fronds here. Start at the base of each leaf and work towards the pointed tip, lightening the pressure on the brush as the leaf gets thinner.

Painting flowers

Flowers are marvellous subjects for watercolour – their beauty, variety and range of colours are perfect for this translucent medium.

When painting flowers, be bold – all too often flowers are rendered in soft, pale washes that have no impact. In nature, flowers come in all hues from pure white to flaming reds, oranges and purples. Flower paintings can range from full flowerbeds to detailed studies of individual blooms. For a whole mass of flowers, overall appearance is important rather than detail. Note that on a bush or in a flowerbed, the blooms will all be at different stages of development – some will be in bud, others fully open or already fading. For a flower study, detail is vital. You must get the form and growth habit just right – count the number of petals and the stamens, and study how the leaves spring out from the stem.

Key points

- Work from the general to the particular. Start with outlines and end with details.

- Study individual flowers, checking on the number of petals and leaves.

- Keep your colours fresh – use clean water and wash your brushes often.

- Colours in a border will 'blue' and become more indistinct the farther away they are – an effect of aerial perspective.

- White flowers rarely appear pure white – look for reflected colour and shadows that influence the local colour.

Taking a closer look

When you are tackling a busy subject such as this, the main challenge is to select what you want to keep in and not to get bogged down in too much detail.

Lupins
by *Hazel Soan*

Carefully reserved areas of white paper give sparkle and form to the lupins.

The lupins – in the middle ground – are rendered in more detail than the flowers farther back. Their warm colour brings them forward.

Wet-on-dry brushwork – a darker green over a lighter wash – gives definition to the spiky leaves of the lupins.

The shape of the delphiniums is only hinted at – their blue colour and lack of detail push them back, creating a sense of recession.

The warm brown wall sets off, and contrasts well with, the exuberant colours of the flowers.

The foreground yellow flowers are too small to be picked out individually – touches of paint indicate their mass without too much detail.

Making a flower study

With a garden flowerbed you can be as free as you like with your brushstrokes, but detail and precision are vital for a flower study.

This is not a botanical drawing and needn't be as detailed, but it pays to look at individual flower heads closely. Any mistake in the finished painting – the wrong number of petals, for instance – will be glaringly obvious.

Build up your flower bit by bit, starting with a detailed drawing. Continue with layers of washes wet in wet and wet on dry. Allow each wash to dry completely before applying the next – this helps to avoid a muddy, overworked appearance.

Tip
Some artists prefer to leave their pencil lines on the finished painting, thinking they add to the look of the picture. Others prefer to delete them completely. If you do rub out the pencil lines, take great care not to abrade the painted surface.

An amaryllis is an excellent subject – it has strong form and colour. This example has been built up with four successively darker red washes on the blooms.

◄1 Start by drawing the outline of the amaryllis. Use a soft pencil, noting the basically circular shape of the lower bloom, the conical shape of the upper one and the narrow, elongated bud.

▲2 Wash cadmium red/light red on the flowers and bud. Leave streaks of white paper in the two main blooms. Apply dilute gamboge yellow to the stalk, then drop in the same colour wet in wet on the tip of the bud.

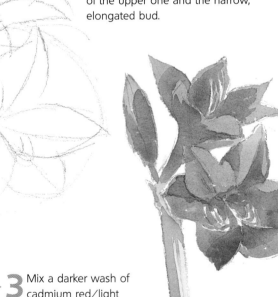

▶3 Mix a darker wash of cadmium red/light red/alizarin crimson and paint selectively over the petals and bud to build form and tone. Mix gamboge and olive green and apply to the right side of the stalk.

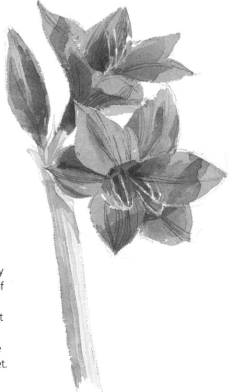

▶4 Mix an even darker wash of cadmium red/light red/alizarin crimson and apply over the blooms again. Paint very fine hairline streaks over some of the petals. Mix a darker wash of gamboge/olive green and use it to give the stalk more shape. Finally, touch in the centre of the lower bloom in ultramarine violet.

Painting spring colours

*Watercolour is the perfect medium for capturing the clear light
and delicate colours of a burgeoning spring landscape.*

In early spring, buds appear and leaves unfurl, soon producing hints of pink, ochre and green, while blossom creates gauzy veils of pink and white. Use broken-colour techniques, such as optical mixing, to modify the browns and greys of winter – and to capture the luminous quality of spring light.

When the leaves are fully emerged, the woodland canopy takes on hues of vibrant lime-green, especially in bright sunlight. To convey this, try lemon yellow or cadmium lemon mixed with a cool blue (cerulean) or with cool greens such as phthalo, Winsor or viridian. Alternatively, lay an underwash of lemon yellow. This will shine through and modify the transparent washes on top. You will need a ready-made violet for crocus and lilac – these violets are brighter and cleaner than those you can mix in your palette.

Key points

● Spring light is often very bright because the sun is low in the sky.

● Greens are more acid than they are later in the year.

● Cadmium lemon or lemon yellow is an ideal base for spring greens.

● Optical mixing – applying colours separately so they blend visually – is good for showing the haze of blossom and emerging leaves.

● Use touches of unmixed colour for spring flowers.

Taking a closer look

In this luminous painting, the artist has captured the moment when a slight plumping of buds lays a delicate glaze of pink and yellow over the leafless winter landscape.

April rain, Bolton Abbey
by *Lesley Fotherby*

Underwashes of pale yellow, green and ochre capture the vibrancy of new foliage caught in a shaft of sunlight.

Washes of pale, acid green are used for the startlingly brilliant green of grass in bright spring sunshine.

Delicate washes of earth colours capture the tracery of tiny twigs and their swollen leaf buds.

Clusters of snowdrops trembling on a grassy bank were laid in with touches of body colour.

Tiny strokes of colour suggest a fine mesh of buds in the middle distance.

Optical mixing

A carpet of flowers shimmering in shady woodland is one of the delights of springtime. Optical mixes allow you to capture the iridescent colours.

In practice — Bluebells in a beech wood

Use cobalt blue as a base for the bluebells and cadmium lemon for the foliage, then build up the image with layered washes and spattering.

1 Start with an outline pencil drawing, then dab on masking fluid for the leaves of the main tree. Mix a wash of cobalt blue and apply criss-cross strokes over the foreground. Add a touch of alizarin crimson and brush this on with loose, horizontal strokes in the background.

2 Apply a loose wash of cadmium lemon across the top of the picture area, and between the drifts of bluebells. Spatter the foreground with water, then with phthalo green. Leave to dry.

3 Spatter phthalo green and cobalt turquoise for the trees and grass – use neutral tint for the shadows. Paint the trees with burnt umber and cerulean blue. When the washes are dry remove the masking fluid – except on the tree trunk.

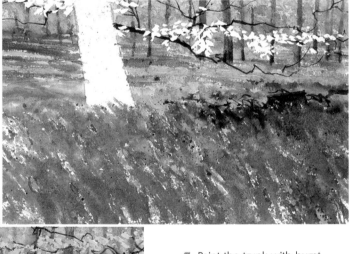

4 Paint the trunk with burnt umber, cerulean blue, Naples yellow and cadmium lemon. While damp, add texture with burnt umber and neutral tint, making it darker on the right side. Spatter and dab dark green into the foreground so that the bluebell shapes emerge from the background. Dab the cobalt blue/alizarin crimson mix over the foreground. Remove the masking fluid from the leaves on the tree trunk, then apply green wash over the leaf shapes.

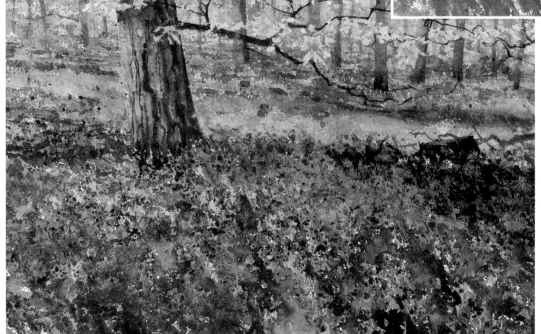

Painting autumn colours

With vivid reds, golds and russets, landscapes in the latter part of the year offer a glorious subject for the watercolour painter.

In an autumn landscape, the browns, reds and yellows of ploughed earth, deciduous trees and distant woods are often muted – very different from the fresh, clear colours of spring. Sharp, crisp mornings enhance the bright tones of autumn leaves and deepen contrasts, while the golden light of the late afternoon sun softens and warms the colours but brings intense shadows. The grey light of overcast days cools the colours, reducing the tonal contrasts.

For your autumn palette, concentrate on earth colours such as yellow ochre, raw sienna and Indian red, and complementary shades of violet, blue and green. Bright colours such as cadmium yellow can be knocked back with a touch of their complementary. For fiery autumn hues, offsetting hot colours with their complementaries makes them sing, while paler tints are brightened by strong, dark shadows. For mellow autumn scenes, build gradually from the palest wash to the darkest.

Key points

- Mix autumn colours from a basic palette, emphasizing the warmer tones.

- Balance autumnal shades of yellow, orange and red with their complementary shades of violet, blue and green.

- For sunny effects choose a high-key palette, that is one with pale tones and very little contrast.

- Analyze how strong autumn light affects the colours of the landscape.

- Make colour studies in your sketchbook at different times of day and in different weather conditions.

Taking a closer look

In this view of autumn woodland, the fiery orange and warm gold foliage glows against the subdued greens and overcast sky.

Autumn, Beaufays Road, Liège, Belgium by *Izabella Godlewska de Aranda*

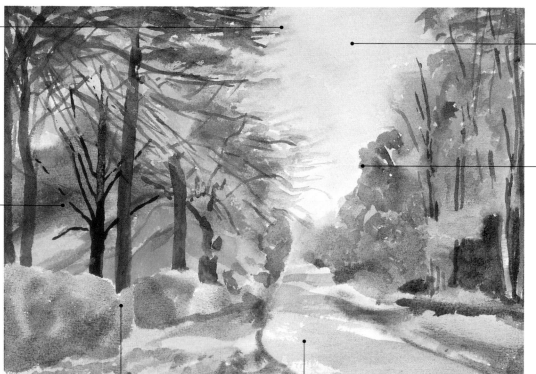

A tracery of lines worked wet in wet suggests the delicate twigs.

The orange wash is laid wet in wet, building slowly from the palest to the hottest tone.

The sky is worked wet in wet, the tones blending subtly for a soft, shimmering effect.

Soft edges help all the elements of the painting to meld into one another, suggesting a hazy autumnal day.

Subdued greens contrast with the orange, giving it added brilliance

The restrained greys of the sky and road contrast with the dazzling foliage colours, preventing them from appearing strident.

An autumn landscape

The warm red light of the autumn sun subdues greens and enhances the golds and russets of the foliage.

 Riverside scene

The blue of the river gives the orange foliage extra vibrancy. Muted greens and strong shadows brighten lighter tones.

1 Working wet in wet, block in an orange wash of cadmium yellow pale/burnt sienna over the bank, distant trees and the base of the foreground tree. Blur the edges in places, and leave white areas for the boats and river.

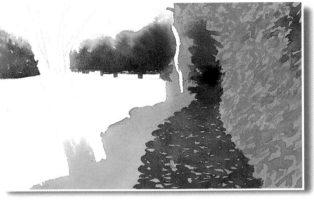

2 Rewet the distant trees and wash in a mix of burnt sienna/alizarin crimson/ultramarine. Darken them with ultramarine. Working wet on dry, use the tree mix for the path, leaving gaps; also use for leaves on the hedge. Darken the distant path area with ultramarine/burnt sienna. Dab cadmium yellow pale/burnt sienna/phthalo green over the hedge.

3 Wet the river area and block in ultramarine/burnt sienna/phthalo green, darkening the mix towards the foreground. Run the tree mix into the wet wash for the reflections, darkening the top with ultramarine. Working wet on dry on the bank and hedge, dab in a patchwork of cadmium yellow pale/burnt sienna/phthalo green.

4 Use Payne's gray/phthalo green for the shadows on the bank, path and nearer trees. Paint the ivy with the green mix, darkening it with Payne's gray. Add branches with the same mix. Use ultramarine/burnt sienna for the boats and add dark reflections. Use burnt sienna for the masts and woodland reflections, and add ultramarine streaks to the water.

Painting stone and brick

Few landscapes are without some hard component that provides a welcome contrast to the softness of foliage and grass.

The contrast between the softness and fluidity of trees and plants and the hardness and solidity of a brick building or granite tor keeps a painting alive and interesting. However, if you try to include every brick, tile and pebble, the painting will become overworked and flat. It's better to express surface textures with a minimal amount of detail, and allow the eye to fill in the rest. School yourself to look for and analyze the texture and character of different surfaces – the roughness of a drystone wall, the regularity of different types of brickwork and the unevenness of cobblestones, for instance.

Key points

• Find a visual shorthand to convey surface textures.

• Don't paint every detail or your painting will be overworked and flat.

• Observe and analyze the character and textures of stone and brickwork.

• Make studies in your sketchbook to help you understand different materials and how they are used.

• Distance changes the appearance of surfaces.

• Observe natural hard surfaces such as chalk cliffs and limestone pavements.

Taking a closer look

In this painting of an old alleyway, the artist has economically conveyed the exact nature of the different surfaces – brickwork, roof tiles and paving stones are all expressed by simple, informative marks that sum up their characteristic textures.

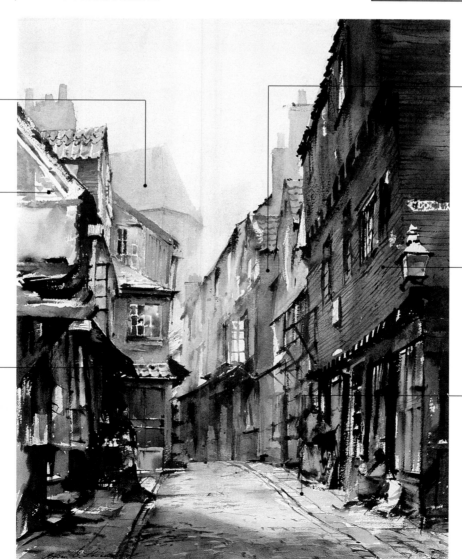

Ancient alleyway, old Newcastle by B.C. Lancaster

The farthest buildings are laid in as flat washes with no surface detail.

The strong light on the facing wall masks much of the detail, so the texture is conveyed with soft washes and a few marks to suggest individual bricks.

A few touches of terracotta paint are applied for the roof tiles, with white paper left to stand for the ridges. The deft, accurate shadows at the end of the row of tiles make this area realistic.

Distance makes surface details less visible, so a few faint lines on top of the wash are all that's needed to imply the texture of the brick wall.

Shadows between the boards are rendered with dark lines, using a ruler as a guide. Twisting the brush and varying the pressure gives thick and thin lines and avoids a mechanical feel.

Pale variegated washes capture the colour and texture of worn paving. The slabs and blocks were drawn freehand with the tip of a fine brush before the wash was quite dry.

Rendering hard surfaces

Observation is the key to getting surface textures right. Look for details, check where surfaces are different – or similar – and familiarize yourself with how walls and buildings are constructed.

Spend some time observing buildings, walls, paving and roofing and make notes in your sketchbook. Notice how distance, and the amount and direction of light, can alter the look of a surface. Close to, you can see all the details of a brick wall; farther off, the details become indistinct, and generalized marks are appropriate. Record the details you can see close-up, as well as the appearance of structures in the distance, and thus build up a repertoire of marks and techniques that will help you express these varying textures and surfaces.

Exploit the marks that different brushes can make. For instance, represent the regular pattern of a brick wall with single marks made with a flat brush. Use the point of a round brush to indicate the construction of a stone wall, and use the same brush in a more calligraphic way to indicate the roundness of cobblestones.

Expert advice

● In a brick or stone wall, use line and tone to suggest the regular shapes of the bricks/stones and leave white paper for mortar.

● Look for key characteristics – bricks are made of baked clay, in colours ranging from yellow or blue-grey to orange and bright red. They are laid in staggered courses in a variety of patterns.

● Roofing tiles are made by machine, so are regular and symmetrical in shape. Use a flat brush to paint them with regular marks applied wet on dry.

● Roofing slates are hand-made and less regular than tiles – paint them in a softer style, wet in wet.

● Natural stone flagstones are hand-cut and aren't exactly regular, either in size or surface. Make sure you vary their appearance when you paint them.

● Drystone walls are laid by craftsmen, who select stones of random shapes and sizes. Your painting must reflect this random quality.

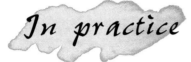 **A village corner**

This scene includes a lot of contrasting surfaces – roof tiles, brick and stone walls and flagstones for example. The characteristic texture of each is expressed in different ways.

The roof slates are picked out in dark shadow lines of varying thickness that convey the way they overlap.

The direction of the light shows up the construction of the facing walls, picking out some of the individual stones. Where the wall is in shadow no distinct texture is visible.

Short regular marks with a flat brush indicate the regular courses of a brick wall. Old bricks are never a uniform colour, so the tone of the wash varies. Only some of the bricks are indicated – the eye fills in the rest.

The distant house is too far away for the surfaces to be seen in detail. Simple parallel lines are enough to hint at the textures of wall and roof.

The variegated wash on the stone wall is overpainted with irregular lines suggesting the irregular shapes of the stones.

The delicate, spiky grasses in the foreground contrast with the rigidity of the stone wall and emphasize its weight and bulk.

Painting glass buildings

Watercolour is the ideal medium for portraying the reflective surface and the character of glass.

Glass is shiny, reflective and solid, strong enough to form part of a structure, yet it can be invisible. The way it looks and the way you decide to express it depend on the source of the light and your viewpoint. When light shines on glass, you may see reflected images and patches of bright reflected light. If there is light behind the glass, you can see images through it. So when you look at a greenhouse you can see plants inside, and reflections of plants and the sky outside. Look carefully to see how glass affects their appearance. Colours seen through glass are bluer than they actually are, images less crisp, and reflected images may be distorted.

Simplify what you see – with too many reflections and highlights, glass lacks solidity. Look through half-closed eyes to find the strongest tonal contrasts and the building framework, and reserve these or scrape them out later.

Key points

● Generally, light falling on glass makes it reflective, while shadows make it transparent.

● Images seen through glass are slightly blurred, and reflections are distorted.

● Colours seen through glass are paler and bluer than in reality.

● Panes of glass are darkest at the base.

● Paint what you see, working from the general to the particular.

● Reserve, lift or scrub out highlights, frames and glazing bars.

Taking a closer look

In this highly textured and detailed painting, the artist explores the play of light on glass and the appearance of plants reflected in and viewed through it.

New conservatory, Cambridge Botanical Gardens by Ronald Maddox

The blurry reflections of garden trees, positioned behind the viewer, appear in the surface of the glass.

Sharper images portray conservatory plants seen through the glass.

The crisp forms of foreground plants worked wet on dry contrast with the softer outlines of the conservatory plants and the reflections.

The panes of glass are darkest at the base while higher up they reflect the blue of the sky.

Using layered washes

Develop a painting of a glass structure by layering wet-in-wet washes. Start by capturing the colours and forms reflected in the glass, and contrast these with the brighter, more definite surroundings.

Tip

Try using additives when you're painting glass. Gum arabic, for example, extends the drying time of washes and gives a slightly glossy appearance that imitates the shiny surface of glass.

Try this! Garden greenhouse

Layered washes and wet-in-wet techniques provide an excellent way to suggest the reflective surfaces of glass and the slightly distorted images seen through it.

◄**1** Reserve the frame, butt and canisters. Use phthalo blue for the sky and cadmium lemon/burnt sienna/ phthalo green for the side, vent, doorway, and foliage. Paint the roof in phthalo blue with cobalt violet and indigo. For the front use phthalo blue/indigo.

▲**2** Use the green wash darkened with indigo for the foliage and burnt sienna for the walkway. Dab green, yellow and blue wet on wet on the side wall and darken with indigo. Darken the lower front. In the doorway, make dark marks wet on dry. Lift out the interior struts.

▲**3** On the path, add streaks of phthalo blue wet in wet. Using indigo, lightly brush in the lines of the struts visible through the glass roof. Remove all the masking fluid.

►**4** Touch in dark shadows on the wooden structure and through the doorway. Leaving white highlights, use cadmium red for the gas canisters, cadmium lemon/indigo for the water butt and burnt sienna for the hose. Use indigo for the shadows and lines on the walkway.

Painting birds

Birds, in all their colourful and engaging guises, make endlessly fascinating subjects for the watercolour artist.

With their myriad forms, colours and patterns, and different textures, birds are inspiring subjects, both for individual studies or as part of a larger scene. They are delicate, light and mobile; a sensitive touch is needed to capture these qualities in paint. As ever, observation is the key to rendering them successfully. Each species, from the humble sparrow to the majestic eagle, has recognizable characteristics. Note the proportions and basic shapes of the head, body and tail, and the distinctive stances. Simplify your approach and aim to capture the essential character – if you try to depict every detail your painting will be too fussy and lifeless. For instance, a quick flick of the brush is enough to suggest a distant bird in flight.

Key points

● Look for basic shapes and proportions and watch for characteristic poses.

● Try to capture the essential nature of the bird and avoid too much detail.

● Feather textures vary from fluffy chest down to sleek flight feathers.

● Use wet-in-wet washes to establish forms and light and dark areas.

● Add textural impressions wet on dry or with a dry brush.

● Use coloured pencils to depict facial and feather details.

Taking a closer look

Without resorting to great detail, the artist has captured the character of this alert little sparrow poised for flight.

**Tree sparrow
by Darren Rees**

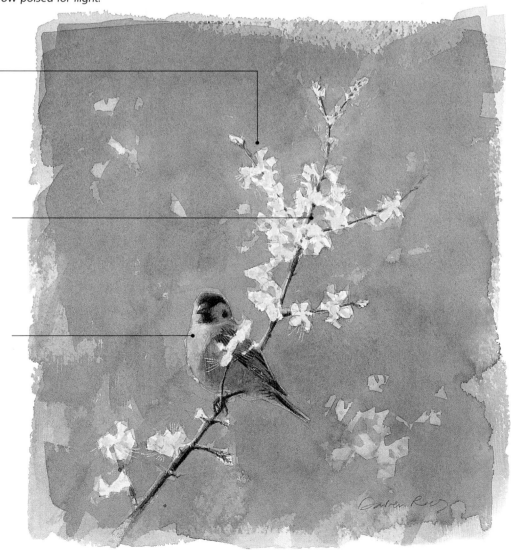

Overlaid washes of harmonious neutrals produce a monochrome background. Against it the blossom shows very white while the subtle nuances of colour in the bird's plumage stand out.

Scale is important and the branch of blossom indicates clearly the size of the sparrow.

Soft, wet-in-wet washes give a hint of the sparrow's downy texture. The longer feathers are indicated with a few dark brushmarks painted wet on dry.

Making a bird study

Use wet-in-wet washes and dry-brush work to build up the impression of feathers of varying textures, and add details sparingly.

Establish the broad shapes with wet-in-wet washes and use wet-on-dry and dry-brush techniques (squeeze the moisture from the brush and use it to drag the paint across the paper) for feather textures. Try combining media, adding details with coloured pencils, for example. Look at the different feathers. The down on the chest is soft and fluffy, while the longer flight feathers overlap to give a smooth surface that creates soft highlights.

Tip

Painting birds from life can be a challenge. To hone your skills, work from photos in books and magazines. Wildlife programmes on TV are often superb and are a valuable source of good ideas for ornithological subjects to paint.

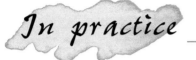

Study of a house sparrow

The sparrow's plumage is not as drab as it may seem at first glance – study it closely and notice the subtle colours of the feathers.

1 An initial pencil sketch helps you get your eye in. Use your drawing to gather information and concentrate on the bird's form and perky character. Note the light areas on the breast and face.

2 Transfer the basic outlines to the paper. Block in the light areas with a thin burnt umber wash, and the shadow areas with ultramarine. Add the pinky legs with a pale crimson wash.

3 Develop plumage texture without trying to paint every feather – form is still more important than detail and will keep the bird 'alive'. Extend the burnt umber wash to the underbelly and tail, and strengthen it for the beak and wing.

4 Sharpen the features of the face – the obvious focal point. Don't depict the eye as a perfect circle with a neat highlight – in reality this is seldom seen. Use the tip of the brush and darker tones of burnt umber to suggest feather textures and twig details.

Painting cats and dogs

Many people like to paint pictures of their pets and watercolour is a rewarding medium for this. Its spontaneity is perfect for capturing the energy and character of the subject.

You must work quickly to capture the essential character of an animal, and watercolour allows you to do this. Work from life whenever possible. Observe, and paint what you see – don't make it up. Look carefully at the features that give the animal its individuality. The eyes, nose, mouth, ears and tail are all expressive and it's vital to get them right. Take note of the position and angle of the eyes, the highlights and the shape of the pupils. Observe the set of the ear and the shape of the nose, muzzle and mouth. You must also take account of the underlying anatomy. Is the fur curly or straight, thick and coarse or fine and silky? Paint the general tones and colours wet in wet, then add textural detail wet on dry. Follow the direction of growth with your brushmarks and try a dry brush for rendering long hair. Don't try to paint every hair – add detail at key points and the eye will fill in the rest. (See pages 63–64 for more information on painting fur.)

Key points

- Work from life whenever possible, study animals and make lots of sketches.
- Study the shape and position of facial features. They vary from breed to breed.
- Try to understand the animal's underlying structure so you can make sense of what you see.
- Work wet in wet to render the general colours and tones of fur.
- Add textural detail wet on dry.
- Follow the direction in which the fur grows with your brushmarks.
- Don't paint every hair or your study will lack spontaneity.

Taking a closer look

For this portrait of a lively family pet, the artist used a combination of broad watercolour washes and fine detail applied with the tip of the brush.

Pippa Weller and her toy by *Sally Michel*

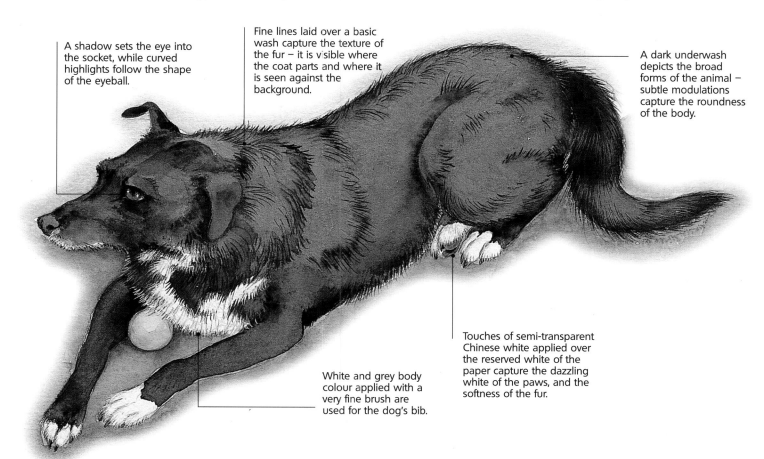

A shadow sets the eye into the socket, while curved highlights follow the shape of the eyeball.

Fine lines laid over a basic wash capture the texture of the fur – it is visible where the coat parts and where it is seen against the background.

A dark underwash depicts the broad forms of the animal – subtle modulations capture the roundness of the body.

White and grey body colour applied with a very fine brush are used for the dog's bib.

Touches of semi-transparent Chinese white applied over the reserved white of the paper capture the dazzling white of the paws, and the softness of the fur.

Making studies of dogs

A series of studies are a great way to capture the unique character of your dog in all his moods.

Spontaneous watercolour sketches, more than photographs, capture the sense of energy, the quality of the fur and the unique personality of a dog. Spend time watching dogs of all kinds – each breed has its own characteristics. See how they move, play and sleep. Notice the facial expressions and the eloquent body language – ears and tails are always a barometer of mood, and the eyes speak volumes.

Use a large sketchpad for quick studies. If the dog moves, simply start another sketch – sooner or later he'll come back to the first position and you can continue the sketch.

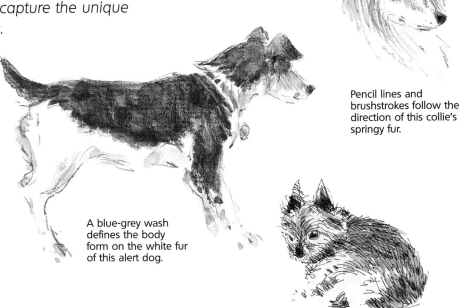

Pencil lines and brushstrokes follow the direction of this collie's springy fur.

A blue-grey wash defines the body form on the white fur of this alert dog.

A technical pen under a broad wash conveys the stiff fur of this little dog.

Try this!

To paint a convincing portrait of your dog, observe carefully and get the features right from the very beginning.

◄1 Start with a pencil outline to get the relative positions of the features right. Look for geometric shapes – such as a three-dimensional rectangle for the muzzle. Sketching this in helps you plot the position for the eyes and ears.

◄2 Use a No.5 round brush to apply a raw sienna wash over the whole form – the lightest fur colour. Reserve highlights on the eyes. Use a mix of cadmium red and cadmium yellow to paint in the darker areas of fur. Add shadows with a very pale wash of cobalt blue.

◄3 Use a drier mix of burnt sienna and cadmium red for the deeper-coloured fur. To depict the texture of the hair, follow the direction of growth with your brushstrokes. Use a fine round brush to add the details. Paint the nose and pupils with a mix of indigo and cobalt blue.

Painting a cat and her kittens

For a group study of animals such as this, sketch the scene first, and use several different techniques to convey the textural detail.

As always, careful observation is the first step to producing a successful picture. A series of quick sketches helps you to understand the dynamics of the family group, the proportions and forms, as well as to observe the patterns and colouring of the fur and the way it grows.

Feline family

A mother cat and her kittens make a gentle, intimate scene. The huddle of bodies provides the opportunity to depict the silky texture of fur and the tortoiseshell and tabby markings.

Key points

● Sketch the group several times to familiarize yourself with forms and markings.

● Reserve the areas of lightest tone.

● Start by applying wet-in-wet washes. Add details wet on dry.

● Brushstrokes should follow the direction in which the fur grows.

● Use the tip of a No.3 brush to flick in the fine texture of fur.

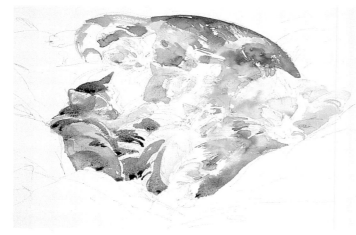

▲**1** Sketch the main outlines of the group with an HB pencil. Use a No.10 brush and washes of Indian yellow, burnt sienna and light ochre for the cat and kittens. Work loosely, gradually building up tones and details. For the dark markings, mix sepia/Prussian blue and apply it wet in wet. Leave white paper for the lightest tones.

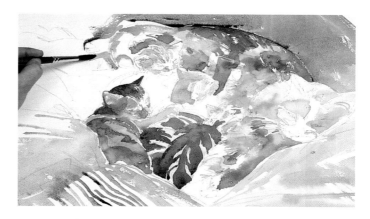

▲**2** Leave the painting to dry. Mix viridian/ultramarine to make a blue-green wash. Wash in the lightest tone of the cushion with the brush. Vary the strength of the wash to indicate shadows and highlights, so the animals appear to be nestling in a hollow and the cushion looks rounded and soft.

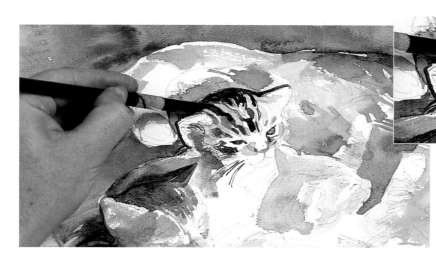

◀**3** Now tighten up the details and fur markings. Make feathery brushstrokes with the tip of the brush for the texture of the fur. Mix sepia/ultramarine for the darkest markings on the kittens. Mix a very dilute wash of Prussian blue for the kittens' eyes (inset).

▲ **4** Working round the painting, build up the fur markings and texture. Define the mother cat's face in a variety of burnt sienna/Indian yellow/sepia tones – use a No.3 brush for finer details.

▲ **5** Add indigo to the cushion wash to deepen the tones of the cushion behind the cat, so she appears to sink into it even more. Paint the dark markings on the mother cat's leg in indigo/sepia washes. Add ultramarine for the darkest tones.

▼ **6** The finished painting is full of texural interest. You can almost feel the warmth and weight of the little bodies and the softness of the fur as they snuggle deep into the cushion. The brushstrokes follow the way the hair grows, which gives a sense of the forms beneath the fur.

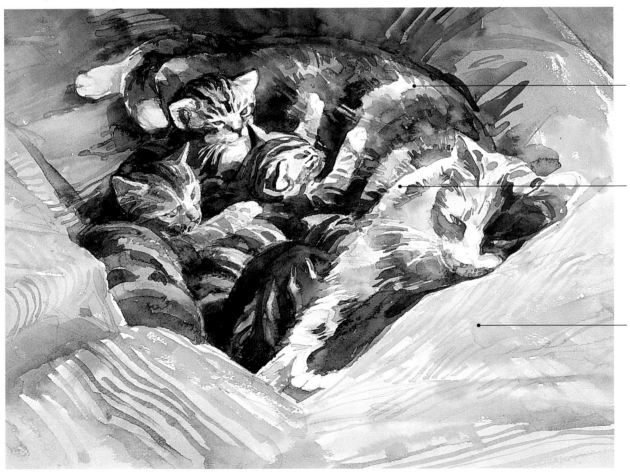

The mother cat's fur is longer than that of her kittens – something that has been expressed by different brushmarks.

Areas of white paper are left for highlights and to depict the white areas of fur on the tortoiseshell cat.

To unify the painting, the same washes are used over and over again, with the tones adjusted as needed – as with the cushion here.

Painting fur

An animal's fur is often its most appealing and distinctive feature, so it's important to paint it in an effective and life-like way.

Each species and breed of animal is characterized by its coat, and the textures vary enormously. It is vital to find a convincing way of portraying the coat, so start by studying your subject carefully. Notice the way the hair grows back from the nose area towards the rear. Look for the 'crowns' where the fur changes direction, and for the areas of light and shade – these are dictated by the animal's anatomy. Fur can hide the forms beneath, making it hard to read the shape of the animal under its coat. Some basic anatomical knowledge is helpful, but if you get the underlying shapes right by observation, they will provide a useful framework on which to 'hang' the fur.

Key points

- Hair grows from the nose, radiating back over the face and body to the tail.
- Fur forms 'crowns' in places where it changes direction.
- Remember the underlying forms that can be obscured by thick fur.
- Use a dry brush to render long hair.
- Follow the direction of growth with your brushmarks.
- Use coloured pencils or other linear media to add textural details.
- Don't paint every hair or the image will be laboured and flat.

Try this!

Here are three animals with very different coats. Try painting them all to find the best way to express the varying textures.

▶ *TABBY CAT*
Apply a background wash, avoiding the eyes and muzzle. Then add the brown areas and dark stripes. Paint the nose and eye. Notice how the hair radiates from the nose back over the face and ears. Use coloured pencils to add the furry texture, making marks in the direction the hair grows.

▲ *SHORTWOOL SHEEP*
Sheep's wool stands up in ridges at right angles to the body – especially around the articulation points. On top of the damp basic wash, paint lines of darker tone for the creases. Darken the folds to deepen the creases and shadows. Add detail in certain areas.

▶ *IRISH WOLFHOUND*
The long, wiry hair of the Irish wolfhound is best depicted with a fairly dry brush on top of the initial wash. Build up the dense coat with layers of marks in different tones, following the direction of growth. Use a few coloured pencils to give added texture.

Long and short hair

Look carefully and simplify what you see in order to render animal coats of varying length realistically.

The gradual changes of tone provided by wet-in-wet washes are just right for the soft forms of short-haired animals. Limit your palette and work from light to dark, building up tones and shadows.

Long hair grows in the same way as short, but the growth pattern may be obscured. It can create misleading shadows, so you need to be aware of the underlying forms. Render long fur with a dry brush for a thick, soft effect.

In practice — Painting a rabbit

Add detail only at key points – around the face or where the fur changes direction. Don't overdo it or the image will be flat and the eye will have difficulty knowing where to focus.

▶1 Draw the rabbit lightly in pencil. Then lay a wash of raw sienna over most of the body and some of the foreground – reserve key light areas such as the paws and around the eye. Let the paint dry.

▶2 Apply burnt umber/burnt sienna to the darker areas with a medium brush. Then paint the shadows with a wash of ultramarine. Add more raw sienna around the rabbit as the basis for the vegetation.

▶3 Add darker brushmarks of burnt sienna and ultramarine to suggest the furry texture – work in the direction of hair growth. Use mixes of viridian, raw sienna and cadmium yellow for the vegetation.

▲4 Change to a small brush and use the point for the fur details, building up the texture with darker versions of ultramarine, burnt sienna and burnt umber. Use darker green mixes to paint the leaves. Finally, use coloured pencils to create the soft fur on the rabbit's leg.

> ## Tip
> For strongly patterned coats, those of zebras or tigers for instance, especially careful observation is needed. Look at the distribution of the pattern over the body – notice how it is affected by perspective. Watch for the way the pattern distorts as it curves around the form.

CHAPTER 2
MIXING COLOURS

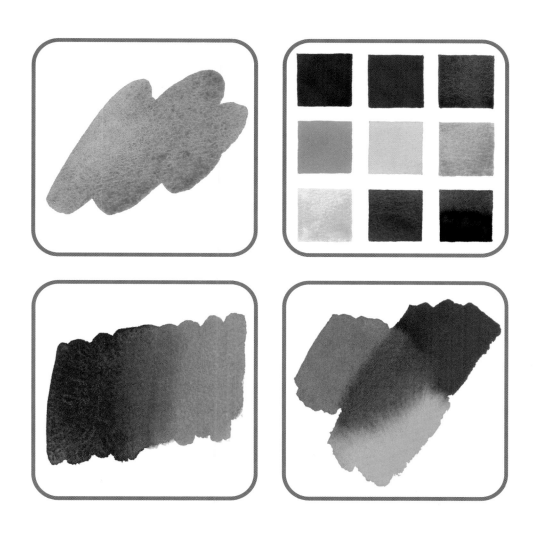

A limited palette of twelve carefully selected colours allows you to mix all the colours you need for any watercolour subject. The palette is based on a warm and a cool version of each primary: cadmium red and alizarin crimson; cadmium yellow and cadmium lemon; French ultramarine and cerulean blue. These allow you to mix clear and muted versions of the three secondaries, violet, green and orange. This basic palette of six primaries is supplemented with two very different greens – viridian and oxide of chromium – and two earth colours – burnt umber and raw sienna. Ivory black and Chinese white allow you to mix dark tones and greys, while Chinese white can also be used for touches of body colour.

In this chapter, each of these palette colours in turn, except raw sienna, is mixed with each of the others in the ratio of 80 per cent to 20 per cent. Two violets and two oranges are also mixed with the palette colours in the same ratio. Vandyke brown has been substituted for raw sienna to show how a dark brown behaves in mixes. The resulting charts will familiarize you with the names, appearance and characteristics of the most common paint colours, and will introduce you to many useful paint mixes.

The charts are based on Winsor & Newton's artist's watercolours. Other manufacturers' colours will be slightly different so make your own charts – there is no substitute for hands-on experience.

Using blues

The colour blue appears everywhere in the natural world – it's in the sky, the seas, the lakes and in distant hills. This makes it a vital ingredient in all landscape paintings.

◀ Indigo
A blackish blue, indigo, once made from a plant, is now mixed from blue and black.

Blue is one of the three primaries from which all other colours can be mixed, and a blue is therefore an essential component of any palette. Mixed with primary red, blue gives a range of violets and mauves, useful for garden flowers, heathery hillsides and deep shadows. With primary yellow it produces the myriad greens required for trees, grass and other foliage.

Blue finds its complementary pair in orange. Placed side by side, blue and orange enhance each other but when they are mixed together they have the opposite effect – they neutralize each other. If a blue wash is too bright, add a touch of orange to knock it back. Blue is a cool colour, which means that it appears to recede when placed alongside warm colours such as red, orange, pink and brown. Adding blue and other cool colours near the horizon in a landscape painting can create an illusion of recession and space.

◀ Cerulean blue
A bright, strong, greenish sky blue, this is fairly opaque.

Taking a closer look

◀ Winsor blue
A bright, powerful blue, this has great tinting strength and permanence.

This picture of a field of linseed in full bloom was painted in Devon. The flowers – looking like a river of blue in the middle of the countryside – are rendered in washes of cobalt blue, with the long stretching shadows across the field in a darker, warmer ultramarine. The sky – a lighter blue – is in cerulean, with a little Naples yellow for warmth.

A river of linseed
by Robert Jennings

◀ Cobalt blue
A bright, transparent blue, this is made from an expensive metallic pigment.

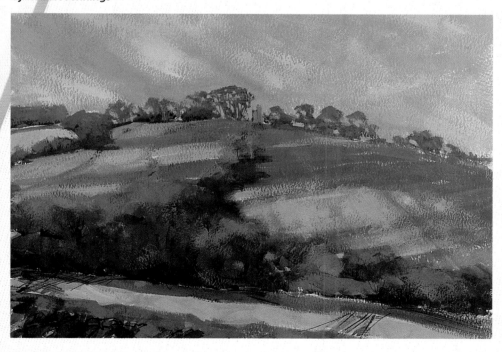

◀ French ultramarine
A violet-blue, this is a synthetic substitute for lapis lazuli, a natural pigment.

◀ Prussian blue
This is a deep, strong, cold, greeny blue.

Exploring blues

Many blues are available other than the two in our recommended palette, cerulean and ultramarine.

It is worth familiarizing yourself with the characteristics of the many blues on the market. There are subtle variations in paints produced by different manufacturers so test them in varying intensities and mixes to find the colours you want. Look for 'hue' in a paint's name. True cerulean blue, for instance, is an oxide of cobalt and combines translucency with a granular quality. Most cerulean blue hues are phthalo blues mixed with white and have different characteristics and mixing behaviours.

Cobalt blue
This gives a good balance between warm and cool blues. In mixes, it tends towards green. It is lightfast, fairly transparent, and a possible substitute for ultramarine.

Indigo
This intense blue-black has many uses for shadows, water and moody sky effects. It is a useful substitute for black and grey.

Prussian blue
A powerful, transparent blue with a greenish tinge, this needs handling with care. It can easily overwhelm a mix. It is lightfast.

Winsor blue (green shade)
This bright, clear, greenish blue resembles Prussian blue and is a good colour for expansive skyscapes and distant views of water.

Mixing blues

Here are some experiments with blue mixes. The results range from muted sage greens and browns to intense violets and turquoise. Some of the colours are predictable, but others will surprise you.

Two-colour mixes

Prussian blue **permanent alizarin crimson**

A cool blue and a cool red give an intense violet. Use at full intensity for flowers or moody, stormy skies.

French ultramarine **lemon yellow**

A warm blue and a cool yellow mix gives an attractive soft, muted blue-green.

indigo **gamboge**

Indigo mixes with cool yellow gamboge to make an intense bottle green. It is good for conifer woods or landscapes.

Three-colour mixes

cerulean blue **cadmium red**

cadmium yellow pale

Three primaries give a greenish brown, useful for landscapes and woodland scenes.

French ultramarine **cadmium red deep**

cadmium yellow

A warm gingery brown results from this mix. It is an intense colour.

cobalt blue **Venetian red**

Naples yellow

This subtle, muted colour has many applications, such as skin tones and autumn colours in a landscape.

Cerulean and its mixes

Cerulean is unlike any other blue in the palette. It is a pale greenish hue and more opaque than other blues. It tends to granulate, that is the pigment separates out to create a mottled effect.

For the chart below, 80 per cent of each of 11 palette colours has been combined with 20 per cent of cerulean blue. The same thing has been done for ultramarine (overleaf) and for the other palette colours in this chapter. You'll notice that the cerulean and raw sienna mix is greener and less brown than ultramarine and raw sienna. With cadmium lemon , cerulean gives a sharp green – ideal for bright spring foliage. With virician, the mix tends towards turquoise Cerulean turns oxide of chromium a brighter green – useful for landscapes. The Chinese white mix is interesting, making a delicate sky blue.

▲ Cerulean blue *derives its name from the Latin 'coeruleum' meaning sky blue, and it is ideal for painting sunny, summer skies.*

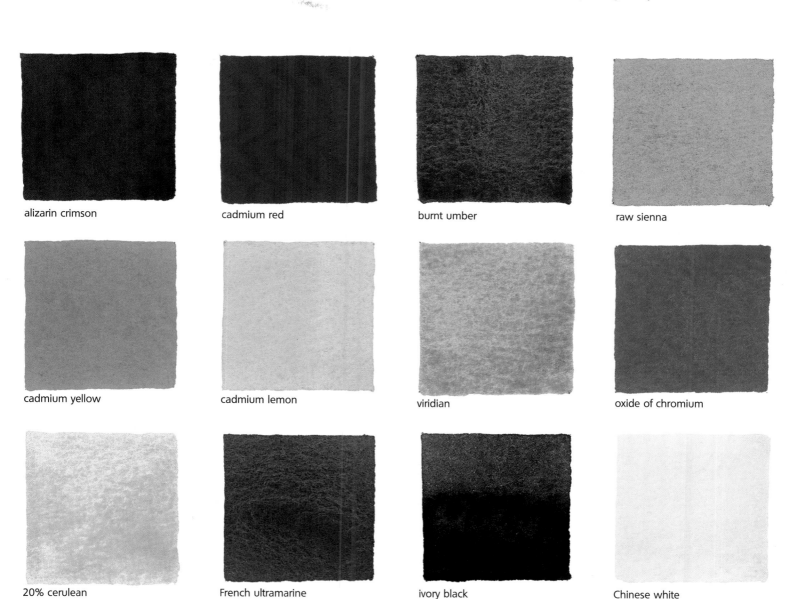

alizarin crimson	cadmium red	burnt umber	raw sienna
cadmium yellow	cadmium lemon	viridian	oxide of chromium
20% cerulean	French ultramarine	ivory black	Chinese white

Ultramarine and its mixes

As the only reddish blue, ultramarine is a must for any watercolourist's palette. A beautiful colour in its own right, it is also useful in mixes.

Real ultramarine, made from costly lapis lazuli, was used to create the vivid blues found in medieval Books of Hours and in the Madonna's cloak in Renaissance paintings. A method of manufacturing synthetic 'French' ultramarine was discovered by the Frenchman J.B. Guimet in 1828, and the new pigment was first used by J.M.W. Turner in 1834. As Reckitt's Blue it was used to whiten laundry. French ultramarine mixes with alizarin to give violet. With cadmium red it gives an earthy terracotta, and with raw sienna a useful sludgy green, good for autumn and summer landscapes. With a warm yellow, such as cadmium yellow, it gives a rather surprising mustard. The cadmium lemon mix gives a sage green, and with viridian it gives a slate blue.

▲ *FRENCH ULTRAMARINE, essential in any palette, is a good all-round colour with wonderful transparency and excellent lightfastness.*

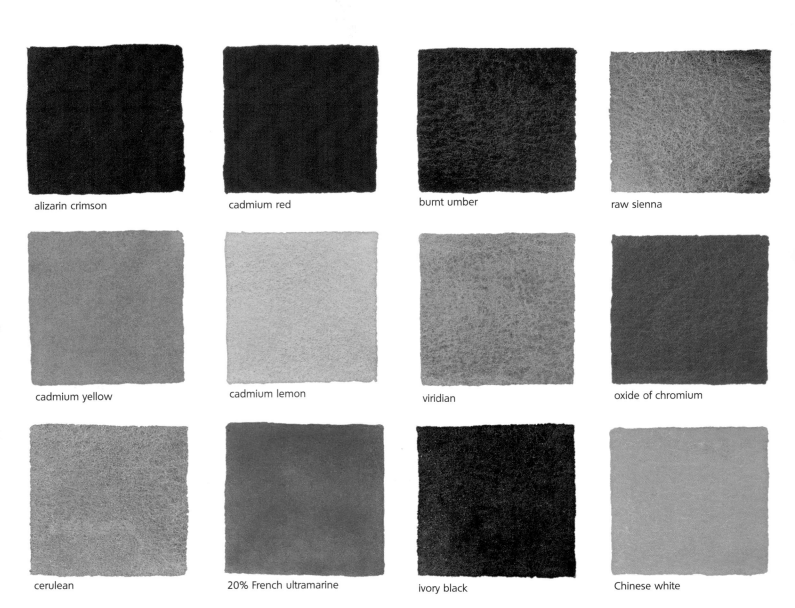

alizarin crimson

cadmium red

burnt umber

raw sienna

cadmium yellow

cadmium lemon

viridian

oxide of chromium

cerulean

20% French ultramarine

ivory black

Chinese white

Using reds

The word 'red' conjures up a bright, insistent scarlet – the red of letterboxes – but it is in fact a complex colour that is remarkably varied in appearance.

As the most dominant colour in the spectrum, red is one of the trio of primaries from which all other colours can be mixed. It can be vibrant and rich – think of the scarlet red of poppies and holly berries, which are represented by colours such as cadmium red, Winsor red and vermilion.

Red can also veer towards purple, burgundy, garnets and rubies – these colours are denoted by magenta and carmine on the artist's palette. Red can be muted too. Consider brick and terracotta – on the palette, earth reds such as Venetian red stand in for these. Delicate and subtle reds are portrayed by rose doré and rose madder.

The origins of red pigments are diverse – rose madder traditionally came from the root of the madder plant, while carmine was made from cochineal beetles from Central America.

Taking a closer look

Bright reds, scarlets, magentas and hot pinks all vie for attention in this sizzling tropical landscape. Touches of green – the complementary of red – enhance the brilliance of the reds, while the blue sky, door and sea startle with their intensity.

Yialia, Cyprus
by Jenny Wheatley

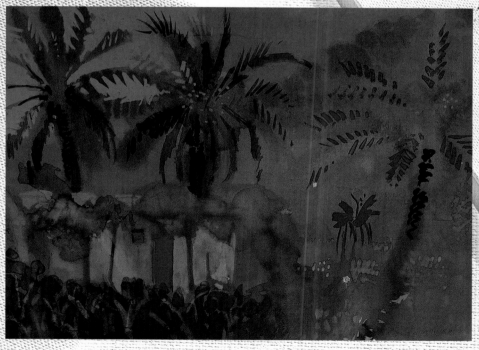

◀ **Carmine**
This red is transparent and highly fugitive.

◀ **Rose madder**
This is a light pink colour.

◀ **Alizarin**
A synthetic substitute for natural madder, alizarin is a cool red with strong staining properties and is highly transparent.

◀ **Cadmium red**
This is made from the metal cadmium. It is a good, warm, opaque red.

◀ **Magenta**
This is a purple-red colour, first synthesized in the 1860s.

◀ **Scarlet lake**
Originally a mix of cochineal lake and vermilion, scarlet lake is now made from various synthetic pigments.

Exploring reds

Alizarin crimson and cadmium red provide a good starting point for a basic palette, but it is worth experimenting with colours such as rose doré and permanent carmine.

There are many new and improved formulations among the reds. Modern organic pigments, the quinacridones for example, have produced new colours such as quinacridone magenta, and traditional colours have been reformulated. Test them for transparency and opacity and see how they mix with yellow and their complementary greens.

Cadmium scarlet
A bright, warm red, this is opaque and mixes to give a good orange. You could substitute it for cadmium red in a limited palette.

Permanent carmine
True carmine, made from cochineal beetles, is costly. Permanent carmine is one of many synthetic substitutes. It is transparent and closely resembles alizarin crimson.

Rose doré
A pretty, old-rose colour, this is very transparent and gives delicate flesh tones. It is useful in flower painting.

Permanent rose
This is a bright, pinkish red, much cooler than rose doré, and very transparent. It has good lightfastness.

Mixing reds

These experiments with red mixes have produced a number of soft browns, oranges and blues. Try out some blue/red mixes, which give a range of mauves and violets, and red mixed with its complementary green, which produces browns and neutrals.

Two-colour mixes

permanent carmine **cobalt turquoise**

Transparent permanent carmine mixed with intense blue-green cobalt turquoise makes a slaty blue.

bright red **gamboge**

For a true orange, mix bright red with brilliant warm yellow gamboge. Use this for flowers and autumn scenes.

bright red **Hooker's green light**

Two complementaries mixed together give a warm, neutral, greenish brown, useful for landscapes.

Three-colour mixes

permanent carmine

gamboge

mauve

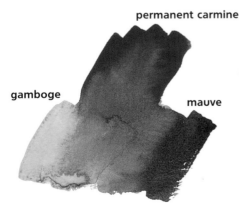

This mix gives a complex, muted, brownish violet, useful for shadows on flesh or misty winter scenes.

permanent carmine

Indian yellow

Antwerp blue

These three primary colours mix to a rich, dark neutral that is almost black.

cadmium red

Hooker's green light

chrome yellow

A rich, warm brown results from this three-colour mix.

Alizarin crimson and its mixes

A cool, transparent red, alizarin crimson is a must for every watercolour palette, however limited.

Alizarin was first synthesized in 1868 and is the oldest synthetic lake pigment. A lake is a paint which is made from a soluble dye. It is turned into a pigment by precipitating it on to a base. Alizarin crimson is a useful mixing pigment, but because of its transparency it is at its most beautiful when applied as a pure wash in various strengths or tints. Mix alizarin crimson with French ultramarine for a strong violet. The combination of viridian and alizarin crimson gives a rich grey, useful for cool shadows or foliage. Mixes of alizarin crimson with cadmium yellow and cadmium lemon produce muted colours that you can use for warm flesh tones or in an autumn landscape.

▲ *ALIZARIN CRIMSON has good tinting strength – one drop on your brush goes a long way.*

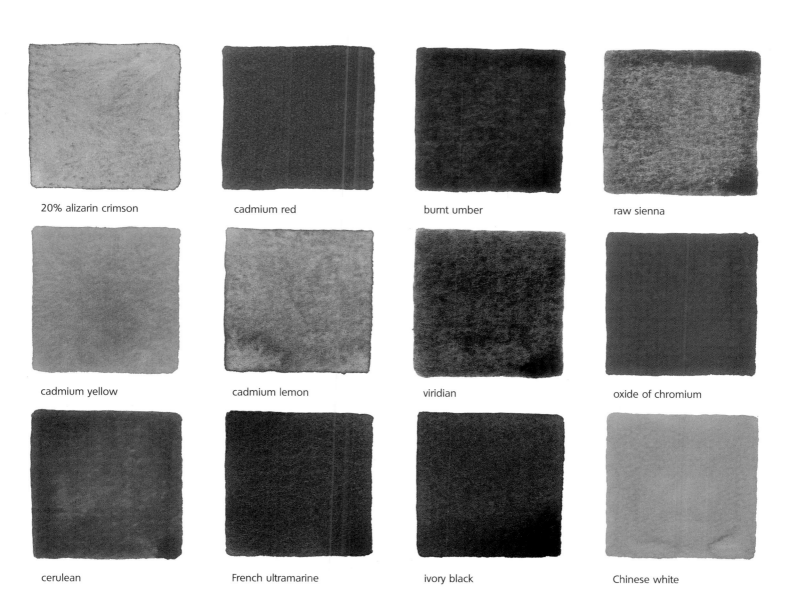

20% alizarin crimson	cadmium red	burnt umber	raw sienna
cadmium yellow	cadmium lemon	viridian	oxide of chromium
cerulean	French ultramarine	ivory black	Chinese white

Cadmium red and its mixes

Cadmium red is a particularly stable, useful colour. It replaces traditional vermilion in the artist's palette.

Throughout history artists have searched for a good, bright, permanent red colour and this is the one. The cadmium reds range from orange-reds to deep red – the adjectives light, medium and deep are sometimes used in their names and give a clue to the type of red you can expect. These colours have a high tinting strength and are fairly opaque when first applied but become less opaque when dry. A warm colour, cadmium red combines with cadmium yellow to produce a true orange. Combined with alizarin crimson it makes an earthy terracotta shade. The green mixes are particularly interesting – with viridian, cadmium red produces a deep browny green colour. The mix with cerulean blue provides a rich slate grey.

▲ CADMIUM RED *is an intense red which should find a place in your palette.*

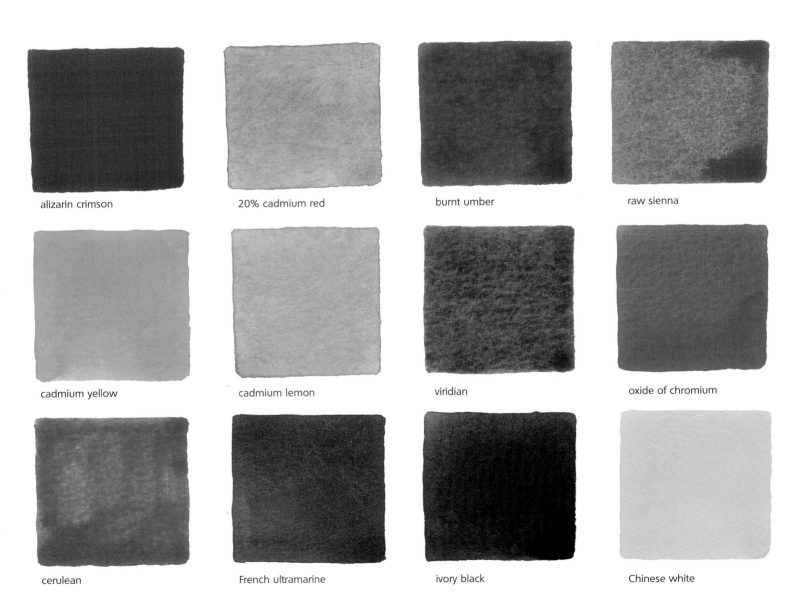

alizarin crimson	20% cadmium red	burnt umber	raw sienna
cadmium yellow	cadmium lemon	viridian	oxide of chromium
cerulean	French ultramarine	ivory black	Chinese white

Using yellows

The third primary colour – yellow – is bright and vibrant. It comes in many guises, some energizing, others strident and stressful.

Nature has many yellows, ranging from the hot, golden orange of sunflowers and the bright, sharp yellow of lemons to the soft creamy tinge of primroses. Therefore the artist's palette contains an extensive range, including yellow ochre, which is warm and rather greenish; intense, bright cadmium yellow; creamy Naples yellow; and sharp, acidic lemon.

Yellow ochre and raw sienna provide the earth tones in the yellow range. But some yellows have unpleasant origins. The Naples yellow that Rubens loved using for skin tones in the 17th century, for example, was based on poisonous lead antimoniate, while Egyptian orpiment was based on arsenic. These pigments are still available, but are largely replaced by harmless synthetics.

Taking a closer look

A golden building on a golden afternoon in Venice – the artist has used hot cadmium yellows with cooler lemon tones and raw sienna and yellow ochre earth colours. Mixing yellows with blue has given darker tones for shadows, while a warm red gives some strong orange hues.

Ca' d'Oro, Venice
by Jenny Wheatley

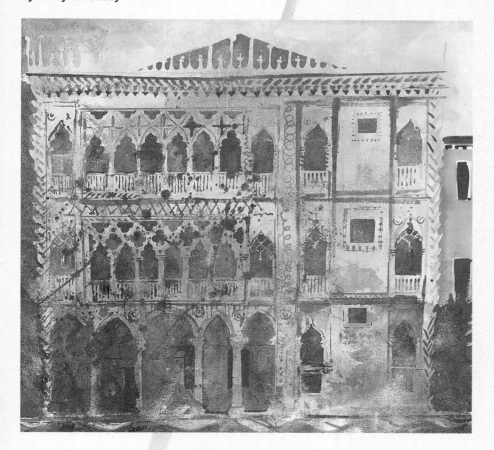

◀ **Strontium yellow**
A cool, light yellow, this has now largely been replaced by other pigments.

◀ **Cadmium yellow pale**
A clean, strong, bright yellow, this has good covering power.

◀ **Chrome yellow middle**
This is a bright yellow, similar to cadmium, but cheaper and quite fugitive, that is liable to fade in bright light.

◀ **Barium**
This cool greenish yellow is now almost obsolete. It is completely lightfast, but its low tinting strength means it has little effect in a mix.

◀ **Orpiment**
A strong yellow, orpiment is based on poisonous arsenic. Cadmium yellow is now used more often than orpiment.

◀ **Realgar**
A reddish orange yellow, similar to orpiment, realgar is also based on poisonous arsenic.

Exploring yellows

Warm cadmium yellow and cool lemon yellow are essential components of a flexible and effective mixing palette. But there are many other yellows available.

Aureolin yellow is a useful lemony yellow which is more transparent and slightly more orange than lemon yellow. Its transparency makes it a useful mixing colour. Aureolin yellow's true beauty comes through in thin washes. The chrome yellows, launched as an artist's pigment in 1816, have many of the characteristics of the cadmium yellows, but are much cheaper.

Yellow ochre
This natural earth colour gives a range of shades from dulled yellow to brown.

Naples yellow
A warm, sandy, semi-opaque yellow, once made from a mineral found in volcanoes but now mixed from a range of pigments.

Indian yellow
A bright, semi-opaque yellow, once made from mud and the urine of cows fed mango leaves. It is now made synthetically.

Cadmium yellow lemon
A reliable, strong and relatively lightfast lemon yellow.

Mixing yellows

Here are some yellow mixes. Some produce what you might expect, but others are surprising – such as the warm pink of a cadmium lemon/rose madder alizarin mix.

Two-colour mixes

chrome yellow **alizarin crimson**

Mixing a bright, hot yellow and a cool red gives a range from blood red to rich oranges, ideal for sunsets.

aureolin yellow **Antwerp blue**

A golden yellow and a chilly blue combine to make a range of rich summer woodland greens.

cadmium lemon **rose madder alizarin**

These colours mix to give a warm pink, wonderful for flesh tones.

Three-colour mixes

sap green

bright red

aureolin yellow

Three warm colours produce a warm ochre, useful for flesh tints.

cadmium yellow

olive green

French ultramarine

Yellow and blue add impact to a muted olive green.

viridian

alizarin crimson

chrome yellow

This muted red-brown is excellent for landscapes and figure painting.

Cadmium yellow and its mixes

Cadmium yellow is a strong, bright, opaque yellow with good covering power. It can be diluted to make some wonderful washes.

The metallic element cadmium was discovered in 1817 and became available as an artist's pigment in 1827. The cadmium yellow mixes range from cool lemon to warm, orange shades. They are smooth, opaque and have a dense consistency.

Cadmium yellow has a warming effect on other colours. Even when a small quantity is mixed with white, it is strong enough to create a distinctive sandy yellow, similar to the much older (but poisonous) Naples yellow. Mix cadmium yellow with cadmium red and you will get a hot orange. Mix it with any blue and you will get muted green or blue-green. Cadmium yellow and viridian make an attractive spring green, while cadmium yellow and French ultramarine make a dark slaty blue-grey.

▲ CADMIUM YELLOW *is an invaluable colour on any palette. It has good tinting strength and opacity. It is made from an artificial mineral pigment – cadmium sulphide.*

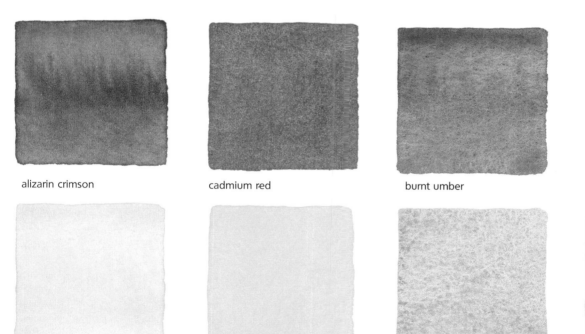

alizarin crimson	cadmium red	burnt umber	raw sienna
20% cadmium yellow	cadmium lemon	viridian	oxide of chromium
cerulean	French ultramarine	ivory black	Chinese white

Lemon yellow and its mixes

Every palette needs a cool as well as a hot yellow, and cadmium lemon fulfils this role admirably.

The term 'lemon' describes a pale, sharp, greenish yellow – it is a hue rather than a pigment. The colour can be made from different pigments depending on the manufacturer. As a result, each manufacturer gives the paint a different name, such as cadmium yellow lemon, cadmium lemon and chrome yellow.

Lemon yellow creates cooler mixes than those made with cadmium yellow. The alizarin crimson mix looks stronger than the cadmium yellow version, while cadmium red is knocked back to give a rich terracotta. Mixed with ivory black, lemon yellow creates a stunning gun-metal grey, and with French ultramarine you get a beautiful distinctive blue.

▲ *CADMIUM LEMON based on cadmium yellow medium pigment is reliable and lightfast.*

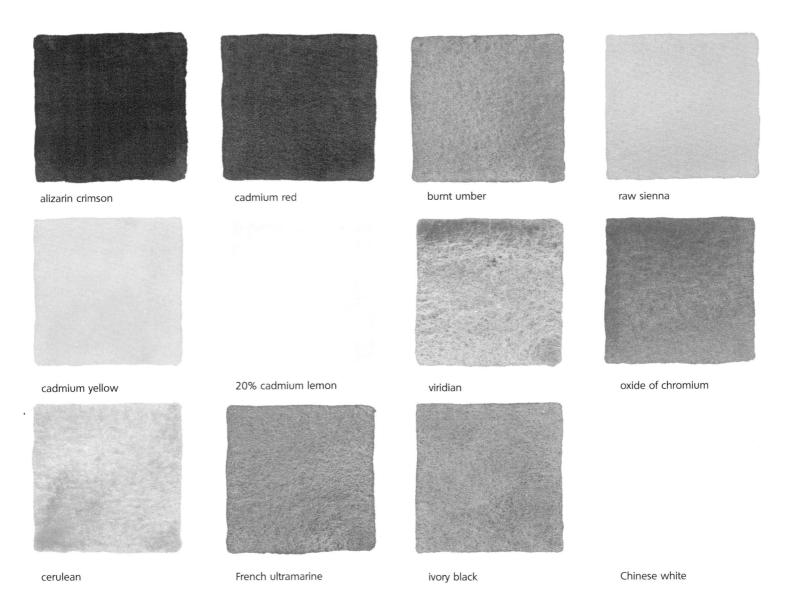

alizarin crimson

cadmium red

burnt umber

raw sienna

cadmium yellow

20% cadmium lemon

viridian

oxide of chromium

cerulean

French ultramarine

ivory black

Chinese white

Using greens

Green is a secondary colour that falls between blue and yellow on the colour wheel. It is the colour of growth and fertility – but also of mould and decay.

The fresh, bright green of spring is a favourite with artists, but there are a huge number of other shades of this colour, ranging from the darker, stronger greens of summer foliage to the golden-greens of mosses, the soft greens of sage leaves and the pale greens of water. The innumerable variety of greens in nature gives artists scope for detailed and imaginative landscape paintings, but be careful because the greens can go disastrously wrong. Sunlight on fresh green foliage or grass creates such a bright and dazzling effect that there is a tendency to make your colours too garish. It takes practice to orchestrate landscape greens satisfactorily.

Taking a closer look

Greens are essential for landscapes and gardens, and they also appear in skies, seascapes and skin tones. The subtleties are endless – from yellow-green to blue-green to nearly black or brown.

Rough sea at Lyme Regis
by Peter Folkes

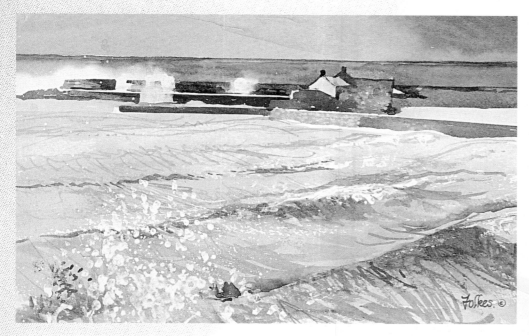

◀ **Verdigris**
This is an antique blue-green pigment based on copper. It was used by the Old Masters, but often blackened over time.

◀ **Cobalt green**
A bright pigment of medium strength, this is reasonably opaque and permanent but has poor covering power.

◀ **Cadmium green**
This is an artificial mineral pigment based on a mix of cadmium yellow with either viridian or French ultramarine.

◀ **Viridian**
This is an intense, transparent and distinctive blue-green valued for its opacity and permanence.

◀ **Green jasper**
This crystallized iron silicate gives the natural earth pigment Verona green.

◀ **Chromium oxide green**
This dull, matt, olive green is opaque, permanent and very reliable.

Exploring greens

You can mix a wide range of greens from the two blues and two yellows in your basic palette. However, the ready-made greens make useful additions.

Cobalt turquoise, cobalt green and phthalocyanine (blue shade) are cool blue-greens, similar in character to viridian (see page 82). Unmixed they give sea and conifer colours, but mixed with a lemon yellow they give bright apple and lime greens. Phthalocyanine yellow shade is a bright emerald green; in fact, some manufacturers name the paint based on this pigment 'emerald green'.

Terre verte
This is a dull, transparent earth colour, traditionally used for underpainting flesh tones.

Sap green
A bright grass green, sap sometimes veers towards yellow-olive.

Hooker's green
This colour is usually made from Prussian blue/gamboge. Its appearance varies from manufacturer to manufacturer. It is not lightfast.

Olive green
You can mix this brownish green yourself from raw sienna and cerulean blue or a lemon yellow and ultramarine. It is not usually lightfast.

Mixing greens

Even with a good selection of greens in your palette, you'll need to modify them. Greens muted with their complementary reds give autumnal russets and browns, cool purply shadows and delicate flesh tints. Adding yellow to greens tends to lighten and brighten them.

Two-colour mixes

viridian **cadmium lemon**

This mix produces a vibrant grass green, ideal for spring landscapes or bright flower studies.

sap green **cerulean blue**

A little cerulean cools this warm green. Adding more produces a useful blue-green, the colour of a chilly sea.

viridian **light red**

The product of this mix is a range of cool browns – subtle neutrals that have many uses.

sap green **cadmium yellow pale**

This warm yellow brings out the brightness of sap green. In nature these colours are seen in mosses and in beech leaves in spring.

Winsor emerald **ultramarine**

A warm blue turns emerald into a pearly blue-grey, ideal for distant vistas in a landscape or complex studies of water.

Winsor emerald **alizarin crimson**

This glorious green is neutralized by a cool red. It is extremely useful for shadows and the muted tones of winter landscapes.

Oxide of chromium and its mixes

This is an opaque, cool and totally permanent green. Inherently subtle, it is useful when you need a dark but muted green for foliage.

Oxide of chromium makes a delicate hue in mixed washes or tints for cool flesh tones. As well as being excellent for foliage, it also complements earth reds, the shadows in warm brickwork for example.

It is not essential to have oxide of chromium on your palette because you can mix a muted green – for instance, cadmium yellow plus a warm blue such as ultramarine with a touch of red – but its delicacy makes it very useful. With yellows it gives a range of muted olive greens, while it knocks back the reds. Mixing it with cadmium red makes an intense brown.

▲ *Oxide of chromium is a high-quality pigment. Its permanence and opacity make it a good all-rounder in the palette.*

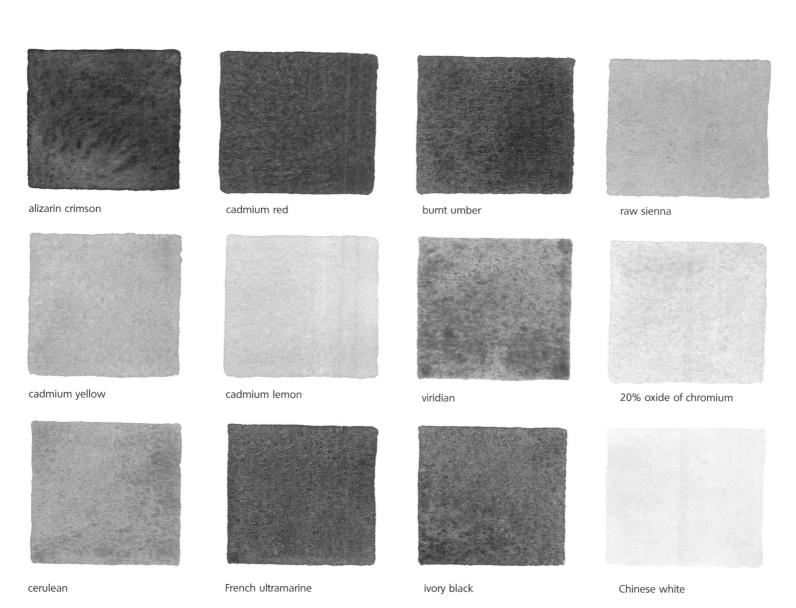

alizarin crimson	cadmium red	burnt umber	raw sienna
cadmium yellow	cadmium lemon	viridian	20% oxide of chromium
cerulean	French ultramarine	ivory black	Chinese white

Viridian and its mixes

This important colour was patented in 1859. A brilliant and transparent emerald green, it is valued for its clarity and intensity.

Useful though it is, viridian needs handling with care – even a hint of it on your brush will taint other colours. On its own it can be rather strident, but in mixes it can produce some wonderful greens. On your palette, or when thickly applied, it can appear almost black. Lay out your palette in an orderly way so you know where it is.

Viridian mixed with cadmium yellow produces a range of bright spring greens – the colours of newly unfurled beech leaves or the leafy rosettes of primroses. With a cool yellow such as cadmium lemon it produces a bright chilly green. Mix it with earth colours such as raw sienna and burnt umber for a range of foliage colours, or with reds for some lovely autumnal shades.

▲ VIRIDIAN *is a bright, strong hue which shows at its best in glazes, washes and mixes.*

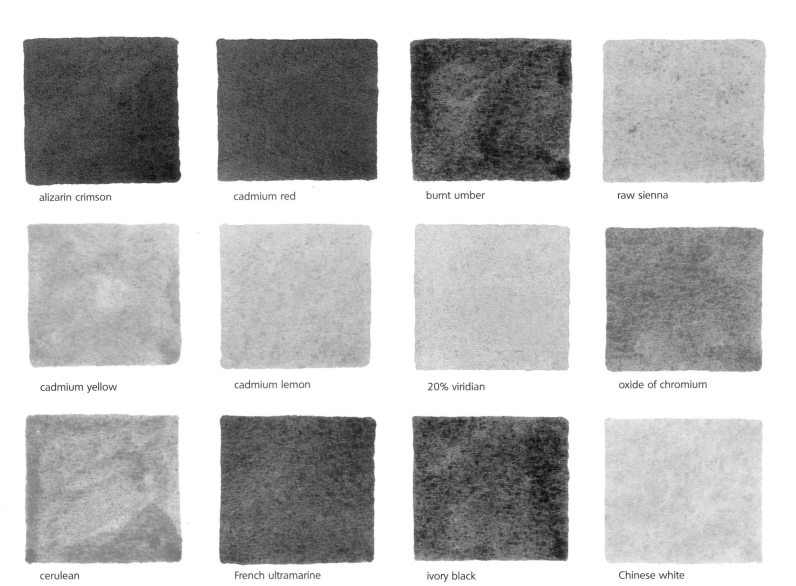

alizarin crimson	cadmium red	burnt umber	raw sienna
cadmium yellow	cadmium lemon	20% viridian	oxide of chromium
cerulean	French ultramarine	ivory black	Chinese white

Using violets

Mixed from two primaries – blue and red – violet (or purple) is an extremely rich, vibrant colour which appears in many flower hues.

The colour violet ranges from the mauves (which have more red in their make-up) to the purples, which hover on the verge of blue. It is a difficult colour to define. Individual people differ in their perception of the various different shades – and paint manufacturers don't agree either.

Although many flowers have given their names to shades of purple – lilac, violet and lavender, to name just three – nature provides very few good purple pigments. In Roman times violet was derived from a type of whelk, while in the Middle Ages it was made from cheaper purple vegetable dyes. The first synthetic violet was made from coal tar derivatives by William Henry Perkin in 1856. Perkin's violet ushered in a host of synthetic dyes, some still in use today.

Taking a closer look

The exact hue of violet is difficult to pin down. This painting includes a beautiful range – from deep, dark purples through to pale mauves.

Salvation Jane, Foothills of Mount Lofty Ranges, south of Adelaide, South Australia
by Roy Hammond

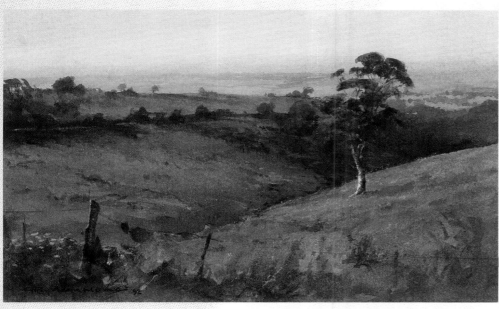

◀ **Violet quindo**
The quinacridone pigments on which this mixed violet is based were first developed in Germany in the 1930s. They are extremely lightfast.

◀ **Winsor violet**
This – also called dioxazine violet – is a semi-transparent, fairly lightfast pigment. It is a good, balanced violet, neither too red nor too blue.

◀ **Côte azure violet**
This is a bluish-red oxide of iron. It is a naturally occurring earth colour.

◀ **Permanent mauve**
This is the first dye distilled from coal tar derivatives and is also known as Perkin's violet, after its creator. It is completely lightfast.

◀ **Purpurite**
Derived from iron manganese, this violet has an intense hue.

◀ **Cobalt violet dark**
Cobaltous phosphate was first made in the early 1800s from a natural ore. It is transparent and varies from red-violet to a bluer version.

Exploring violets

Beautiful violets and mauves are available that are ideal for flower and garden studies. They are also handy for landscapes, shadows and flesh tints.

The cobalt violets, a range of light and deep colours, are almost impossible to achieve by mixing. Dioxazine violet is particularly powerful and is sometimes called permanent violet or dioxazine mauve. It can be used to create intense passages of colour or delicate washes. Some colours, such as purple madder, are actually mixed pigments.

Winsor violet (dioxazine)
A good clear violet which can be thinned to produce delicate washes and has good lightfastness.

Cobalt violet
This pinkish purple is a delicate, transparent colour, useful for flowers and subtle sky effects.

Permanent mauve
This semi-opaque colour is best used at high intensity, rather than in thin washes. It is a weak colour but lightfast.

Permanent magenta
This is a reliable red violet. It is relatively lightfast and transparent, and it gives clear washes.

Mixing violets

Tube or pan violets are bright and clear, but you may want to use them in more muted versions. One way of uncovering their qualities is to mix them with white – this brings out their blueness or redness. Mixing them with their complementaries – yellow, lime-green and yellow-orange – creates wonderful neutrals.

Two-colour mixes

Winsor violet (dioxazine) **Winsor emerald**

An intense violet mixed with a vivid green gives a range of subtle blue-greens and greys.

Winsor violet (dioxazine) **scarlet lake**

Clear, bright violet is neutralized by a hot red – the result is a rich terracotta brown.

permanent magenta **lemon yellow**

This mix gives a particularly delicate pearly pink – ideal for flesh tones or a sky flushed by the setting sun.

permanent magenta **viridian**

Viridian is an intense but transparent green which mixes with magenta to produce a range of heathery shades.

permanent mauve **Winsor orange**

This mixture of colours produces a rich, warm, browny-orange neutral, useful for autumn landscapes.

purple madder **cadmium red**

Cadmium red knocks back the purple to produce a soft terracotta colour.

Permanent mauve and its mixes

To appreciate this colour at its best, dilute it with water or mix it with Chinese white – the resulting tint is a delicate lilac, a colour almost impossible to mix from the palette primaries.

Permanent mauve, a warm reddish colour, is a manganese violet. Mix it with the viridian in the basic palette to produce a range of attractive greys. With alizarin crimson, permanent mauve gives an intense burgundy red; with cadmium red, it produces a strong but muddied terracotta brown. The raw sienna mix is a clear pinky-brown, useful for andscapes and flesh tones. Mixed with the yellows, it produces a range of interesting greenish neutral shades. Note that permanent mauve has a tendency to granulate – see the Chinese white and viridian mixes – producing textural effects.

▲ PERMANENT MAUVE *is completely lightfast, semi-opaque and handles very well. The sample above shows the colour at full intensity.*

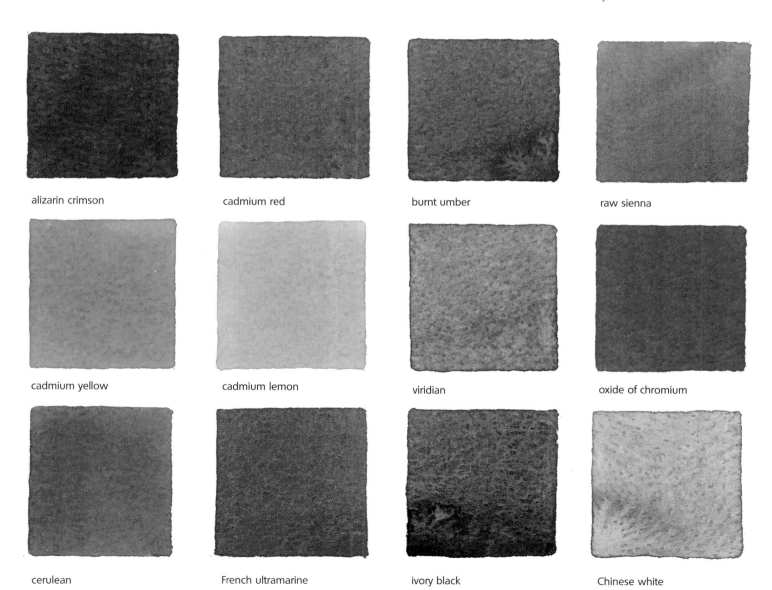

alizarin crimson	cadmium red	burnt umber	raw sienna
cadmium yellow	cadmium lemon	viridian	oxide of chromium
cerulean	French ultramarine	ivory black	Chinese white

Permanent magenta and its mixes

This colour is much warmer, pinker and more delicate than permanent mauve, and produces lighter and brighter mixes.

Permanent magenta, a quinacridone violet, enhances the rosy qualities of alizarin crimson to give a bold, lively colour, but knocks back oxide of chromium to produce a khaki green. The raw sienna and cadmium lemon mixes are particularly useful for flesh tones. The blue mixes are interesting – cerulean is slightly muted to produce an intense grey-blue, while the mix with ultramarine produces an intense blue-violet – the colour of some irises.

The mix with Chinese white shows the cool transparency of permanent magenta to its maximum advantage. Mixed with ivory black, permanent magenta produces a slate grey, useful for landscapes and shadows.

▲ PERMANENT MAGENTA *is a very reliable red-violet and a useful addition to your palette. It is lightfast, transparent and gives very smooth washes.*

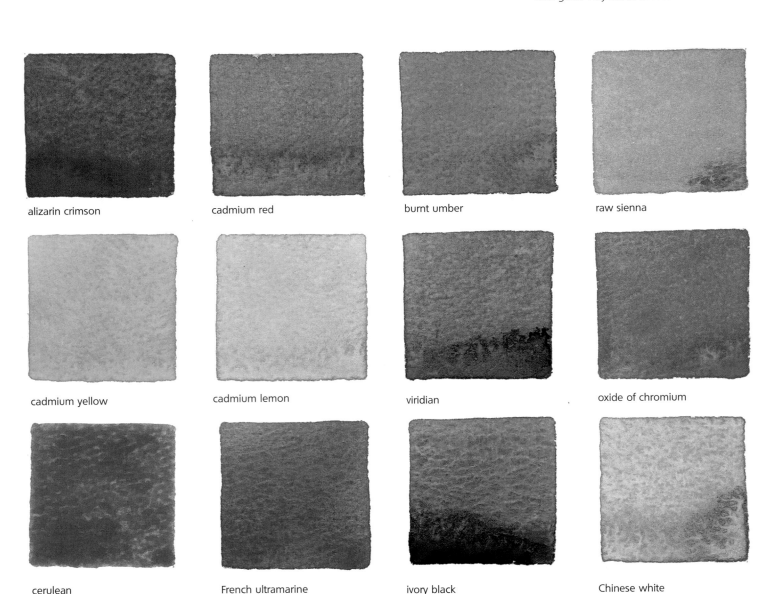

alizarin crimson	cadmium red	burnt umber	raw sienna
cadmium yellow	cadmium lemon	viridian	oxide of chromium
cerulean	French ultramarine	ivory black	Chinese white

Using oranges

Bright, insistent and extrovert, orange – mixed from red and yellow – is the warmest of all the secondaries.

Orange has similarities to both its parent primaries. Like red, it is strong and strident, yet it is also as cheerful and welcoming as yellow. Orange is always warm, unlike reds such as crimson and yellows such as lemon, which are relatively cool.

The exact hue of any orange depends on the proportions of the mix – most oranges have a bias towards either red or yellow. Physically, orange is closest to yellow, since both are the brightest of the pure colours.

The complementary partners of orange are blues and blue-greens. These combinations enliven each other when they are placed side by side, and neutralize each other when mixed.

In nature, orange is most obvious during the summer and autumn months – in flamboyant flowers, ripe fruits, leaves and berries. Hedgerows and woodlands abound with orange in autumn, and the colour shows its strength in stunning sunsets and stormy skies.

Taking a closer look

In this striking landscape, a range of oranges – pale yellowy-beige darkening to a mid hue and some strong streaks of pure orange – culminates in a few dramatic, fiery bursts of concentrated colour of a volcano-like intensity.

Pembrokeshire landscape
by *John Cleal*

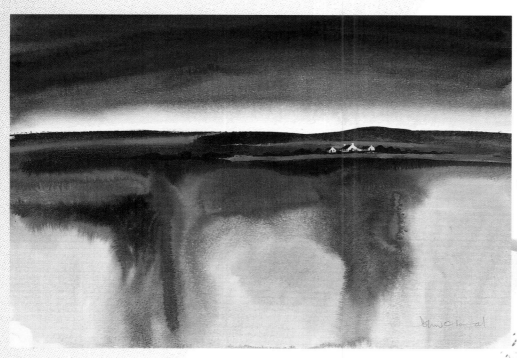

◄ Chrome orange
An artificial mineral pigment based on lead chromate, this produces highly saturated colours.

◄ Cadmium orange vermilion
Cadmium, a silvery metal, produces colours from pale yellow to warm orange. This pigment has good lightfastness.

◄ Titanium orange
This pigment is strong and quite opaque. It is slightly muted and leans towards yellow.

◄ Isoindolinone orange
A synthetic orange pigment, this is a reliable, strong mid-orange with a high tinting strength. Its transparency makes it good for glazes.

◄ Iron oxide orange
Synthetic iron oxide is a good substitute for the natural earth colours. It produces quite a good brown-orange.

◄ Cadmium orange light
A variation of cadmium orange, this slightly paler pigment is bright and strong.

Exploring oranges

The colour orange was in the past called tawny, tan or gold. The name orange comes from the Arabic word 'naranj' and was introduced to Europe with the fruits in the 11th century.

Orange is the colour of sunrise and sunset, of marigolds, nasturtiums and tangerines, and the striped fur of marmalade cats. Its pale pinkish versions give delicate flesh tints. It darkens to brown and terracotta for a range of warm earth tones and the golds and russets of autumn foliage. The glamorous versions of orange are the metallics – gold, copper and bronze.

Scarlet lake
This vibrant red-orange is transparent in thin washes and has good tinting strength.

Burnt sienna
This earth colour is created by roasting natural sienna. It is a lovely translucent orange-brown.

Cadmium orange
Bright, strong and opaque, cadmium orange can be diluted to create good washes because of its intensity.

Cadmium yellow deep
This clean, opaque yellow-orange has excellent lightfastness. It gives bright oranges when mixed with warm reds.

Mixing oranges

Orange and orange-reds are useful mixers, but their effect on other colours depends on how much red or yellow is in their make-up. Thinning with water or adding white gives some delicate pink or yellow flesh tones, while adding black gives some useful browns.

Two-colour mixes

cadmium yellow deep **cerulean**

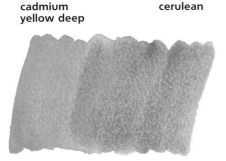

This orange-yellow/greenish blue mix gives a good green for spring foliage.

cadmium orange **Antwerp blue**

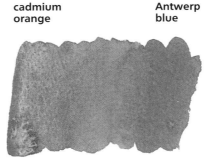

A cool blue neutralizes orange to produce subtle, neutral greys.

scarlet lake **permanent mauve**

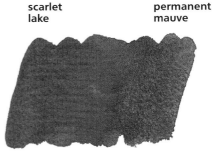

This hot red-orange combines with permanent mauve for a deep terracotta.

cadmium yellow deep **French ultramarine**

This yellow-orange is neutralized by French ultramarine to create a strong green-grey, useful for seascapes or mountain scenes.

cadmium orange **alizarin crimson**

This combination gives some lovely clear rose colours – use them for flesh tones, flower studies and the flush of sunsets.

cadmium orange **viridian**

Viridian is a useful mixing colour. Here its sharpness is modified by an intense orange to make a range of warm greens.

Winsor orange and its mixes

*This bright, lively orange is opaque and slightly staining.
It is entirely dependable in washes, so use it for sunset
and sunrises, and for orange fruits and flowers.*

This orange produces a number of surprising and useful mixes. For example, alizarin crimson is lightened and brightened to create a lovely rose-red colour, while with its complementary – French ultramarine – it produces a true neutral brown. The Chinese white mix highlights the reddish character of the pigment.

Orange is one of the colours you can leave out of your palette – it is easy to mix a reasonably good version using a warm yellow such as cadmium yellow deep or medium with a hot red such as cadmium red – but it is well worth buying a Winsor orange if you want a particularly bright hue, or need to maintain colour consistency.

▲ *WINSOR ORANGE is a good clean, bright, strong orange with excellent lightfastness. It is made from a single pigment, which gives good consistency.*

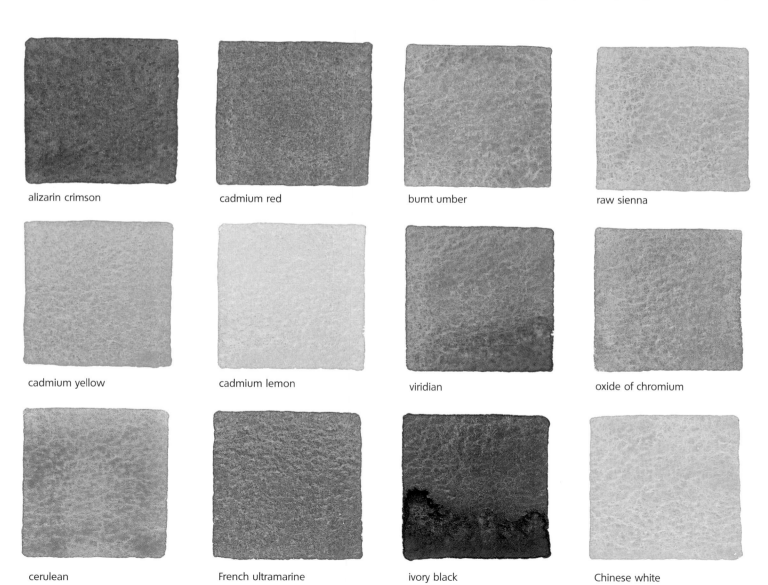

alizarin crimson

cadmium red

burnt umber

raw sienna

cadmium yellow

cadmium lemon

viridian

oxide of chromium

cerulean

French ultramarine

ivory black

Chinese white

Cadmium orange and its mixes

Some cadmium orange paints are made from the pigment cadmium orange. For others, such as the one shown here, manufacturers mix yellow and red pigments.

This cadmium orange – mixed from cadmium yellow and cadmium red – is bright, strong and glowing. Mixed with raw sienna and cadmium yellow, it creates a range of golden and marigold shades. It neutralizes greens to create leaf and sage shades, ideal for spring and summer landscapes.

With French ultramarine, cadmium orange gives a range of greenish browns, while the cerulean mix is a bluish green. Of particular interest is the black and cadmium orange mix which gives a warm, earth brown with a wide variety of applications – ranging from landscapes and interiors to skin tones.

▲ CADMIUM ORANGE, *like all cadmiums, is very warm and strong. It is also opaque, but it can be thinned to create very even, consistent washes.*

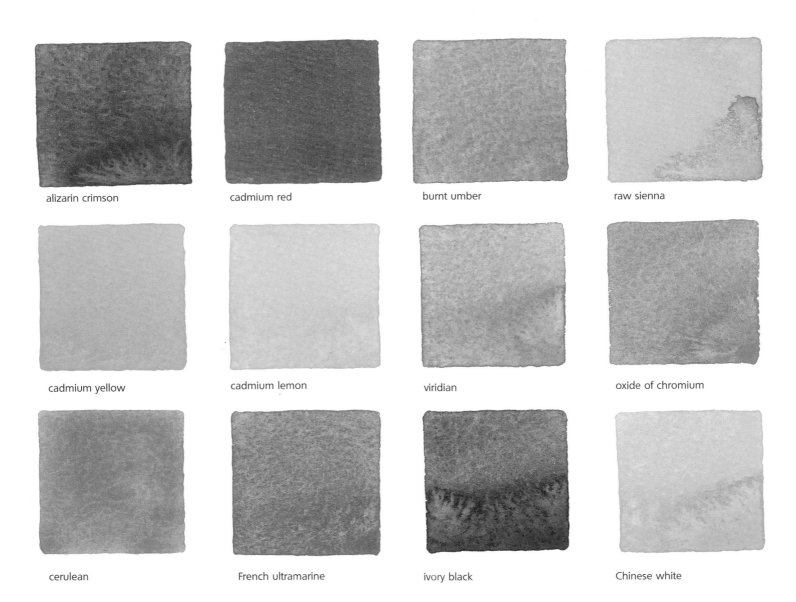

alizarin crimson	cadmium red	burnt umber	raw sienna
cadmium yellow	cadmium lemon	viridian	oxide of chromium
cerulean	French ultramarine	ivory black	Chinese white

Using browns

Brown has a varied character: it can be intense, strong, solid, even sombre – but it can also be mellow, smooth and comforting.

In the natural world, brown is the colour of the earth – rich, dark, wet mud or the milky cocoa of tilled fields. Cool grey-browns and pinkish browns create a backdrop to woods and hedges. The autumn landscape provides the richest range, with russets, golden ochres and chocolate browns. Winter's palette is more subtle – delicate browns and pearly neutral browns are set off by others so dark they look black. There are many lovely browns to choose from among the earth pigments, including burnt umber, burnt sienna, sepia and Indian red.

Technically, brown is a coloured neutral – the warm equivalent of the cool greys. It can be created by darkening yellow, orange or red with black or their complementaries. Mixes of yellow and violet, orange and blue and green will give you a range of beautiful browns – yellow-brown, red-brown, orange brown or browns with a red-violet tinge. The three primaries can mix to a neutral brown or grey.

Taking a closer look

An almost inexhaustible range of muted browns and earth colours have been used in this painting of a country village in the rain on an autumn evening – all blending together to create a gentle, harmonious image.

Autumn evening, Elton (Shropshire)
by *Keith Noble*

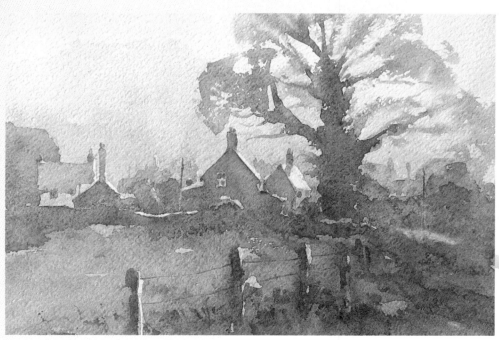

◀ **Raw sienna**
This golden-brown pigment is derived from a natural clay containing iron and manganese.

◀ **Burnt sienna**
A bright golden-brown, burnt sienna is created by heating raw sienna in a furnace.

◀ **Raw umber**
Umber pigment originally came from Umbria in Italy. The tones of this deep brown pigment range from green-yellow to violet.

◀ **Burnt umber**
This also came from Umbria and, along with raw umber, it is the most widely used brown pigment.

◀ **Burnt green earth**
Also called terre verte, this semi-transparent brown is derived from clay stained green by manganese and iron in the earth.

◀ **Yellow iron oxide ochre**
This is a yellow earth pigment.

Exploring browns

Brown pigments, including many of the earth colours, are among the most useful of hues – notice how they tend to granulate. Choose from the wide range available or mix them yourself.

Earth colours, a group of natural mineral pigments, are produced by refining clays, rocks and earths coloured by metallic oxides. They include a glorious range of browns, yellows, reds and a few greenish shades. All the natural or native earths contain traces of organic matter, clay and other impurities. These account for much of their brilliance, beauty and character.

Indian red
Once made from natural iron oxide red imported from India, this is now made artificially.

Sepia
Originally from the ink bag of a squid or cuttlefish, this is now made from various pigments, including lamp black.

Raw umber
This earth pigment is a warm reddish brown with a green undertone. It is invaluable for portraiture.

Burnt umber
Warmer and redder than the raw version, burnt umber – a reddish hue – is a useful all-rounder.

Mixing earth colours

Some browns are muted versions of red, yellow or orange: in mixes they behave as modified versions of their parent colours. Venetian red neutralizes green, as does a cadmium red. Burnt ochres and umbers have a reddish cast and knock back greens and blue-greens. Sepia and Vandyke brown are almost true neutrals and are easily shifted to the warm or the cool side.

Two-colour mixes

Venetian red	**viridian**

A rich terracotta-like Venetian red can be used to knock back a bright intense green – useful for landscape shadows.

sepia	**raw sienna**

This mix of two earth colours gives a range of warm, smoky shades, useful for dark flesh tones and landscape studies.

burnt umber	**scarlet lake**

Burnt umber is a gingery red-brown – here it is mixed with scarlet lake to produce an autumnal brown.

Venetian red	**cerulean blue**

Here a muted brown-red is mixed with a cool blue to produce a good slate grey.

terre verte	**Vandyke brown**

Terre verte is one of the few earth greens – here it is darkened with Vandyke brown.

burnt umber	**Winsor violet**

A lovely violet complements this chestnut brown – together they produce a soft purple-brown.

Vandyke brown and its mixes

Vandyke brown is a strong, dark, transparent hue traditionally derived from earth rich in humus – the raw materials resemble lignite, or brown coal.

Vandyke brown is a well-balanced brown, which is less red than burnt umber. Two manufacturers produce a genuine Vandyke brown; the rest use mixes of pigments, often black and brown iron oxides. A dark chocolate brown such as this is always useful although you can make an equivalent by mixing ivory black and burnt sienna.

Notice in the mixes below how subtle the effects of Vandyke brown are. With the two blues – cerulean and French ultramarine – it gives a series of pearly greys, while both the reds and the greens are very slightly knocked back. The yellows tend to become slightly muddied. The white mix gives you the best clue to its character.

▲ VANDYKE BROWN *was originally a naturally occurring organic pigment. Now, although the name persists, the pigments generally used have no relation to the original colour.*

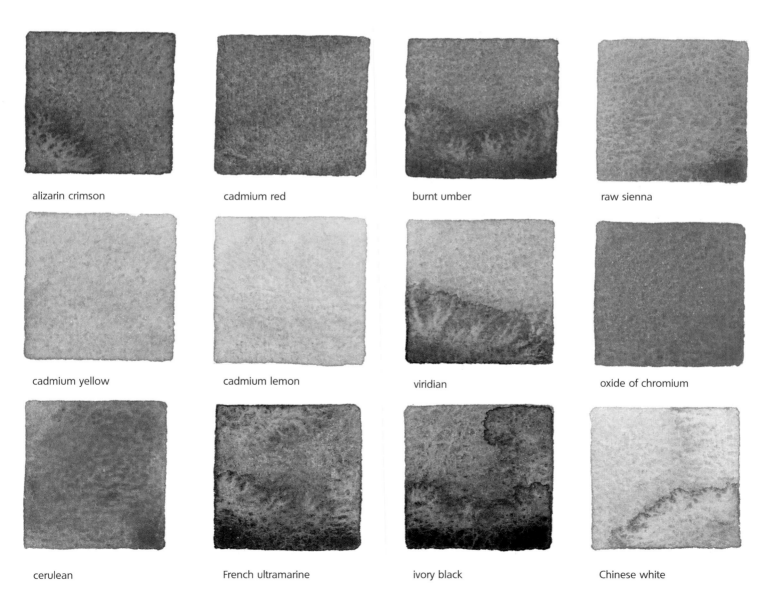

alizarin crimson	cadmium red	burnt umber	raw sienna
cadmium yellow	cadmium lemon	viridian	oxide of chromium
cerulean	French ultramarine	ivory black	Chinese white

Burnt umber and its mixes

Heating raw umber – an earth pigment – in a furnace produces burnt umber, which is a decidedly reddish brown with a slight but attractive underlying pink tone.

The final colour of burnt umber depends on the temperature of the furnace and the length of roasting, but it ranges from a muted burnt orange to a rich ginger. An intense, stable colour, it may darken with age if the underlayers aren't completely dry. In washes and glazes it gives a delicate pinkish tint. Used more solidly, it has the burnished richness of a conker. Burnt umber gives many coloured neutrals – terracotta with cadmium red, dull khaki green with oxide of chromium. The blue mixes are useful – with cerulean it makes a subtle grey, with ultramarine a dark, rich purple. With the yellows – raw sienna, cadmium yellow and cadmium lemon – it gives pinkish yellows.

▲ *BURNT UMBER has high tinting strength combined with good covering power. Try using it instead of black to knock back a mix.*

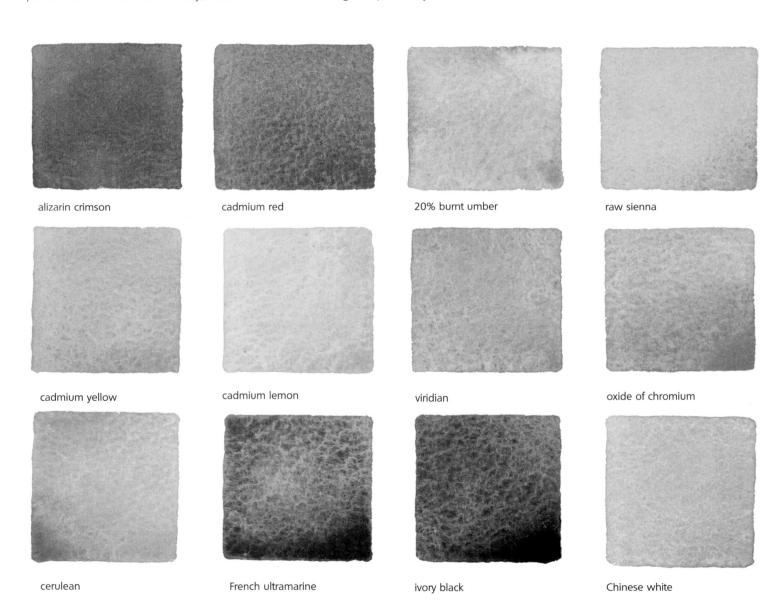

alizarin crimson	cadmium red	20% burnt umber	raw sienna
cadmium yellow	cadmium lemon	viridian	oxide of chromium
cerulean	French ultramarine	ivory black	Chinese white

Using black and white

Black represents the negation of colour – and yet in theory it is achieved by mixing all three primaries. White is its opposite.

For the artist, black can be warm or cool, matt or glossy, opaque or transparent. The Dutch artist Frans Hals (1581–1666), who painted 'The Laughing Cavalier', created 27 different shades of black! Although you can mix black from the three primaries, the best you can get is a very dark neutral. A good black in the palette is useful when you want a true black and for greying other colours. No blacks are perfect – they all have either a blue or a red bias.

A pure white is difficult to find. Most are warm or cool although whites have to be laid side by side for you to see this properly. It is the most responsive pigment to adjacent colours and the ambient light, and generally betrays a hint of another colour. When white paint is mixed with other colours it gives a range of lighter tones, or tints. In watercolour, the white used most often is Chinese white – for highlights and making corrections, and to paint in items that have white as their local colour.

◀ **Vine black**
This is a blue-black made from burnt vine twigs or wood.

◀ **Bone black**
Produced from charred bones, this is a light black with a brownish tinge. It is denser than lamp black.

Taking a closer look

The great simplicity of this image – painted in just three colours – gives it drama and impact. The cockerel is painted in a rich black watercolour wash, with his comb in brilliant red, while the white hen is represented by the pure white of the paper itself.

Coq et poule, 1991 by Patrick Procktor

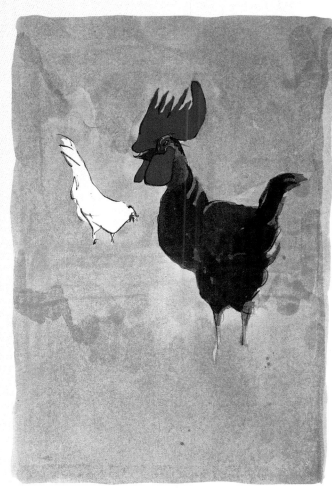

◀ **Manganese black**
Also known as manganese brown, this artificial colour is a useful neutral.

◀ **Ivory black**
Originally produced by burning ivory, this is actually a high-grade bone black. It is a deep black with a brownish tinge.

◀ **Mars black**
Like all Mars colours, this is an artificial oxide of iron. Dense, heavy, opaque and permanent, it has a brownish tinge.

◀ **Lamp black**
This deep, velvety black is made from the soot of oil, tar, pitch and resins. It is used in printing inks and in Chinese-ink sticks.

Exploring blacks

Black can give some wonderfully subtle shades – the secret is to use it sparingly.

A cool black, such as blue-black, can be mixed with a cool yellow to give a range of acid greens – ideal for foliage and landscapes. Black can be used to give some pleasing slate greys and neutrals – look, for example, at the ivory black/cobalt blue mix, which resembles Payne's gray.

If you choose more than one black for your palette, go for a warm black (such as ivory black), plus a cooler one (such as lamp black). Lamp black tends to be more opaque than ivory black.

Neutral tint
This varies between manufacturers. This version is semi-opaque and very dark with a bluish-purple undertone.

Payne's gray
Originally made from slate, Payne's gray is now mixed from several pigments. This version is distinctly blue.

Davy's grey
Like Payne's gray, this was based on a pigment made from slate. Now it is mixed from several pigments. It is opaque with a smoky greenish cast.

Lamp black
This is a dense, sooty black with high tinting strength and covering power. It is ideal for areas of solid black, but can be diluted to create washes.

Mixing blacks

There is a limited range of ready-mixed blacks available in watercolour. One should be enough for most purposes since it can be modified by mixing with other colours.

Two-colour mixes

blue-black	cadmium lemon

This combination gives an acid green, suitable for spring landscapes – especially the colour of new beech leaves.

ivory black	yellow ochre

Ivory black and yellow ochre, both warm colours, mix to give a soft beige, ideal for skin tones.

neutral tint	cadmium yellow deep

Neutral tint softens and lightens cadmium yellow deep, giving a brownish neutral.

ivory black	permanent sap green

This mix gives some interesting sage and khaki greens – excellent for landscapes.

ivory black	cobalt blue

Black and blue make for some subtle, soft slaty blues, good for stormy skies or shadowy water.

neutral tint	alizarin crimson

This mix creates a warm pinkish terracotta colour, useful for garden scenes and interiors.

Ivory black and its mixes

Black can be used to create an interesting range of tones, but if you use too much you'll find your colours begin to look dead – so always handle it with care.

As you can see from the chart below, ivory black gives some pleasing results in mixes. For example, look at the lovely midnight blue it makes with ultramarine, and at the dark airforce blue you get from the cerulean mix. With cadmium lemon, it gives a sharp, mossy green and with cadmium yellow you get a rich old gold.

The red mixes are interesting, with alizarin crimson producing a deep claret red, cadmium red an intense terracotta, and burnt umber a rich brown. Bear in mind that some versions of ivory black have a more obviously brown cast than the one shown here. As always, remember that the colours vary from one manufacturer to another.

▲ *IVORY BLACK is no longer made from ivory, but is produced by burning animal bones from which the fat and gristle have been removed by boiling.*

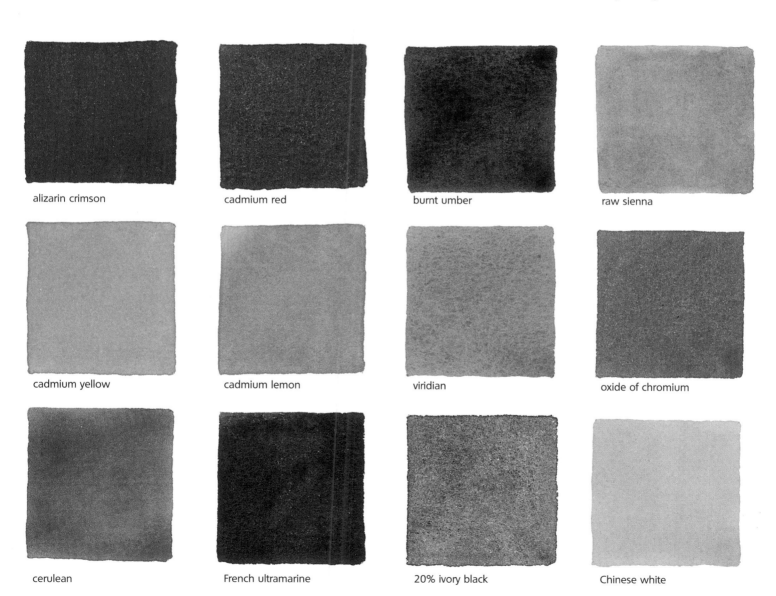

alizarin crimson

cadmium red

burnt umber

raw sienna

cadmium yellow

cadmium lemon

viridian

oxide of chromium

cerulean

French ultramarine

20% ivory black

Chinese white

Chinese white and its mixes

Chinese white is a cold, zinc white with excellent covering power. It is the white commonly used to add 'body' to transparent watercolour.

If you look at the reds mixed with white in the chart below, you will see that the alizarin tint is a cool fuchsia while cadmium red turns salmon-orange. Chinese white mixed with viridian and with oxide of chromium provides an interesting comparison. Viridian retains its transparency to give the colour of the deep sea or coloured glass, but oxide of chromium is rendered more solid and opaque.

Cerulean blue mixed with white produces a cool sea-blue tint, while ultramarine and white give a pretty bluebell blue – the addition of white seems to emphasize the difference between the two.

The earth colours burnt umber and raw sienna demonstrate surprising delicacy and transparency with white – producing tints that are excellent for a range of flesh tones.

▲ *CHINESE WHITE has long been the white of choice for watercolourists, but titanium white, which surpasses zinc white in whiteness and covering power, is increasingly popular.*

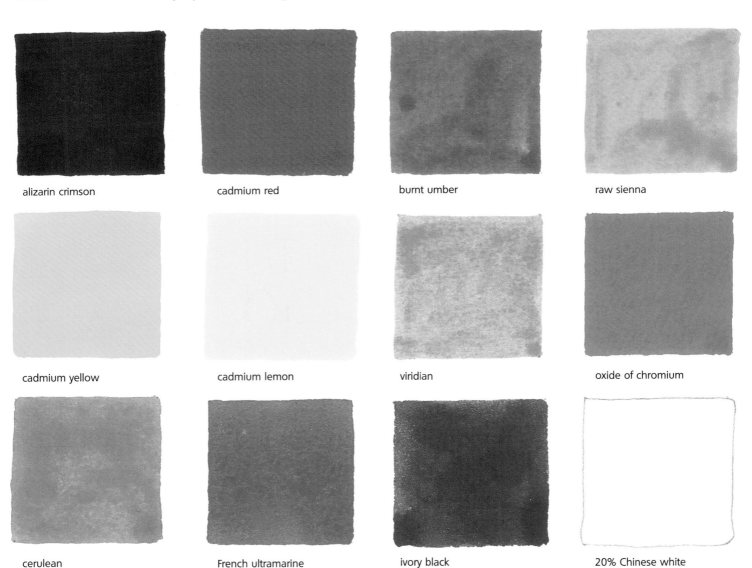

alizarin crimson	cadmium red	burnt umber	raw sienna
cadmium yellow	cadmium lemon	viridian	oxide of chromium
cerulean	French ultramarine	ivory black	20% Chinese white

CHAPTER 3

PROJECTS

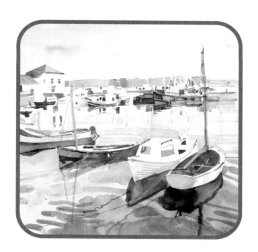
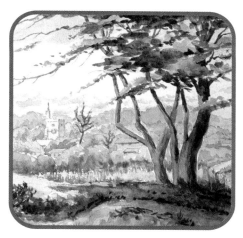
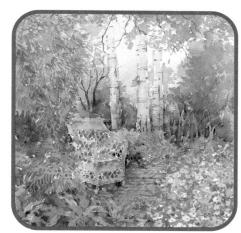
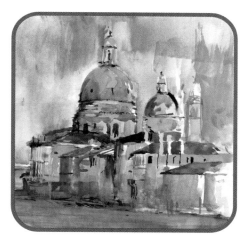

The landscape in all its manifestations is a popular choice for many watercolour painters. While it is important to be able to render all the components of the picture, the play of light across the scene and the moods created by different weather conditions are the real substance of most landscape paintings. Every artist has a different approach to achieving the desired effects, and in this chapter you are invited to learn from them as they tackle a range of different subjects.

The first step in painting a watercolour is often an on-the-spot pencil sketch, which it is useful to annotate with notes on light source, colours and weather conditions. It is also a good idea to take some photographs for reference, or make a watercolour sketch. In order to smooth the path a little, some of the projects in this chapter have a template of the picture for you to trace and use as an underdrawing if you wish. Draw lightly so that the pencil lines do not dominate the final painting. You can enlarge it on a photocopier to the size you want.

Autumn fields

The later part of the year is a wonderful time to paint landscapes – it gives you the perfect opportunity to mix some glorious warm tones that bring out the golden glow of a sunny afternoon.

The secret of coping with an expansive landscape is to simplify it into two main areas – sky and land. Start with the sky, applying a blue-green wash over a red underpainting (see Step 2). In the finished picture, the red is visible as a rosy glow on the horizon. For the clouds, the artist lifted out colour from the wet sky with tissue.

For the fields, begin with washes of bright yellow. Trees, hedges and other details can be added later, leaving patches of the yellow peeping through to represent sunshine falling on the distant hills. These splashes of bright colour focus attention on the distance, creating a sense of space in the composition.

Tip

A paint shaper is a pen-like tool used for spreading thick paint, such as oil or acrylic. It is also good for applying and spreading masking fluid on watercolour paper (see Step 1). Shapers have flexible tips and come in a range of sizes. They are useful for covering large areas and for masking out details.

The set-up

This rolling patchwork of golden fields was painted in the late afternoon. A chalk cliff and a winding river show up clearly in the bright sunshine, and are important features in the painted landscape.

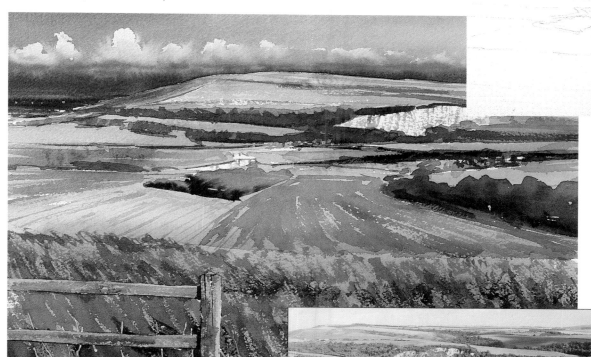

▲ **PENCIL SKETCH**
Use a B pencil to make an outline drawing of the subject, focusing on the contours of the main features – the hills and field and the winding river.

▲ **FINISHED PICTURE**
Many techniques contribute to the overall complexity and textural interest in the finished painting. Wet-in-wet sky details contrast with the wet-on-dry foreground furrows. Masking fluid kept the gate pristine until a late stage in the painting.

◄ **REFERENCE PHOTOGRAPH**
Photographs help to fix the main features of a landscape painting and they can also be a useful reference for colours and weather conditions. But they should not be copied slavishly.

What you need

- A 38 x 50cm (15 x 21in) sheet of stretched NOT watercolour paper – Whatman 425gsm (200lb) has a strong, soft surface
- Staples and staple gun
- Masking tape
- Drawing board
- B pencil
- Masking fluid
- Paint shaper for applying masking fluid
- Nine paints: Winsor red, Winsor blue, Winsor green, ultramarine, cadmium lemon, burnt sienna, Naples yellow, Venetian red, indigo
- Three brushes: No.8 and No.4 round brushes; a 50mm (2in) soft flat
- Two jars of water
- Palettes
- Tissues

▲**1** Staple the paper to the board and define the picture area with masking tape to ensure a clean, crisp edge to the finished painting. Make an outline drawing of the subject using the well-sharpened B pencil. Paint the foreground gate with masking fluid, using a paint shaper to spread the fluid smoothly and quickly (inset). Add a few streaks of masking fluid with the tip of the shaper to indicate blades of grass in the foreground.

▲**2** Wet the sky area with clean water, using the 50mm (2in) soft flat brush. Apply a wash of Winsor red to the lower half of the wet sky with the No.8 round brush, then strengthen the red along the horizon. Allow the painting to dry.

Expert opinion

Q How can I achieve clean, white shapes when lifting out wet colour from the paper?

A Start lifting wet colour as soon as possible after application – before the pigment has had time to sink into the paper, and certainly before the paint starts to dry. In this painting, the artist used a clean tissue to lift each white shape for the clouds. Avoid using dirty tissues as this can spread smudges of colour.

▲**3** Wet the top of the paper and paint a broad band of a Winsor blue/Winsor green mix across the top of the sky. Wet the lower half of the sky, taking the water precisely to the horizon line. Drop the blue/green mix on to the wet paper, letting it find its own way along the wet horizon.

blue sky c

Winsor blue

Winsor gre

▶ **4** While the sky is still wet, darken the area just above the horizon with ultramarine. The red underpainting should show through as a rosy glow. Dab the wet sky with a crumpled tissue, lifting the colour to reveal white clouds. Change to the No.4 brush and soften the lower edge of the clouds with clean water (inset). Drop dilute mixes of Naples yellow, Winsor red and ultramarine into the wet areas. Leave to dry.

▶ **5** Block in the foreground with diluted burnt sienna and a touch of Winsor blue, using the No.8 brush. Paint the sunlit fields in cadmium lemon and burnt sienna. Add a touch of ultramarine to the mixture and paint the distant water and background hill, taking the colour up to and along the horizon line.

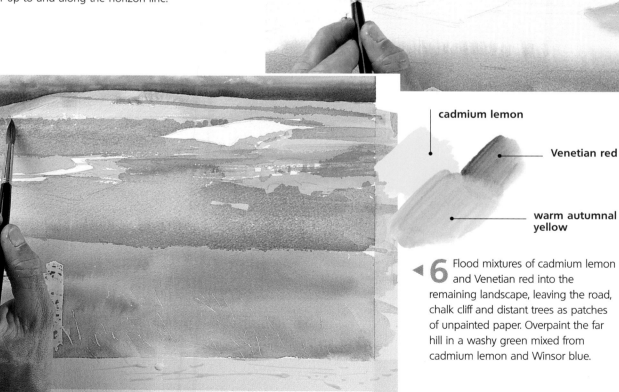

cadmium lemon

Venetian red

warm autumnal yellow

◀ **6** Flood mixtures of cadmium lemon and Venetian red into the remaining landscape, leaving the road, chalk cliff and distant trees as patches of unpainted paper. Overpaint the far hill in a washy green mixed from cadmium lemon and Winsor blue.

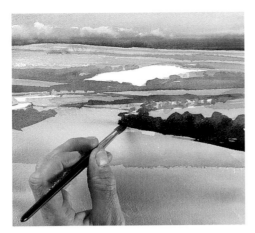

▲**7** Paint the distant shadows in washes of cadmium lemon, Venetian red and indigo. Bring these forward to define the white cliff. Use a strong mix of indigo/Venetian red/cadmium lemon for the central hedges. Paint the ploughed field in Venetian red/Winsor blue. Let the yellowy underpainting show through.

▲**8** Lightly paint the cliff texture in dry strokes of indigo/burnt sienna. Put in reflections on the river in indigo. Rub off the masking fluid in the foreground and paint the grass in bold, diagonal strokes of burnt sienna. Overpaint this in a very dark mixture of burnt sienna/indigo, using short, textural strokes.

▲**9** Remove the masking fluid on the gate, lifting one end of the rubbery mask and carefully pulling upwards. Paint the gate in a pale wash of cadmium lemon/indigo/burnt sienna. Paint the wood grain in burnt sienna/indigo with the tip of the No.4 brush (inset).

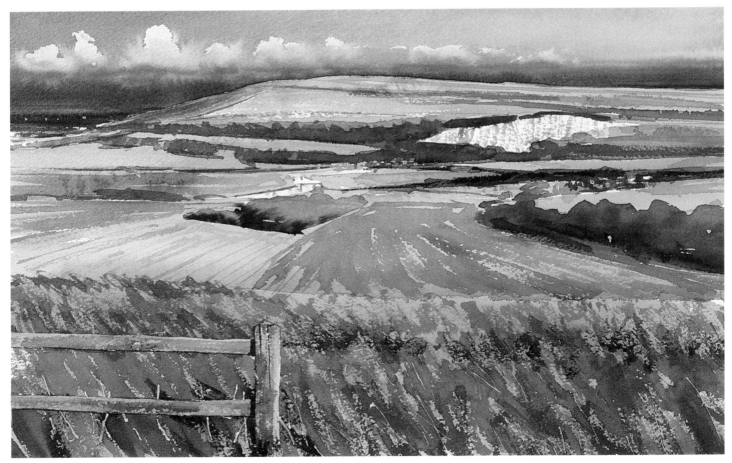

▲**10** Stand back and review the painting, comparing it with the reference photograph. It is important to ensure the illusion of recession from foreground to background is successfully achieved. To bring the foreground forward, add more texture on the wooden gate using the burnt sienna/indigo mix, and apply touches of unmixed burnt sienna to the foreground vegetation.

FINISHED PICTURE
Various compositional devices draw the viewer into and around the painting. The converging furrows of the ploughed field and the diagonal of the hedge provide a route from the foreground into the distance, while the gleaming white crescent of the chalk pit is an important focal point, echoed in the river and clouds.

Bury Hill in autumn by *Joe Francis Dowden*

Old mill and stream

This peaceful scene with verdant trees, a gently flowing stream and a distant building provides the opportunity to develop the technique of painting reflections in water.

The first thing to remember here is a rule of perspective: parallel lines converge on the horizon – or your river will appear to flow uphill. Notice how the river narrows sharply as it flows into the distance, and how the ripples become smaller and denser as they recede. Don't include every ripple and reflection. The more simply you paint water, the wetter it looks. The artist used a large brush to make broad washes, letting his colours spread softly on the damp paper and merge wet in wet. Right at the end, he put in a few dark ripples and shadows. The contrast between light and dark tones gives the effect of brilliant light reflecting from the water's surface.

Tip

When you're painting skies and water, it's a good idea to prepare your washes in advance, each in a separate well of the palette. This way you can paint quickly and confidently, without having to stop in mid-flow to mix a colour.

The set-up

The white clapboard walls of this old restored mill, lit by a shaft of sunlight, make a strong focal point that is attractively framed by the surrounding trees.

◀ WATERCOLOUR SKETCH
This will familiarize you with the subject so that you aren't approaching it 'cold'. It will also help you plan the tonal key of the picture.

◀ PENCIL SKETCH
Use a soft pencil with a blunt point to make your initial sketches of the scene; this glides easily over the paper and will give you a full range of tones from silver-grey to black.

▶ TRACE TEMPLATE

<table>
<tr><td colspan="2">

What you need

</td></tr>
<tr><td>

- A 56 x 38cm (22 x 15in) sheet of 640gsm (300lb) Saunders Waterford Rough watercolour paper
- Drawing board
- HB pencil
- 10 watercolour paints: French ultramarine, raw sienna, burnt sienna, burnt umber, alizarin

</td><td>

crimson, light red, cadmium yellow, Winsor red, Winsor blue (red shade), Payne's gray
- Four brushes: No.16 and No.8 round brushes; a No.3 rigger; and a 50mm (2in) flat
- Two jars of water
- Palette
- Tissues

</td></tr>
</table>

1 Draw the mill in simple lines, using the well-sharpened HB pencil. Indicate the surrounding trees and the stream, but avoid putting in too much detail.

2 In separate wells of the palette, prepare washes of raw sienna and French ultramarine with a touch of alizarin crimson, and a dark blue mixed from French ultramarine/burnt umber. Dampen the lightest part of the sky and touch in some raw sienna with the edge of the flat brush.

French ultramarine and alizarin crimson

raw sienna

French ultramarine and burnt umber

3 While the underwash is still damp, start the clouds with the ultramarine/alizarin mix. Apply the paint with random strokes of the No.16 round brush and let it bleed wet in wet to create soft shapes. Use a tissue to lighten some of the clouds and to blot unwanted runs (inset).

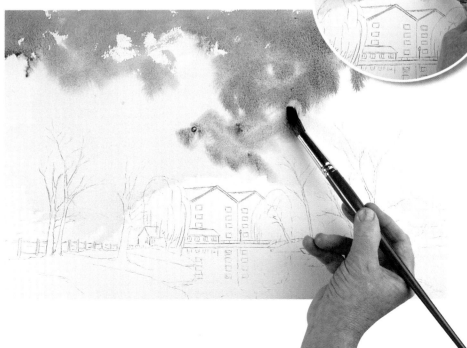

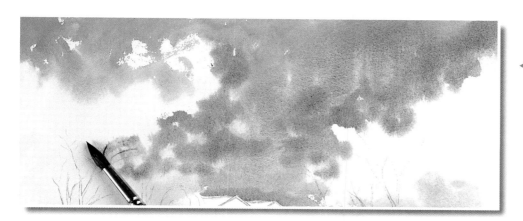

◄**4** Add a little burnt umber to the mix and put in the darker cumulus clouds. To give the effect of moving, broken cloud, hold the brush horizontal to the paper and roll it between your fingers while moving it from left to right.

Tip

To tackle reflections, a good rule of thumb is simply to dilute the mixes you used for the features themselves – a slightly diluted foliage mix for reflections of trees, for example. Where the reflections are in shadow, use slightly darker, stronger mixes.

▶**5** Mix a dilute, greyish green from ultramarine and raw sienna and put in the line of trees in the far distance. Warm the mix with more raw sienna for the nearer row of distant trees. Then mix cadmium yellow, raw sienna and a little ultramarine for the farthest of the grassy banks.

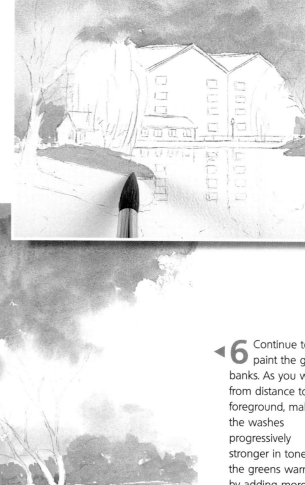

◄**6** Continue to paint the grassy banks. As you work from distance to foreground, make the washes progressively stronger in tone and the greens warmer by adding more cadmium yellow to the mix. Leave to dry.

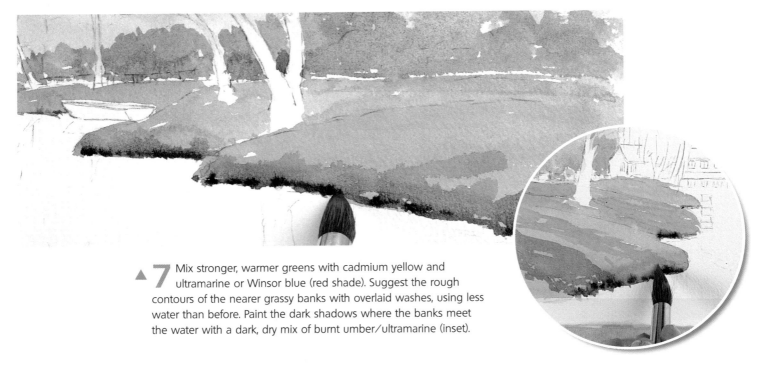

▲ 7 Mix stronger, warmer greens with cadmium yellow and ultramarine or Winsor blue (red shade). Suggest the rough contours of the nearer grassy banks with overlaid washes, using less water than before. Paint the dark shadows where the banks meet the water with a dark, dry mix of burnt umber/ultramarine (inset).

▲ 8 Paint the reflections of the sky on the water's surface using the same colours mixed for the sky (raw sienna applied to damp paper, overlaid with ultramarine and a hint of burnt umber). This time apply the colours with smooth, flat strokes, making them smaller and narrower in the distance.

light red

burnt umber

raw sienna

red roof colour

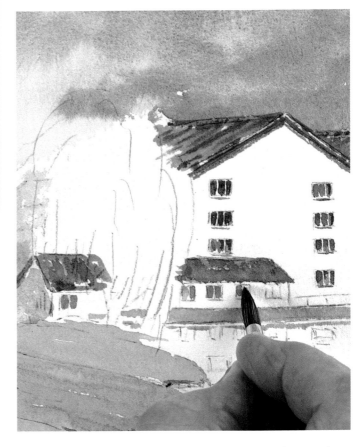

▲ 9 Use the No.8 brush with light red/raw sienna/burnt umber for the red roofs and the wooden walkway. Add more burnt umber/ultramarine for the darker parts. Paint the shadows of the eaves and the windows with ultramarine/burnt umber.

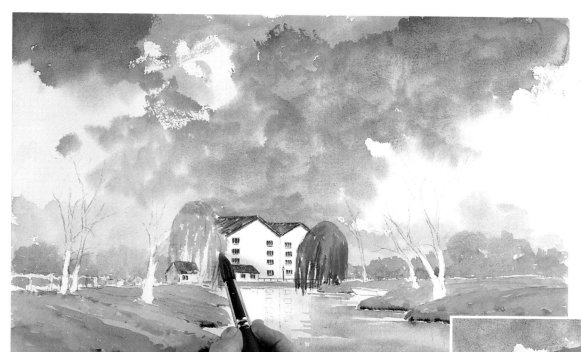

◀**10** Mix cadmium yellow with a hint of Winsor blue (red shade) and paint the two willow trees with downward-sweeping dry-brush strokes. Add Payne's gray to the mix and put in the darker foliage.

Winsor blue (red shade)

cadmium yellow

ultramarine

foliage colour

▶**11** Paint the reflection of the willow tree on the right and break it up with ripples of dark blue. Then use mixes of cadmium yellow, Winsor blue (red shade) and ultramarine for the foliage of the foreground trees. Push the brush upwards to create broken strokes that suggest clumps of foliage moving in the breeze.

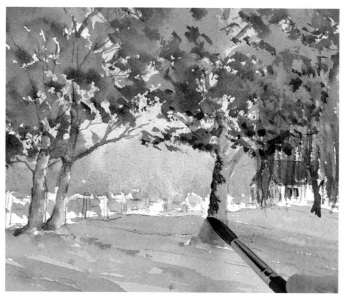

◀**12** Paint the foliage of the trees on the left in a little more detail to show that they are nearer than the other trees. Use raw sienna for the trunks, overlaid with ultramarine and burnt umber on the shadow side. Paint the shadows down into the grass to 'anchor' the trees to the ground.

Expert opinion

Q I always seem to overwork my paintings. How can I overcome this problem?

A Try using bigger brushes. Small brushes tend to encourage small, fiddly brushwork and also they don't hold much paint. One large watercolour brush (anything from a No.12 upwards) is more useful than three small ones. A good-quality brush – a pure sable or a sable/synthetic mix – holds plenty of paint for covering large areas and also comes to a point fine enough for the smallest details.

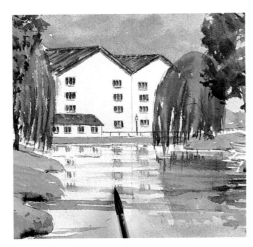

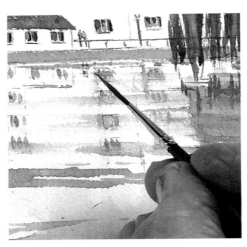

▲**13** Use the rigger for the small branches and the tree trunk shadows. Paint the boat shadows and the red trim. Use the No.8 brush for the tree reflections with diluted tree colours. Use ultramarine/burnt umber for the window reflections and a few ripples.

▲**14** Paint the wooden fence on the left with raw sienna/burnt sienna/burnt umber. Use the rigger for the weather-boarding under the mill roof. Jot in a couple of figures sitting on the railings, and their reflections in the water below.

▲**15** Mix a near-black from burnt umber/ultramarine and use the rigger brush to put in a few reedmace plants on the riverbanks. Use the tip of the brush for the stalks, then press lightly with the side for the seedheads.

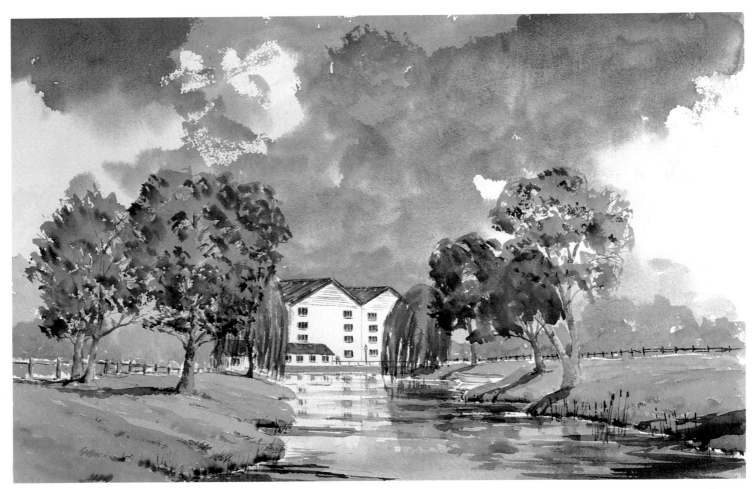

▲**16** Using the dark blue mix, add the shadows cast by the trees and suggest a few clumps of grass in the foreground. Add some dark reflections to the foreground water. This brings the foreground forward and stops the eye from dropping out of the bottom of the picture.

FINISHED PICTURE
This simple but effective study uses a traditional division of the picture, with the sky occupying two-thirds of the area. The low horizon ensures that the trees and the mill are dramatically silhouetted against the blustery sky.

The old mill
by *Frank Halliday*

Harbour view

This bird's-eye view of a quiet harbour emphasizes both the haziness of the morning light and the sharp silhouettes of a church and a ruined abbey on the clifftop in the distance.

The artist wanted to convey the misty quality of the sunlight in this scene, yet at the same time to capture the silhouette effect of the buildings. He decided to work in loose washes, building up the colour in transparent layers. In this way, he kept his picture in a fluid state until the very last stages. He then used a rigger and a small round brush to define some of the buildings and the bridge.

It is important not to overdo the finishing touches in a scene such as this. A few dots and lines using the tip of the brush are enough to suggest architectural details and to show the bridge. These sharp definitions bring selected parts of the painting into focus, leaving the surrounding areas – sky, sea and cliff – as spontaneous washes of colour.

Tilt the drawing board at a slight angle to allow diluted washes to run and form bands of darker colour along the lower edge of the brushstrokes. The tonal variations create natural-looking rock strata on the cliff face and lend depth to the shadows on the grass.

Tip

Avoid using a board with a laminated surface. Washes and very wet colour can cause the surface to buckle and disintegrate, resulting in a very lumpy support for the paper.

The set-up

To capture the quality of the morning light, the artist took a series of photographs of the harbour. However, he didn't want the photos to determine the shape and proportion of the painting, so he mounted his chosen view on a card and extended the scene in paint, thus giving himself a wider vista from which to select his composition.

▲ WATERCOLOUR SKETCH
There was no preliminary pencil sketch for this painting. Instead, the artist made this rapid sketch to establish broad blocks of colour in the composition.

What you need

- A 20 x 28cm (8 x 11in) sheet of acid-free board
- 13 paints: cadmium yellow, permanent rose, cerulean, ultramarine, cobalt green, burnt sienna, cadmium red, Winsor violet, lemon yellow, viridian, raw umber, alizarin crimson, yellow ochre
- Three brushes: No.4 and No.14 rounds; a rigger
- Two jars of water
- Mixing palettes

▶ **1** Loosely wash in the lower sky area with the No.14 round brush and some diluted cadmium yellow. While the paint is still wet, drop a little permanent rose into the yellow wash.

◀ **2** Working in broad, sweeping strokes, paint the rest of the sky in a dilute mix of cerulean and ultramarine.

▶ **3** Define the horizontal waves on the left side of the cliff with a mix of cerulean and cobalt green. Block in the top part of the cliff with diluted burnt sienna, allowing the colour to run slightly down the tilted paper to suggest the rock strata.

Tip

Acid-free board makes an excellent support for watercolours. A cream-coloured surface rather than pure white gives an attractive overall warmth to the finished painting.

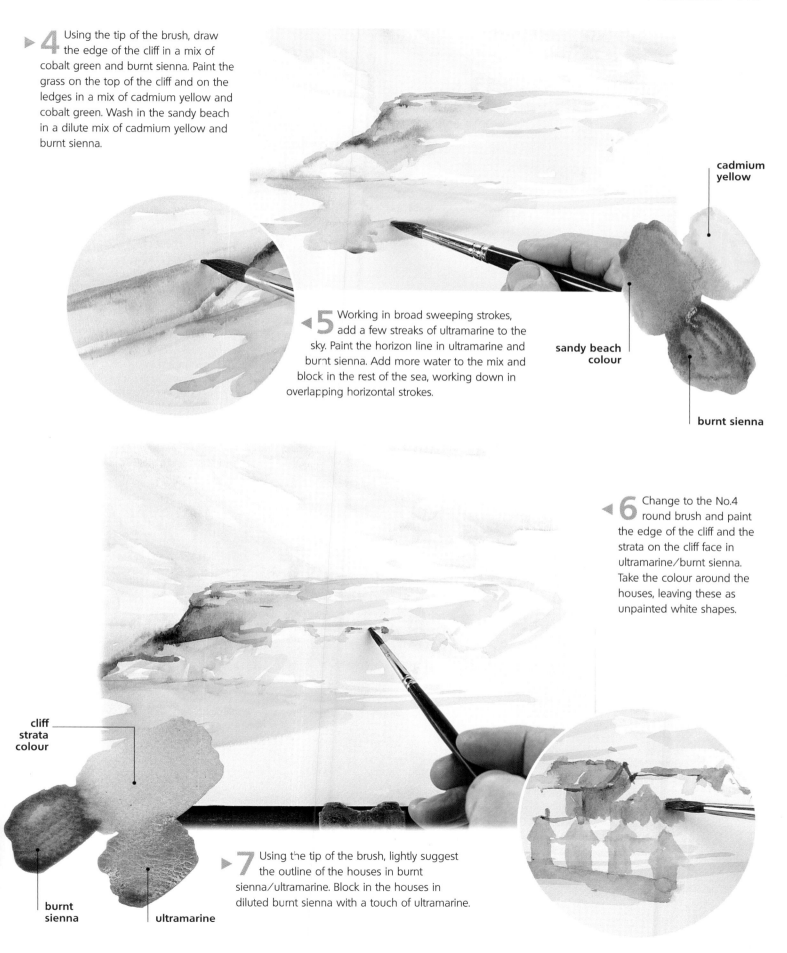

▶ **4** Using the tip of the brush, draw the edge of the cliff in a mix of cobalt green and burnt sienna. Paint the grass on the top of the cliff and on the ledges in a mix of cadmium yellow and cobalt green. Wash in the sandy beach in a dilute mix of cadmium yellow and burnt sienna.

cadmium yellow

◀ **5** Working in broad sweeping strokes, add a few streaks of ultramarine to the sky. Paint the horizon line in ultramarine and burnt sienna. Add more water to the mix and block in the rest of the sea, working down in overlapping horizontal strokes.

sandy beach colour

burnt sienna

◀ **6** Change to the No.4 round brush and paint the edge of the cliff and the strata on the cliff face in ultramarine/burnt sienna. Take the colour around the houses, leaving these as unpainted white shapes.

cliff strata colour

▶ **7** Using the tip of the brush, lightly suggest the outline of the houses in burnt sienna/ultramarine. Block in the houses in diluted burnt sienna with a touch of ultramarine.

burnt sienna

ultramarine

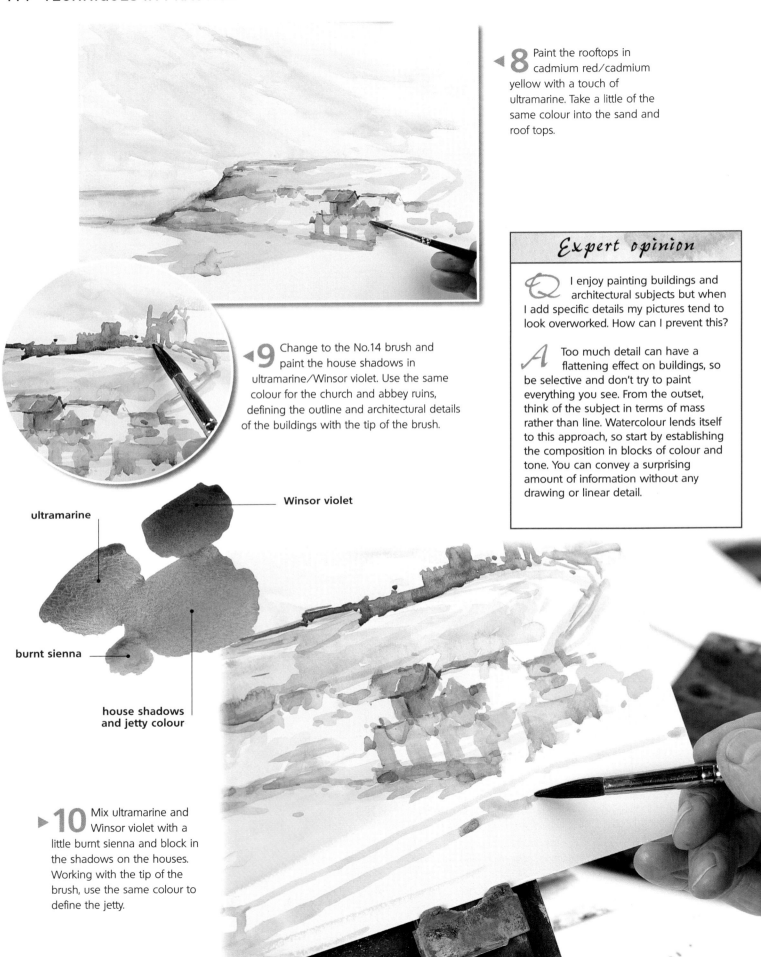

◄ **8** Paint the rooftops in cadmium red/cadmium yellow with a touch of ultramarine. Take a little of the same colour into the sand and roof tops.

◄ **9** Change to the No.14 brush and paint the house shadows in ultramarine/Winsor violet. Use the same colour for the church and abbey ruins, defining the outline and architectural details of the buildings with the tip of the brush.

Winsor violet

ultramarine

burnt sienna

house shadows and jetty colour

▶ **10** Mix ultramarine and Winsor violet with a little burnt sienna and block in the shadows on the houses. Working with the tip of the brush, use the same colour to define the jetty.

Expert opinion

Q I enjoy painting buildings and architectural subjects but when I add specific details my pictures tend to look overworked. How can I prevent this?

A Too much detail can have a flattening effect on buildings, so be selective and don't try to paint everything you see. From the outset, think of the subject in terms of mass rather than line. Watercolour lends itself to this approach, so start by establishing the composition in blocks of colour and tone. You can convey a surprising amount of information without any drawing or linear detail.

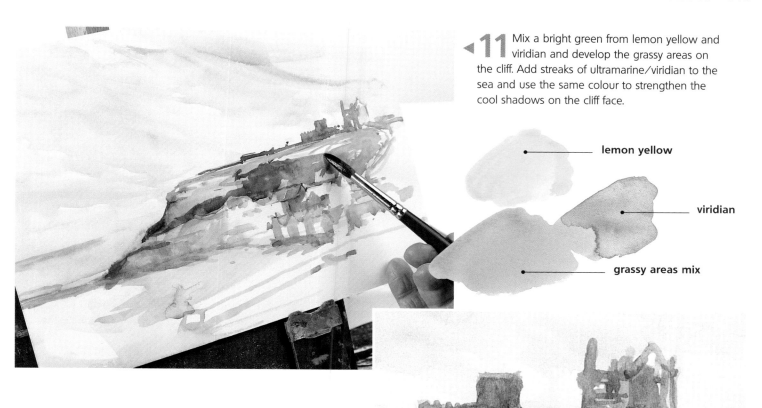

11 Mix a bright green from lemon yellow and viridian and develop the grassy areas on the cliff. Add streaks of ultramarine/viridian to the sea and use the same colour to strengthen the cool shadows on the cliff face.

lemon yellow

viridian

grassy areas mix

12 Change to the No.4 brush and add a little local colour to the church and the ruined abbey in varying tones of raw umber.

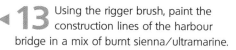

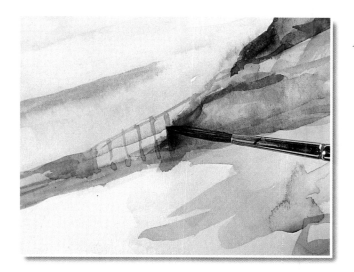

13 Using the rigger brush, paint the construction lines of the harbour bridge in a mix of burnt sienna/ultramarine.

14 Following the curved line of the tide mark on the beach, add streaks of diluted permanent rose to the sand to echo the warm tones of the sky.

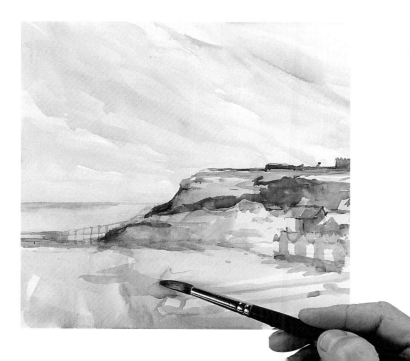

▲**15** Define the jetty by painting the shadows and waterline in raw umber with a touch of viridian. Use the tip of the No.4 brush to touch in details such as the bollards on the jetty.

▲**16** Assess the painting and develop any colours and tones which may need strengthening or defining in relation to the rest of the picture. Here, the local colour of the cliffs is being strengthened in raw umber/raw sienna.

▲**17** Finally, bring the painting into focus by adding a few details and darker tones. Dot in the doors and windows of the abbey ruins with viridian/alizarin. Complete the shadows on the jetty in raw umber and yellow ochre.

FINISHED PICTURE
Contrasting with the developed detail on the buildings and harbour, the sky, sea and sand are left as broad brushstrokes of diluted colour which extend outwards to the edges of the composition.

Whitby Harbour
by David Carr

Country garden

This lovingly cultivated retreat provides an interesting subject with its abundance of foliage and different tree shapes. A variety of textures and colours, as well as the subtle light effects, present an intriguing challenge.

A garden is a favourite source of inspiration for many painters. In this case, the artist was drawn to the pattern of repeated shapes.

Explore the subject first with a quick pencil study, then begin the painting without an underdrawing. Instead use muted washes wet in wet to plot the basic shapes and suggest areas of light and shade. Change to gouache, using loose washes, and thicken the mixes for more specific textural details. Describe the foliage textures in broken colour, dabbing on strokes to build up layers of marks for a sense of depth without solidity. Work from dark to light as well as light to dark, moving about the painting, assessing and evaluating, and exploring 'lost and found' edges. The result should be a richly textured fabric of leaf patterns, dappled sunlight and deep shadow.

Tip

Instead of using palette greens, you can mix a harmonious range of tones and shades with a limited palette of four colours: yellow ochre and ultramarine in both watercolour and gouache; lemon yellow and cerulean blue in gouache. Complementary purple and bright pink touches resonate within the mainly green image.

The set-up

In this area of the garden, an abstract pattern of spherical tree forms creates a 'pathway' through the scene.

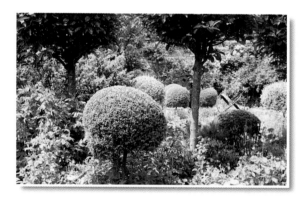

▶ *REFERENCE PHOTOGRAPH*

▲ PENCIL SKETCH
A rapid preliminary pencil study is useful to explore the tonal values of the scene. Sketch in the basic light and dark areas, and plan the main focus of the composition. At the same time, consider a suitable format and crop.

▶ FINISHED PICTURE
The visual surprises produced in this garden by the juxtaposition of tree shapes work well. With gouache you can relax a bit, letting it dry while considering your next move.

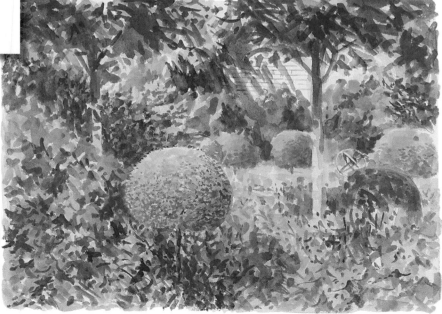

What you need

- A 56 x 41cm (22 x 16in) sheet of 300gsm (140lb) NOT watercolour paper, stretched on to a board
- HB pencil and ruler
- Four brushes: No.1 and No.6 rounds; a 20mm (¾in) flat; and a hake (Japanese pony hair brush)
- Three watercolour paints: yellow ochre, cerulean, ultramarine
- Six gouache paints: Bengal rose, cerulean, yellow ochre, ultramarine, lemon yellow, white
- Two jars of water
- Two mixing palettes

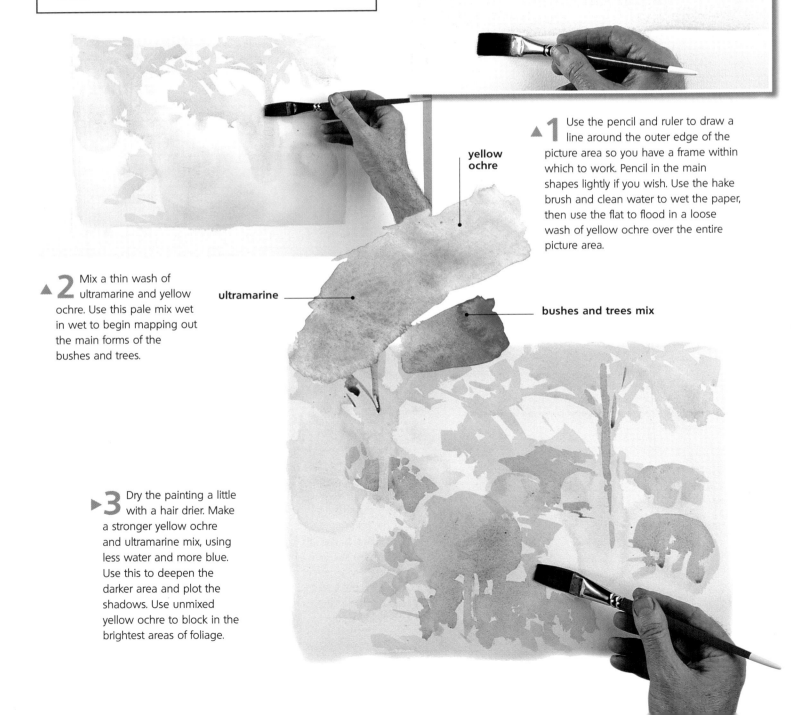

yellow ochre

ultramarine

bushes and trees mix

▲**1** Use the pencil and ruler to draw a line around the outer edge of the picture area so you have a frame within which to work. Pencil in the main shapes lightly if you wish. Use the hake brush and clean water to wet the paper, then use the flat to flood in a loose wash of yellow ochre over the entire picture area.

▲**2** Mix a thin wash of ultramarine and yellow ochre. Use this pale mix wet in wet to begin mapping out the main forms of the bushes and trees.

▶**3** Dry the painting a little with a hair drier. Make a stronger yellow ochre and ultramarine mix, using less water and more blue. Use this to deepen the darker area and plot the shadows. Use unmixed yellow ochre to block in the brightest areas of foliage.

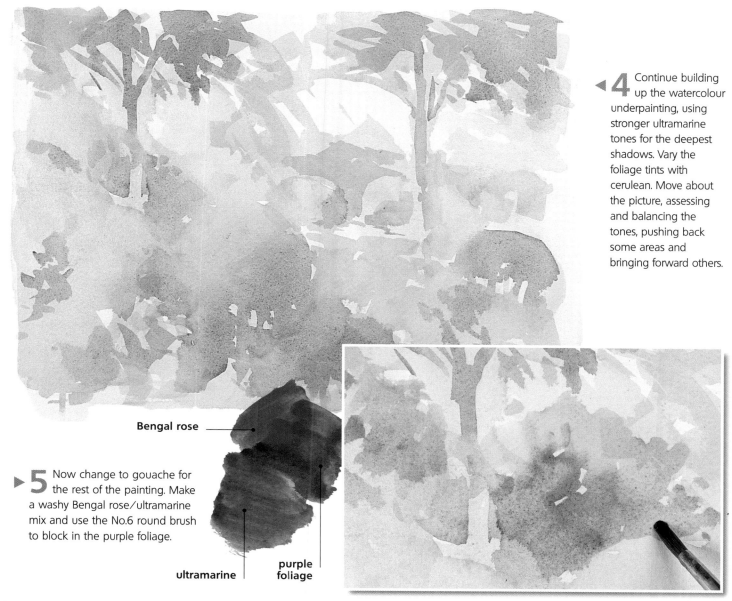

◄**4** Continue building up the watercolour underpainting, using stronger ultramarine tones for the deepest shadows. Vary the foliage tints with cerulean. Move about the picture, assessing and balancing the tones, pushing back some areas and bringing forward others.

Bengal rose

ultramarine | purple foliage

▶**5** Now change to gouache for the rest of the painting. Make a washy Bengal rose/ultramarine mix and use the No.6 round brush to block in the purple foliage.

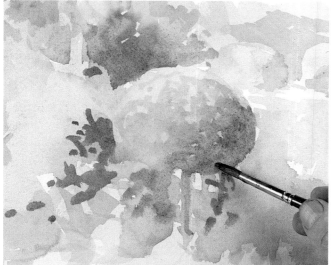

◄**6** Still using the gouache quite thinly, mix yellow ochre and ultramarine to work up the shadows and begin to hint at forms and foliage. Add more ultramarine to the mix to deepen the shadows and textures. Use lemon yellow for the brightest foliage on the clipped tree in the centre.

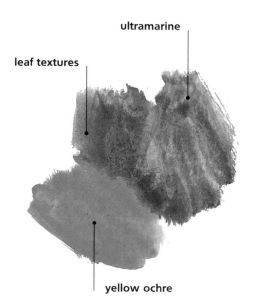

ultramarine

leaf textures

yellow ochre

▶ **7** Build up tones and textures across the painting in thin washes. Use the darker yellow ochre and ultramarine mix to add depth and form to the trees and shrubs. Introduce balancing touches of lemon yellow in the middle distance and on the tree canopy. Echo the purple foliage with touches of the Bengal rose/ultramarine mix in the foreground. Introduce textural dabbing marks in the foreground.

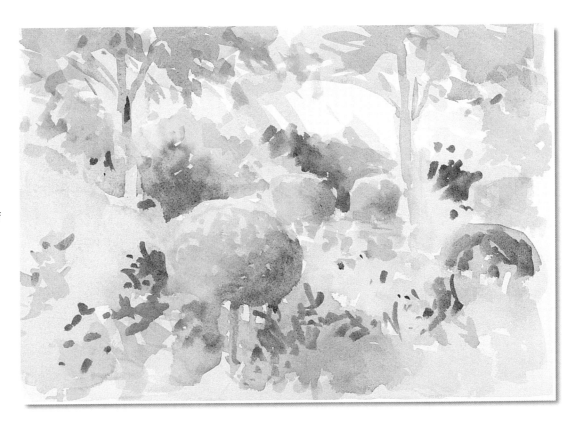

◀ **8** Start to thicken your washes. Use darker yellow ochre and ultramarine mixes to deepen the shadow textures. Continue using dabbing brushmarks to express foliage surfaces. Move around the image without dwelling too long on any single area, and stand back from time to time to assess the tonal balance.

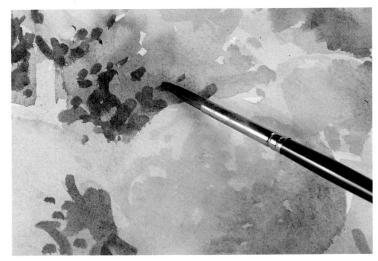

Tip

Palettes that keep gouache paint moist and workable are available. The plastic tray contains 'reservoir' paper that you dampen before squeezing your colours on to it. The moisture prevents the paint from drying out so you can continue to use it and none is wasted.

▶ **9** Let the painting dry a little so you can make crisper brushmarks. Strengthen the tree canopy with the darker ultramarine mix. Use the same mix to intensify the background bushes. Strengthen the Bengal rose/ultramarine mix and add small textural marks to the purple shrub. Use the same mix to paint the shadows on the back wall.

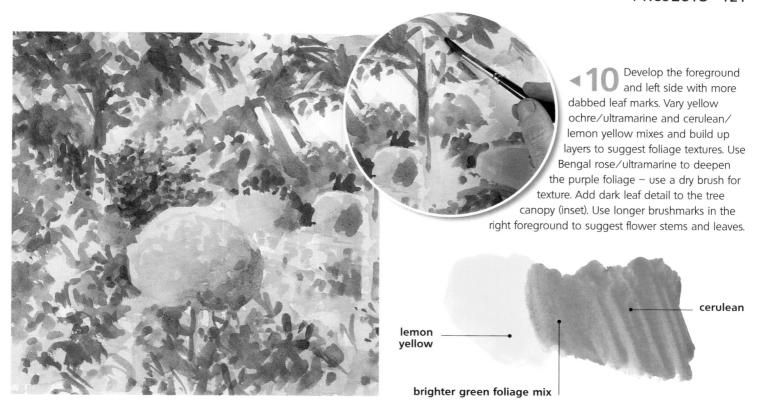

10 Develop the foreground and left side with more dabbed leaf marks. Vary yellow ochre/ultramarine and cerulean/lemon yellow mixes and build up layers to suggest foliage textures. Use Bengal rose/ultramarine to deepen the purple foliage – use a dry brush for texture. Add dark leaf detail to the tree canopy (inset). Use longer brushmarks in the right foreground to suggest flower stems and leaves.

lemon yellow

cerulean

brighter green foliage mix

11 Intensify the leaf textures on the left side of the central tree with more leaf-shaped marks, using ultramarine/yellow ochre mixes. Introduce touches of lemon yellow to suggest sunlit grass through the leaves.

12 Use the No.1 round brush to add more detail to the central round tree, bringing it into focus so it advances into the foreground. Suggest the clipped foliage with small dots of broken colour, using mixes of lemon yellow/yellow ochre. Work up the leaf area beneath the tree with more ultramarine mixes.

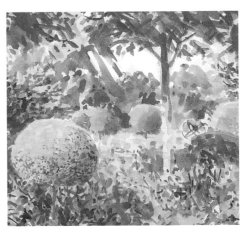

▲**13** Keep the foliage textures open in the right foreground and add small touches of Bengal rose here and there to suggest flowers. Dot echoes of the same colour among the dense foliage in the foreground on the left.

▲**14** Use the No.1 round to 'draw' the sundial in dark ultramarine/yellow ochre. Use the No.6 round to deepen foliage texture. Use ultramarine mixes for the tree canopy and lemon yellow/yellow ochre for the trimmed light green trees.

▲**15** Use light Bengal rose/ultramarine for the brickwork. Soften with clean water and blot with tissue. In the centre and foreground suggest sunlight with lemon yellow. Put in highlights on the sundial with the No.1 round brush and white gouache.

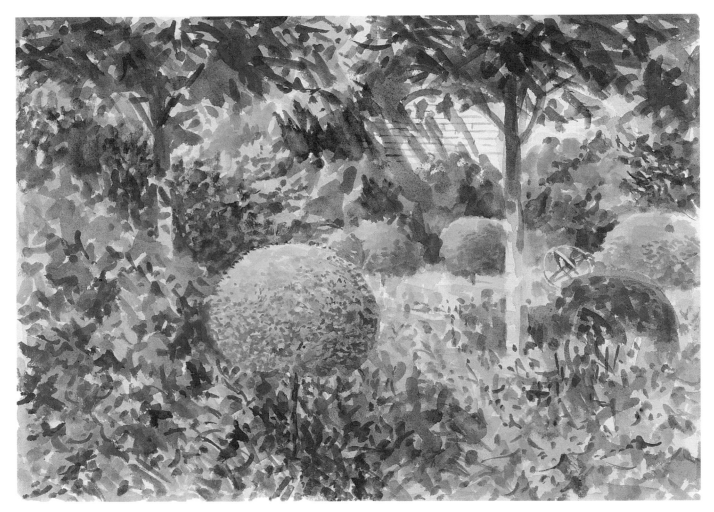

▲**16** Add more leaf detail to the central trimmed tree with lemon yellow/yellow ochre mixes. Use a darker mix to add more generalized texture to the distant round trees.

FINISHED PICTURE
A combination of transparent watercolour and gouache was used to build up the complex shapes and textures, and dappled light and shade in this study. Touches of complementary red and pink enliven the predominant greens.

A Gloucestershire garden
by *Derek Daniells*

Rocky coastline

The sea in all its ever-changing moods makes a compelling subject for a painting. Apart from the test of capturing the restless energy of the waves, it is important to get the composition right.

Views looking straight out to sea can appear flat and monotonous, and it may be better to look along the shoreline. Cliffs give a picture a vertical, rather than a horizontal, emphasis, which helps strengthen the sense of recession as the eye is led along the coast.

In this painting, the artist has given his composition a strong vertical emphasis by using the headland, which juts into the sea dividing the picture roughly in half. This allows him to contrast the two different styles used for the sea and the land. For the sea, he worked loosely, applying washes wet in wet and using a sponge to soften edges. For the cliffs, on the other hand, he worked exclusively with crisp-edged washes, overlaying washes applied wet on dry to build up depth of colour and emphasize the solidity of the rock face.

Tip

Flat brushes are also known as one-stroke brushes, but the name is misleading. You can make a broad flat mark with the side of the brush, and also a narrow vertical mark with the tip. Flats can be exploited for a range of graphic textural effects. Here two flats of different sizes have been used for the cliff faces.

The set-up

This sea view has cliffs and headlands marching away into the distance, set off by waves crashing into the cliff face in a mass of churning white water.

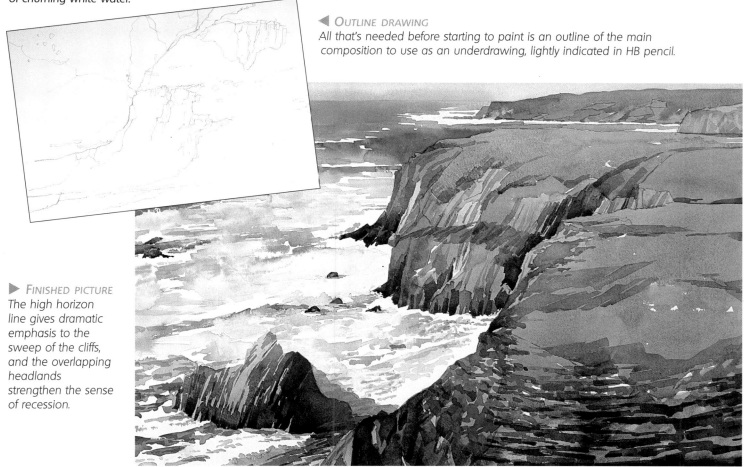

◀ **OUTLINE DRAWING**
All that's needed before starting to paint is an outline of the main composition to use as an underdrawing, lightly indicated in HB pencil.

▶ **FINISHED PICTURE**
The high horizon line gives dramatic emphasis to the sweep of the cliffs, and the overlapping headlands strengthen the sense of recession.

What you need

- A 57 x 38cm (22½ x 15in) sheet of 300gsm (140lb) NOT watercolour paper
- HB pencil and rubber
- Small natural sponge
- 12 watercolours: raw sienna, burnt sienna, purple madder alizarin, cerulean, cobalt blue, French ultramarine, Winsor blue, indigo, sap green, Winsor green, Vandyke brown, ivory black
- Permanent white gouache
- Four brushes: No.2 and No.8 rounds; 13mm (½in) and 20mm (¾in) flats
- Two jars of water
- Deep-welled palette

▶ **1** Mix separate washes of cerulean, indigo and Winsor blue. Using the 20mm (¾in) brush, apply a narrow band of cerulean at the top of the paper for sky. While still wet, sweep in washes of indigo and Winsor blue for the distant sea. Leave strips of white paper for the wave crests.

▶ **2** Mix ivory black and indigo for the sea in the middle distance. Use short strokes for the choppy waves, leaving white paper for highlights and sea spray. Use the sponge to lift out wet paint and soften the washes. Add Winsor green to the earlier mix for the dark water around the foreground rock on the left.

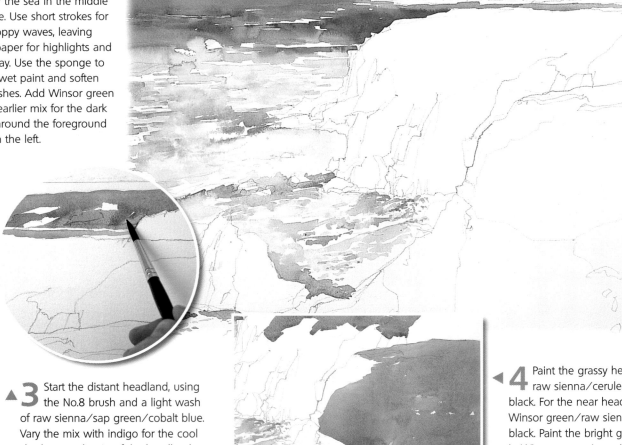

▲ **3** Start the distant headland, using the No.8 brush and a light wash of raw sienna/sap green/cobalt blue. Vary the mix with indigo for the cool shadows at the tip of the headland, and purple madder alizarin/ivory black for the reddish rock face.

◀ **4** Paint the grassy headland in raw sienna/cerulean/ivory black. For the near headland, mix Winsor green/raw sienna/ivory black. Paint the bright grassy patch in Winsor green/raw sienna. Use the 20mm (¾in) brush and Vandyke brown/Winsor green/ivory black for the exposed rock face in the bottom right corner.

5 Paint the edges of the cliff in shades of grey mixed from ivory black/cobalt blue/raw sienna. Use the tip of the 20mm (¾in) brush. Use a pale, neutral version of this wash to paint over the smaller rock on the left (see Step 6).

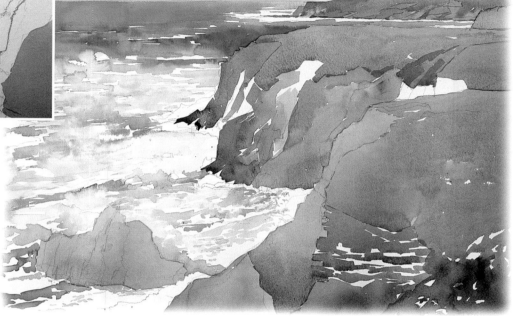

6 Put in the horizontal layers of the foreground cliff face with the 20mm (¾in) brush and Vandyke brown/Winsor green/ivory black. Use Winsor green for the bright grass and a thin wash of burnt sienna for the rock on the left where the sunlight gives it a golden glow.

7 Once the washes on the cliffs and rocks are dry, switch to the 13mm (½in) brush and paint the crags with thin glazes. Use a warm grey mixed from burnt sienna/indigo/ivory black and a cool grey mixed from ivory black/indigo.

8 Model the small rock on the left with the same colours used for the cliff. Feel free to use very dark tones – you want a good contrast to do justice to the sunny day.

Mixing greys

ivory black + indigo = cool grey

burnt sienna + ivory black + indigo = warm grey

It takes very small amounts of different colours to alter a mix. To mix the two greys used for the craggy cliffs, start with indigo – but make one grey cool by adding ivory black, and the other warm by adding ivory black and burnt sienna.

▶ **9** Use the No.2 brush to apply dabs of the grey mixes to the tips of the rocks poking through the water. Mix indigo and French ultramarine for the shadows of the rocks in the water. Leave to dry. Suggest the foam around the rocks with permanent white gouache.

▲ **10** For the earthy red area on the left of the foreground cliff, use burnt sienna/purple madder alizarin/ivory black. Suggest the rugged texture of the rock face by working horizontally with both the No.8 and the 13mm (½in) brushes.

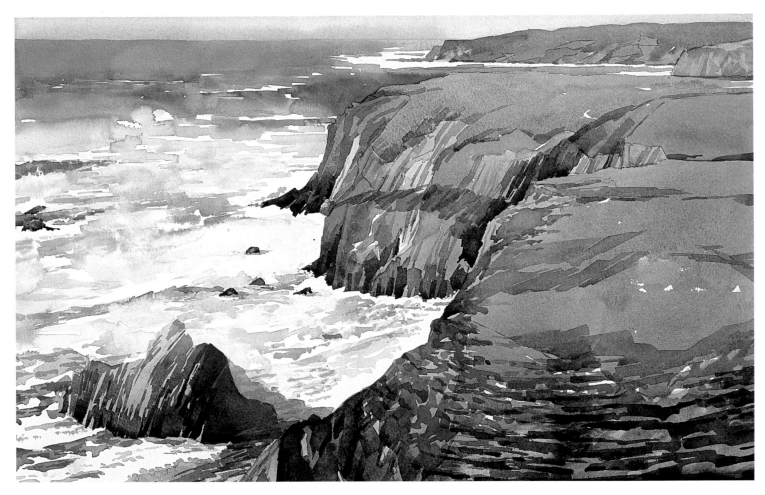

▲ **11** Finish the cliffs by adding the cast shadows on the grass with the 13mm (½in) brush and two mixes – ivory black/indigo and raw sienna/Winsor green/cobalt blue. For the near cliff, use mixes of ivory black/burnt sienna/Winsor green/purple madder alizarin for the grey areas.

FINISHED PICTURE
The drama of the subject matter is matched by the drama of the composition with its high viewpoint, and by the contrast between the calm water and the white foam, and the grassy cliff tops against the rugged cliff face.

A rocky coastline by Adrian Smith

Mountain village

A combination of very wet washes and extremely detailed pen work is necessary to capture the character and charm of a small rural community such as this.

The difficulty in painting landscapes from life is that, as you paint, the light often changes. This can present problems in setting the tonal scale, but there are some practical ways around it – the secret is to be prepared. Spend some time familiarizing yourself with the landscape, taking in the view, before you start. It helps to take some photographs for colour reference and to start with some quick preliminary sketches with written notes on light source, shadows, colour, tones and textures. This preparation covers you in the event of a sudden change in the weather, and allows you to continue your painting later, using your sketches and photos for reference.

Tip

Use a palette knife to scrape out sections of paint. This technique has been used on the drystone wall in this painting (Step 3), and it gives just the right effect for the characteristic stone slabs. Thin vertical strokes with the palette knife suggest tall blades of grass in the foreground (Step 4).

The set-up

This detailed view has a rambling cluster of crooked houses, bright roofs, a bell tower and distant cypresses.

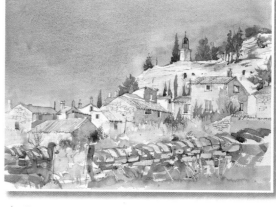
▲ FINISHED PICTURE
Good preparation, careful portrayal of light and shade, and painting quickly with confident strokes resulted in this fresh view of a mountain village.

▲ ANNOTATED PENCIL SKETCH
Several of these help you to recognize the distinctive characteristics of a view.

▶ TRACE TEMPLATE

What you need

- A 50 x 38cm (20 x 15in) sheet of 300gsm (140lb) NOT watercolour paper
- Drawing board
- 2B pencil
- 12 watercolour paints: terre verte, olive green, ultramarine, lemon yellow, cadmium yellow, yellow ochre, orange, alizarin crimson, light red, purple, raw sienna, burnt umber
- Two flat sable or sable/synthetic blend brushes – a 13mm (½in) and a 9.5mm (⅜in)
- Dip pen with a calligraphy nib, size 4
- Palette knife
- Kitchen roll
- Two jars of water
- Large palettes

▲ **1** Make a light outline drawing of the composition with the 2B pencil. Maximize perspective by taking care over the directional positioning of houses and the scale of the landscape as the eye is drawn up towards the distant hilltop.

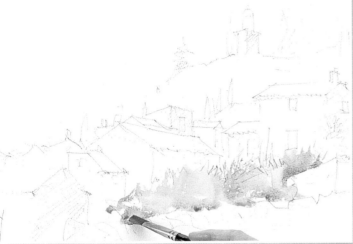

▲ **2** Scrub in the dry grass verge in a bright wet mix of light red, yellow, terre verte and orange. Add ultramarine to the mix to paint the cool shaded foliage on the right. Work quickly wet in wet with the 13mm (½in) brush, allowing the colours to blend.

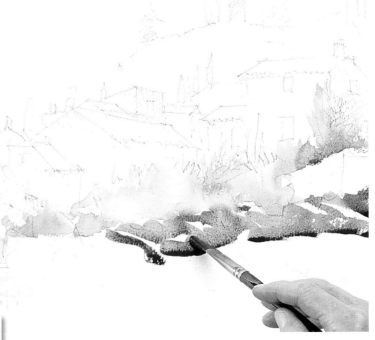

▲ **3** Paint the front wall on the right, adding ultramarine and umber to the previous mix. Work loosely, keeping the paint wet. Use the palette knife to scrape out lighter tones on the stone in curved horizontal and vertical marks that characterize the uneven effect of the wall (inset).

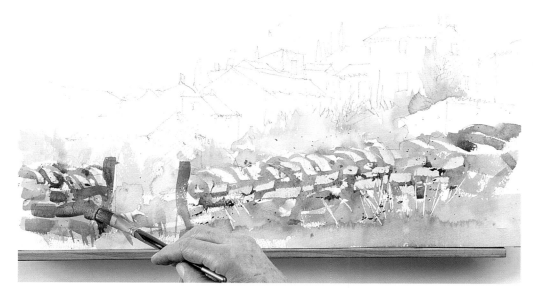

◄4 Continue blocking in the foreground grass in dilute yellows, red and terre verte. Paint the left wall, gateposts and vertical grass blades with burnt umber/ultramarine. Use the flat side of the palette knife to scrape back lights in the wall, turning it on its edge to scrape out fine overlapping lines to suggest thin blades of wispy grass.

►5 Charge the 13mm (½in) flat brush with plenty of water and a strong mix of burnt umber/terre verte/cadmium yellow. Flick the brush, spattering paint over the wall to give intensity of tone and a variety of effects.

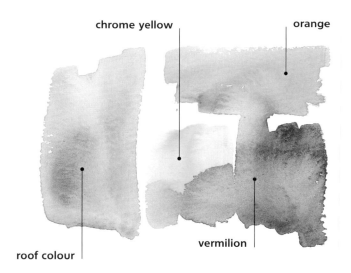

chrome yellow

orange

roof colour

vermilion

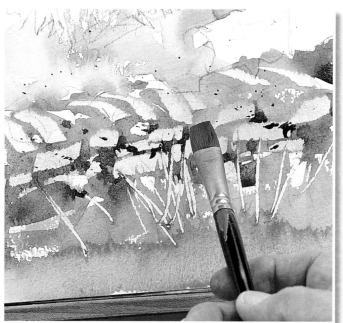

►6 Paint the roofs in orange, using single bold diagonal brushstrokes. Let some of the paper show through to suggest bright sunlight. Vary the tone by diluting the mix and adding vermilion and chrome yellow. Use the edge of the knife to scrape back highlights on the textured terracotta tiles.

▶ **7** Wash in the left side walls of the foreground houses in pale yellow/orange. Paint the sides in shadow in contrasting mixes of orange/ultramarine, adding red and terre verte. Continue over the central foreground grass with the same mix, using vertical brushstrokes for fine blades of grass. Leave some background houses unpainted to enhance the contrast of light and shade.

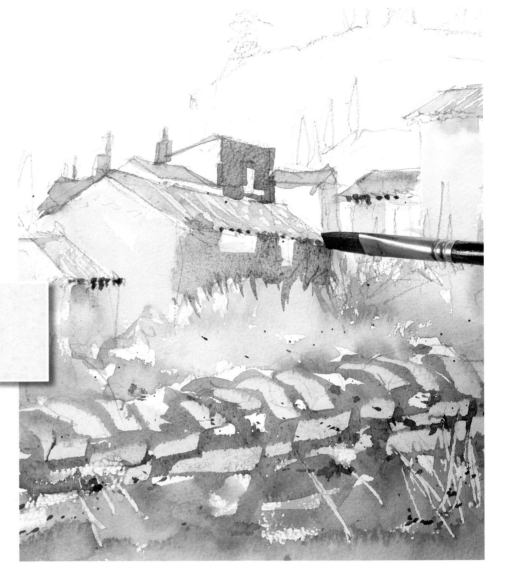

▲ **8** Paint shadows under the roofs in a mix of crimson/ultramarine/burnt umber. Use the edge of the 13mm (½in) brush to apply small dots of paint to emphasize the undulating shape of the roof. Detail the windows and shutters in a wet wash of ultramarine in single flat brushstrokes.

◀ **9** Mix a wash of lemon yellow/ochre for the background hill. Scrub in the wash, keeping it pale to suggest the effect of bright sunlight (inset). Drag out strong colours with kitchen paper in a sweeping movement, working horizontally across the page.

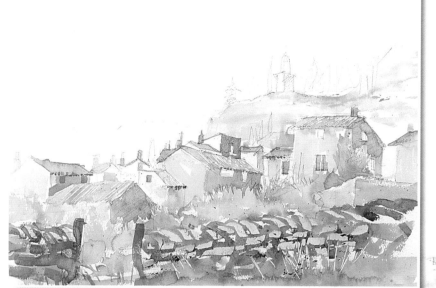

◄10 Step back and take an overview of the painting. The contrast of light and shade, texture and loose painting creates a harmonious dynamic which works throughout the composition, focusing the eye in and around the landscape.

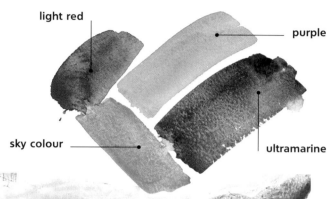

light red

purple

sky colour

ultramarine

►11 Mix ultramarine/purple/light red for the sky. Turn the support upside down and, using very wet paint, wash in the sky with the 9.5mm (⅜in) brush. Keep adding water to maintain a pale tone. Paint around the rooftops. When the whole sky is blocked in, tip the paper and let the paint drip down for a vertical sweeping effect. Wipe off excess with kitchen paper.

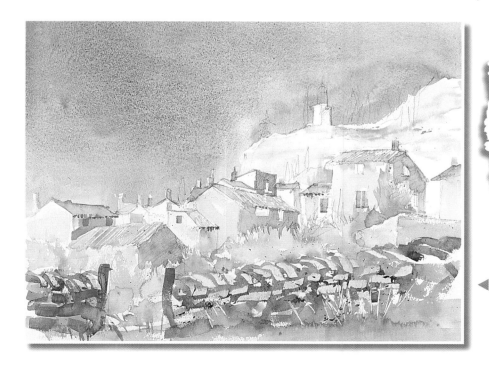

Tip

When a very watery wash is necessary for the sky, turn the paper upside down to avoid the paint dripping down along the horizon. Tilting the paper at an angle allows the excess to run off the edge and it can then be blotted dry with kitchen paper. The result is a soft, even sky sweeping up and emphasizing the gradient of the hill.

◄12 This is a good time to stand back again and assess your work. The colour of the sky will have added a lot to the character of the composition, which now needs some fine details to sharpen the contrasts of tone.

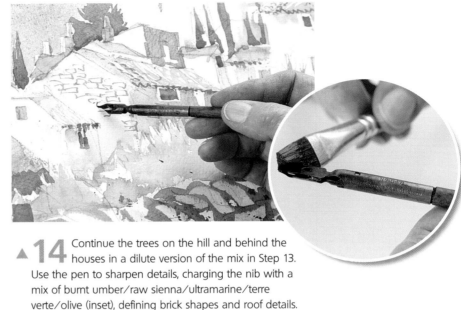

▲**13** Use the sky mix and the 13mm (½in) brush for shadows in the shutters. Paint the pines and cypresses with ultramarine/terre verte/brown. Vary the mix and strokes for the other hillside trees and their shadows.

▲**14** Continue the trees on the hill and behind the houses in a dilute version of the mix in Step 13. Use the pen to sharpen details, charging the nib with a mix of burnt umber/raw sienna/ultramarine/terre verte/olive (inset), defining brick shapes and roof details.

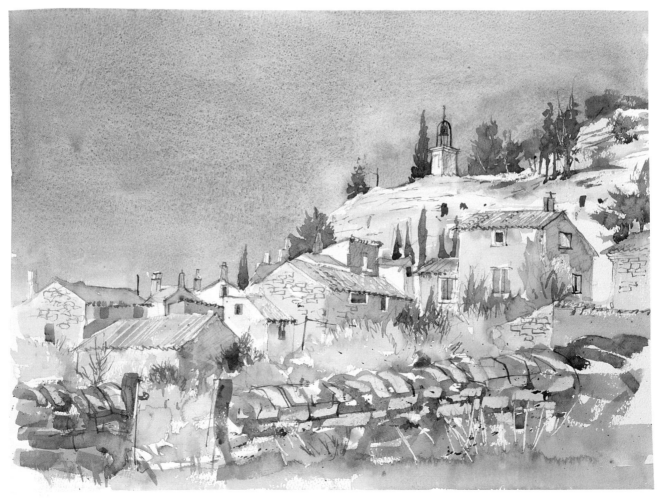

▲**15** Add details and spattered texture to the hill top trees. Use pen and paint to draw rooftop aerials, the church tower and bell, and to add definition to the shadows around the windows.

FINISHED PICTURE
Ancient buildings cascading down a hillside have been rendered with delicate wet-in-wet washes. Foreground textures were added by scraping into wet paint with a painting knife, while the rough-hewn masonry was sketched in with a pen loaded with paint.

**Mountain village
by Kay Ohsten**

Seashore at low tide

The white of the paper shining through layers of transparent watercolour wash gives a luminous quality that is ideal for seascapes. Use a Rough paper and a dry-brush technique to add sparkle to the water.

This project is built up using a series of washes. The secret is to break the subject down into a series of overlapping planes: sky, land and sea. The clouds and the highlights on the water and sand are light in tone so make sure you reserve both those areas. Begin by laying in the sky – this will set the mood for the rest of the painting. The foreground consists of the beach at low tide – water, sand and seaweed are rendered in horizontal bands of wash. The sky and the shore are separated by three rocky headlands. For these you need to emphasize the spatial relationships: pale blue for the most distant headland and a warm violet for the nearest.

▼ PENCIL SKETCH
Use a pencil to make quick sketches on the spot. Here the artist has focused on the areas of light and dark tone. Notice how simply the figures have been introduced.

The set-up

This summer coastal scene was painted at low tide. The sand is glazed with a film of water which acts as a mirror to the sky, giving the entire view a lively, light-filled quality.

▶ WATERCOLOUR SKETCH
Watercolour is a sympathetic medium for depicting skies and water. Here the sky is painted in a variegated wash while the white of the paper is reserved to stand for the clouds.

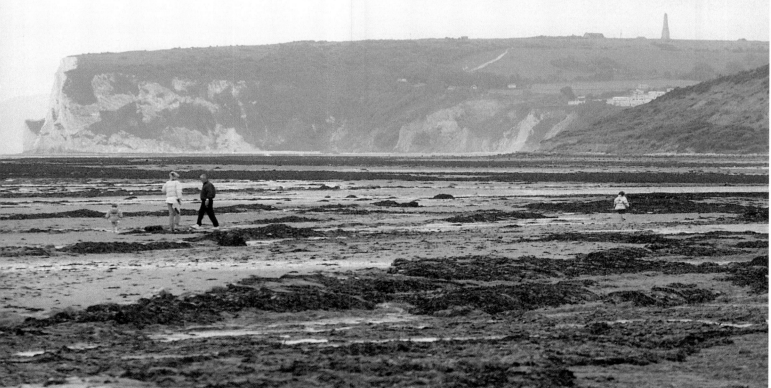

What you need

- A 38 x 50cm (15 x 21in) sheet of Rough watercolour paper. Arches 640gsm (300lb) mouldmade paper (used here) doesn't need stretching
- Masking tape
- Drawing board
- 2B pencil
- 11 paints: Naples yellow, ultramarine, cerulean, raw umber, yellow ochre, lemon yellow, sepia, Winsor violet, cobalt, alizarin crimson, cadmium yellow
- Three brushes: No.9 and No.6 synthetic fibre round; 13mm (½in) flat
- Two jars of water
- Mixing palette

▲1 Fix the paper to the board with tape. Draw the sky, the headland and the light and dark tones on the sand with the 2B pencil. The water's edge falls less than halfway down the picture area. This division allows your eye to travel across the sand and the water, yet leaves room for the sky which is vital to the composition.

▲2 Wet the sky area with the 13mm (½in) flat. The sky will be laid on the wet paper with several washes – see Step 3.

Mixing sky blues

ultramarine　　　+　　　cerulean　　　=　　　sky blue

Ultramarine is a warm blue, while cerulean has a cool undertone. Both are suitable for skies. Every artist has a favourite and it is worth experimenting to see which you find most pleasing. A mix of two blues often gives the best result. For this project, the artist felt a mix of ultramarine and cerulean gave a good summer sky blue. Test the colour on a scrap of paper and remember it will be lighter in tone when dry.

◀3 Mix a pale wash of Naples yellow and use with the No.9 brush to apply touches to the wet sky area. Then lay three swathes of wash across the sea and sand with a darker mix of the same colour. Load the No.9 brush with a sky blue wash mixed from ultramarine and cerulean (see above) and apply loosely, leaving areas of white paper for clouds. Leave to dry.

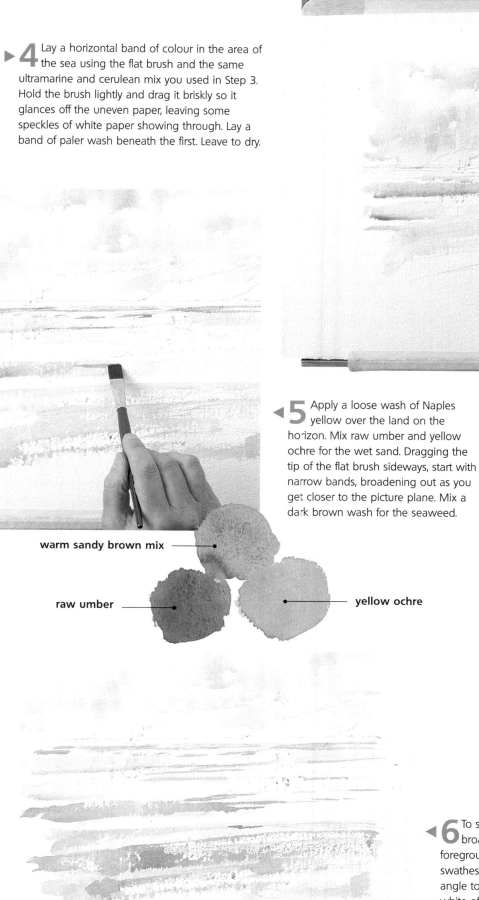

4 Lay a horizontal band of colour in the area of the sea using the flat brush and the same ultramarine and cerulean mix you used in Step 3. Hold the brush lightly and drag it briskly so it glances off the uneven paper, leaving some speckles of white paper showing through. Lay a band of paler wash beneath the first. Leave to dry.

5 Apply a loose wash of Naples yellow over the land on the horizon. Mix raw umber and yellow ochre for the wet sand. Dragging the tip of the flat brush sideways, start with narrow bands, broadening out as you get closer to the picture plane. Mix a dark brown wash for the seaweed.

warm sandy brown mix

raw umber

yellow ochre

Expert opinion

Q How can I create a sense of space when there are so few clues to perspective?

A If your painting is looking a little flat, you can create a sense of recession by using larger brushmarks and bolder textures in the foreground. Here various techniques are used to pull the foreground to the front of the picture. Broad brushmarks contrast with the narrower marks farther back, while speckles of white paper showing through the washes and spatters of dark colour suggest that this area is nearer to the front of the picture.

6 To suggest a sense of recession – distance – lay broader bands of the same dark brown wash in the foreground. Use the full width of the brush for these swathes of colour. Hold the brush loosely and at an acute angle to the paper so it dances over the surface, letting the white of the Rough paper show through in places.

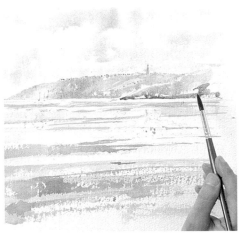

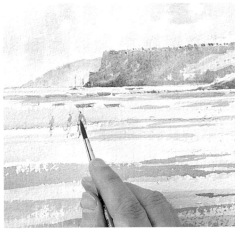

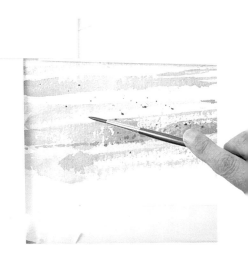

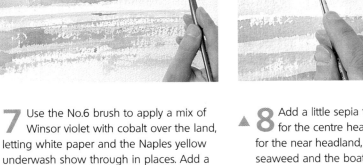

▲**7** Use the No.6 brush to apply a mix of Winsor violet with cobalt over the land, letting white paper and the Naples yellow underwash show through in places. Add a touch of sepia to the mix for the darker right side. Use the tip of the brush to suggest trees and shrubs on the headland. Leave to dry.

▲**8** Add a little sepia to the violet/cobalt mix for the centre headland. Add more sepia for the near headland, the rocks, the darkest seaweed and the boats. Mix a pale wash of alizarin with a touch of sepia to suggest moving figures. Strengthen the foreground seaweed with a sepia/cadmium yellow mix.

▲**9** Use scrap paper to protect the painting surrounding the beach. Load the No.6 brush with wash, hold the brush over the painting and tap the handle briskly with your forefinger. Droplets of paint spattered on the painting suggest the pebbles on the beach.

◄**10** Complete the picture by adding touches of red and blue to the figures – dab the colour with a tissue to soften the effect. Use the tip of the brush to flick in the form of the gambolling dog.

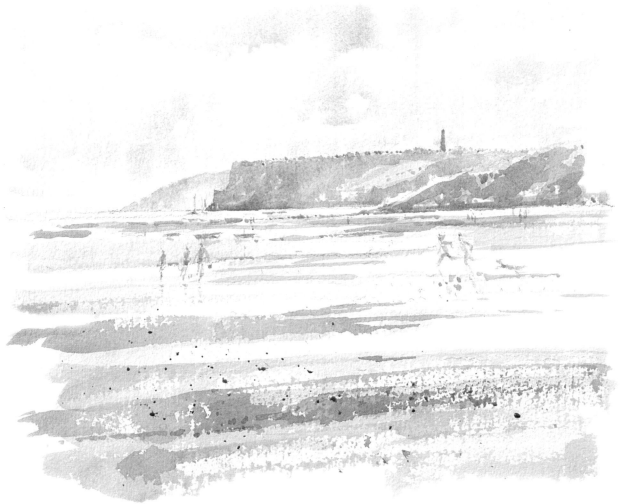

FINISHED PICTURE
The broken paint surface captures the dazzling quality of light reflecting on water, while the people on the strand are suggested with tiny strokes and dots of colour. Narrow marks and pale tones in the distance help make that area sit back in space, while broad brushmarks and dark tones in the foreground bring this part forward.

Seascape at low tide
by *Albany Wiseman*

Lakeside scene

This colourful view provides you with a glorious opportunity to put wet-in-wet and wet-on-dry techniques into practice – and use a variety of washes as well.

The basic forms in this project are fairly simple – it's just a matter of observing the trees, shrubs and features of the landscape carefully, and drawing in what you see. The more challenging task of interpreting the tones and colours and describing them convincingly requires a little more skill. You need to make maximum use of your knowledge of wet on dry, wet in wet and overlaid washes to create a picture that is tonally accurate.

Take a look at the finished painting first and see how the artist has created a sense of recession. The sky is lighter towards the horizon while the colours are stronger and the details crisper in the foreground. Colours in the mid-ground and background are slightly muted. The picture has a sense of space and distance and is a fine interpretation of the subject.

The set-up

Magnificent trees and plants are beautifully reflected in the smooth surface of the lake in this tranquil scene.

Tip

Many artists like to leave their pencil marks on the finished painting because they are part of the working process. If you don't want them, remove them carefully with the corner of a putty rubber, but first ensure the paint is absolutely dry.

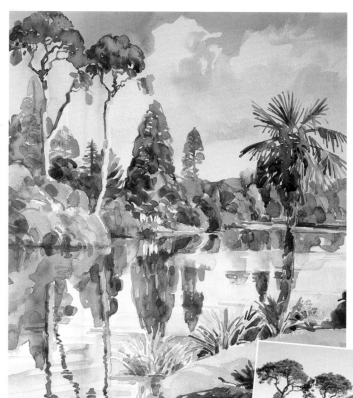

◀ FINISHED PICTURE
The artist has picked up on the reflections in the water and, with subtle use of colour, has created a picture that has a very pleasing decorative quality.

▲ OUTLINE DRAWING
If you have the time, make an on-the-spot, accurate, reasonably detailed pencil drawing like this for your painting. Alternatively, make some quick sketches and work them up later.

▶ REFERENCE PHOTOGRAPH
This is one of several which were specially taken. Photographs like this are a great help in assessing tones – but don't copy them slavishly.

What you need

- A 53 x 35cm (21 x 14in) sheet of stretched 300gsm (140lb) NOT watercolour paper
- 2B pencil
- Putty rubber
- 13 paints: French ultramarine, cobalt blue, cerulean blue, Winsor green, sap green, yellow ochre, Indian yellow, lemon yellow, Winsor violet, permanent magenta, scarlet lake, burnt sienna, sepia
- Two round brushes: No.3 and No.10 sable or sable/synthetic
- Two jars of water
- Mixing palette

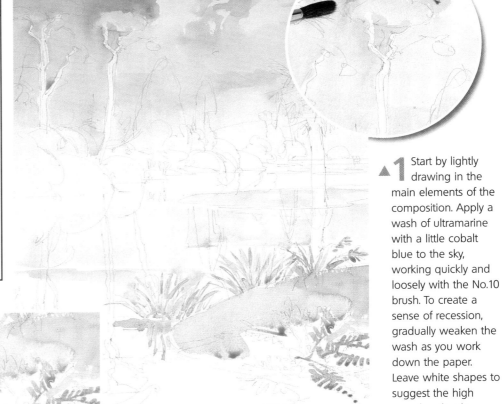

▲**1** Start by lightly drawing in the main elements of the composition. Apply a wash of ultramarine with a little cobalt blue to the sky, working quickly and loosely with the No.10 brush. To create a sense of recession, gradually weaken the wash as you work down the paper. Leave white shapes to suggest the high cumulus clouds.

▶**2** Add a touch of cerulean to the sky wash and paint the lake with three broad horizontal brushstrokes. Leave streaks and patches of white paper to suggest highlights on the surface. While this is drying, paint the grassy bank on the right with a pale wash of Winsor green. Then mix yellow ochre, Indian yellow, lemon yellow and Winsor green in different proportions and paint the grasses and ferns (inset) at the water's edge, still using the No.10 brush.

▲**3** At this stage, stand back and view the whole painting. You can see the value of using a large brush for the initial stages: it encourages you to make broad, sweeping strokes that keep the painting fresh and lively.

burnt sienna

soft orange mix

Indian yellow

Expert opinion

Q How can I make reflections in still water look realistic?

A In still water, reflections appear directly below the object causing them – but you should paint the reflected colours in slightly muted tones to allow for the effect of the water.

▶**4** Put in the shadow areas on the bank with more Winsor green washes. Now change to the No.3 brush until Step 7. Paint the dead foliage in the centre of the fern with a mix of burnt sienna and Indian yellow. Allow the paint to form pools – these dry darker than a thin flat wash, and provide interesting tonal contrasts and crisp edges.

5 Paint the trunks of the tall Scots pines with a light yellow ochre wash. Add shadows on the left side of the trunks with a light wash of Winsor violet. Paint the branches under the tree canopies with a mix of sepia and Winsor violet. The sepia will give the wash a darker tone.

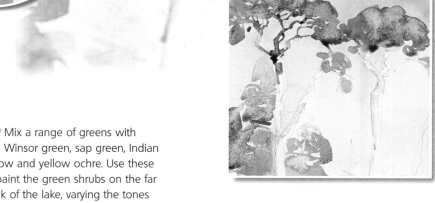

6 Paint the canopies with a wash of sap green, then add touches of a stronger mix to parts of the foliage. Lighten the wash and paint the trees in the distance (inset) with loose scrubby strokes. Before the canopies dry, touch in a few hints of sepia to give form and volume – notice how the paint spreads, making dark pools in some places and transparent pale shapes in others, perfectly describing the clumps of foliage (inset far right). Use sepia for the dark left side of the trunks.

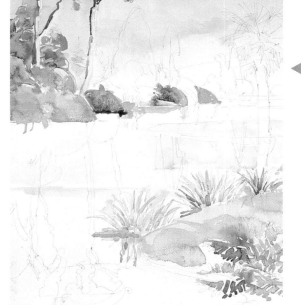

7 Mix a range of greens with Winsor green, sap green, Indian yellow and yellow ochre. Use these to paint the green shrubs on the far bark of the lake, varying the tones as you work. Paint the reddish shrubs with a dusky red mix of permanent magenta and scarlet lake. Paint the tall conifer in the centre with a wash of sap green, overlaid with a darker wash of sap green and Winsor green, capturing the natural shape and rhythm of the tree with your brushstrokes.

dusky red mix

scarlet lake

permanent magenta

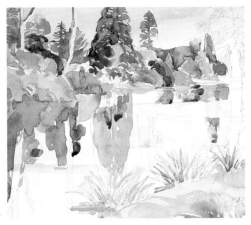

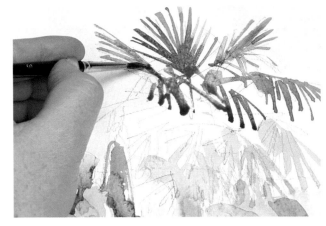

9 Use the No.3 brush to paint the palm tree on the right. Apply a thin wash of yellow ochre and Winsor violet to the trunk. Paint the palm fronds wet on dry with mixtures of sap green and Winsor green. Use the tip of the brush and work from the centre of the branch outwards. Leave to dry.

8 Lighten the green mixes from Step 6 and block in the reflections in the water with the No.10 brush. The washes spread wet in wet, suggesting the smooth surface of the water. Add a touch of sepia to the greens for a more neutral tone.

10 Mix ultramarine and cobalt blue and apply wet in wet with the No.10 brush for the dark water. Paint the dark reflections of the foreground pines in a mix of sap green, Winsor violet and sepia. With the No.3 brush make rapid lines and squiggles to capture the water's light and movement.

11 Paint the foreground grass in sap green. Allow to dry slightly, then add more washes of sap green and Winsor green, leaving patches of lighter tone to show through.

FINISHED PICTURE
The picture is full of colour and texture, the calm glassy surface of the water contrasting with the exuberant shapes of the trees and shrubs. See how the reflections get darker and the ripples more emphatic the closer they come to the foreground.

Lakeside garden
by *Polly Raynes*

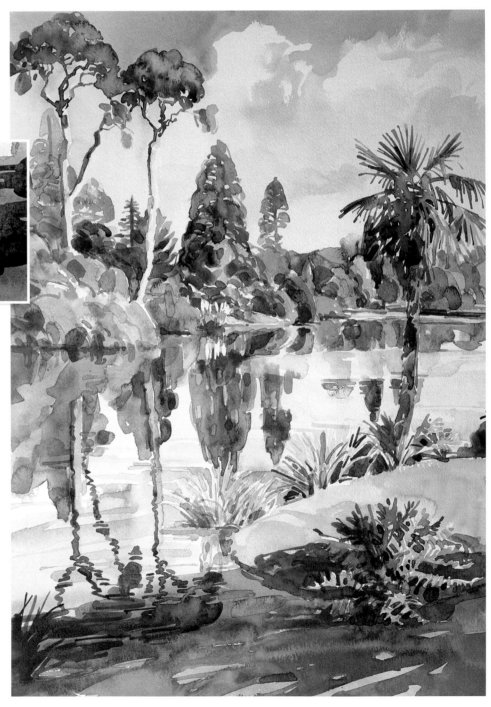

Bustling harbour

With so many boats bobbing about in this colourful harbour scene, the challenge was to create an overall impression of the busy background by simplifying the subject into blocks of tone and colour.

The background appears realistic and convincing, but look more closely at the harbour and jetty. The buildings and one or two boats are shown in some detail, but the rest of the background and most of the boats are painted simply as flat coloured shapes. Because a few selected areas have been painted more specifically, the viewer is deceived into seeing detail in the rest of the scene.

The composition is divided into two: foreground and background. The artist developed the picture as a whole, working simultaneously in both areas. The tall mast and the blue water provide important links between the foreground boats and the distant harbour. The artist made the most of these connecting elements, leaving the mast of the nearest boat as a strong pale shape against the darker background.

▼ *FINISHED PICTURE*
The contrast between light and dark areas is central to this composition. The darkest tones are the foreground shadows, which reflect the curved forms of the boats. Light areas include the white on the boats.

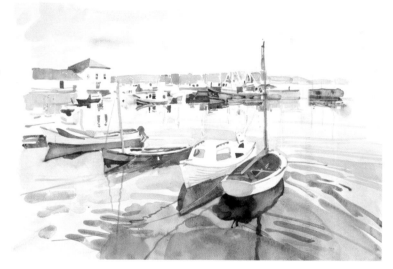

The set-up

A few boats reflected in the water and, in the distance, a small, crowded harbour provide an interesting test for the artist.

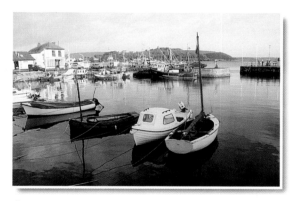

▲ *REFERENCE PHOTOGRAPH*
Several of these help with decisions on the composition of the painting, and a photograph makes a good colour reference.

▶ *TRACE TEMPLATE*

What you need

- A sheet of 55 x 75cm (22 x 30in) stretched Bockingford paper
- Drawing board
- Masking fluid
- Three brushes: a Chinese brush; a 25mm (1in) flat brush; and an old brush for masking fluid
- 17 watercolour paints: cobalt blue, gamboge yellow, cadmium red, cadmium yellow, violet, black, burnt sienna, alizarin crimson, ultramarine blue, Winsor blue, Winsor green, cadmium orange, cerulean, raw sienna, sap green, yellow ochre, Naples yellow
- Two jars of water
- Mixing palette

▲ **1** Using the Chinese brush, lightly sketch in the composition in diluted cobalt blue. Keep the tone pale so you can move easily from one area to another, making any necessary adjustments and corrections by overpainting the lines.

▲ **2** Apply masking fluid to any small areas that will be white in the finished painting. These include the masts and details on the harbour and houses. Don't try to paint every mast in exactly the right place. Get one or two right, then add the rest.

gamboge yellow

cobalt blue

background greenery mix

▲ **3** Leave the masking fluid to dry. Then use the Chinese brush to paint the distant hills and background greenery in a mix of gamboge yellow and cobalt blue. Take the colour over the masked-out masts.

4 Start to block in the background, beginning with the largest boat on the jetty. Paint the patches of bright local colour in pure cadmium red, cadmium yellow and cobalt blue. Add the shadows in a mix of violet and black.

Tip

Crisp clean lights and highlights are essential if you are to capture the sparkling quality of light on water. To retain the contrast between important light and dark tones, masking fluid was used to block out all the smaller areas which were to be white or light in the finished painting.

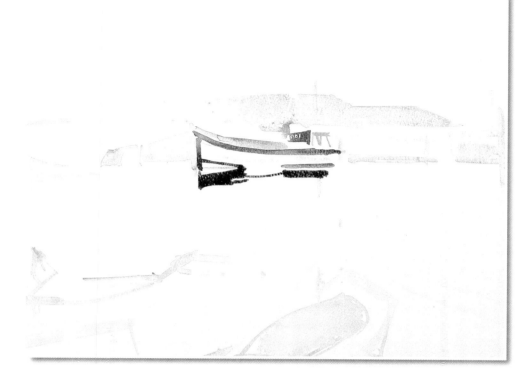

5 Develop the background with small areas of dark tone in black and black/violet washes. In the foreground paint the main mast in diluted burnt sienna/black. Define the foreground boats in black/violet. Use the same mix to block in the reflections. Leave the guy rope as an unpainted white line.

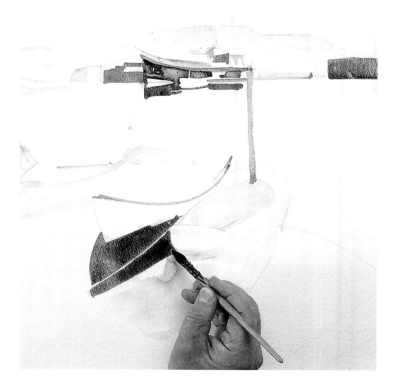

Expert opinion

Q I have always found the curved shapes of boats difficult to draw. Is there a simple way of doing this?

A The curves must be free and unrestrained. Hold the pencil or brush loosely and draw from the wrist rather than the fingers. This gives you a sweeping line rather than a cramped shape. In addition, look carefully for the point of contact between the bottom of the boat and the water. If your eye level is close to the water, this will be a straight line.

▶ **6** Paint the top of the red boat in alizarin crimson and the lower part of the hull in dilute black and burnt sienna. Paint the boom of the boat on the right in diluted cobalt blue. Establish some of the dark tones, including the windows and the interior of the boat on the right in mixes of black, alizarin and ultramarine.

alizarin crimson

ultramarine

black

shadow in boat mix

◀ **7** Extend the background, blocking in small areas of local colour and strengthening the dark tones to match the dark foreground tones. In the foreground, block in the row of boats. Put in the boat on the left in washes of Winsor blue and its interior in diluted Winsor blue/Winsor green with a little black.

▶ **8** Build up local colours in the background and block in darker shapes and shadows in mixes of cadmium red/cadmium orange/cerulean/raw sienna/black. Strengthen the shadow under the foreground boat in violet/ultramarine/black. Paint the mast's reflection as a broad squiggly line. Dab out wet colour to lighten the shadow on the right side of the boat.

violet

black

ultramarine

dark shadow mix

9 Wait until the painting is completely dry, then remove the masking fluid by rubbing carefully with a clean finger.

10 Using the 25mm (1in) flat brush, paint the sea in a diluted mix of cerulean blue with a touch of gamboge yellow. Work in bold vertical and diagonal strokes, taking the colour loosely around the background shapes and the foreground boats.

11 Before the pale blue wash is dry, add dark reflections to the foreground water in Winsor blue. Leave narrow streaks of pale underpainting showing to indicate ripples and reflections on the water. Change to the Chinese brush and strengthen the tones on the boats on the left in black.

Tip

The contrast between light and dark areas plays a central role in this composition. The darkest tones are the foreground shadows, which reflect the dramatically curved forms of the boats. Pale areas include the highlights on the water and the white on the boats.

▲**12** Develop the dark tones in the background, adding small areas of local colour. Paint the rooftops in mixes of raw sienna/yellow ochre/Winsor blue. Block in the local colours to the right of the main mast in raw sienna with burnt sienna or cadmium orange.

▲**13** Extend the distant landscape in gamboge yellow/sap green. Paint the beach in gamboge yellow. Add details to the background, and dot in doors in violet and windows in burnt sienna/black. Change to the 25mm (1in) brush and develop the reflections in the foreground water with Winsor blue/black.

▲**14** Add splashes of bright red and yellow to the distant boats, use burnt sienna/raw sienna for the roofs, and lay in the sky with Naples yellow with touches of cerulean/black. Paint the ropes and masts.

FINISHED PICTURE
Wet-on-dry applications of wash capture the shimmering surface of the sea. The cluster of boats and buildings around the harbour are laid in very simply as patches of flat colour, a few deft details pulling the image into focus.

Cornish harbour by *John Raynes*

Sheep in the snow

How do you paint white sheep in the snow? The answer is that neither the sheep nor the snow is actually pure white. The sheep look yellowish grey against the snow, while the snow itself is tinted by shadows.

Animals lend scale as well as life and interest to your landscape paintings. But painting them in the field is not always practical – sheep, for instance, have a habit of wandering off. This is where sketchbook studies come in useful – if you make sketches of individual animals, you can transpose them to an otherwise empty landscape.

Arrange the animals in groups rather than stringing them out. Place the groups at different distances into the scene and overlap some to encourage the eye to move through the picture. Vary their positions, placing them so they face in different directions or with their heads at different levels. In this picture (see page 152), the group of three sheep have similar poses but their heads are turned at different angles. They form a unified shape and because they overlap they introduce perspective. Variety is added by the fourth sheep, set slightly apart and staring out inquisitively.

(see page 152)

Tip

If you are worried about painting animals' feet accurately – horses' hoofs or sheep's feet for instance – don't spend time struggling. Just ensure that your subject is standing in long grass, tufty turf or – as here – snow. It looks very natural to see the animal's legs disappearing into the grass or snow – it 'grounds' them securely.

The set-up

An imaginary winter landscape can be put together with the help of a selection of watercolour sketches and photographs to provide both inspiration and practical reference.

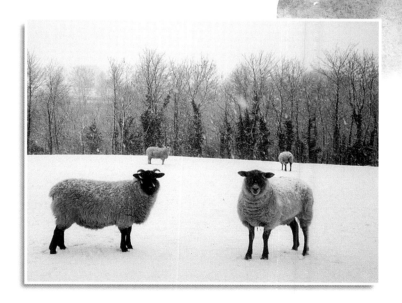

▲ REFERENCE PHOTOGRAPH
You can borrow different elements from several photos like this one, and combine them to make a composite image.

▲▼ WATERCOLOUR SKETCHES
A couple of thumbnail watercolour sketches help you loosen up before you start work on your painting. It's a good idea to make some sketches of the sheep since they never stay in one position for very long.

What you need

- A 47 x 30.5cm (18½ x 12in) sheet of stretched NOT watercolour paper
- Drawing board
- HB pencil
- Six paints: French ultramarine, light red, raw sienna, Winsor blue, cadmium red, burnt umber
- Three brushes: No.12 and No.6 round brushes; a 25mm (1in) soft flat brush
- Leaf-green coloured pencil
- Scalpel or craft knife
- Two jars of water
- Mixing palette
- Tissues

1 Using the sketches and photographs as a guide, draw the sheep and loosely indicate the main background features with the HB pencil.

2 Tilt the board at a slight angle. Use the 25mm (1in) flat brush to dampen the sky area with clean water. Apply a broad band of ultramarine across the top of the paper. Work down to the bottom of the dampened area, without reloading the brush, to create a softly graded wash.

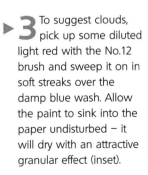

3 To suggest clouds, pick up some diluted light red with the No.12 brush and sweep it on in soft streaks over the damp blue wash. Allow the paint to sink into the paper undisturbed – it will dry with an attractive granular effect (inset).

◄ 4 Mix a stronger solution of ultramarine and apply it in a broad band across the horizon with the flat brush. While it's still wet, quickly put in a few random spots of light red with the tip of the No.12 brush and let them bleed out. Later, this will give the impression of distant trees shrouded in mist.

Tip

If you don't have a steady hand for painting the fine twigs on the winter trees, try using a well-sharpened dark grey coloured pencil to suggest the fine branches – it's much more controllable than a brush.

▶ 5 Mix a cool grey from French ultramarine and light red, diluted to a pale tint. Use the edge of the flat brush to paint the shadows in the snow. Make the wash slightly stronger in the foreground, weaker in the background to give a sense of spatial recession.

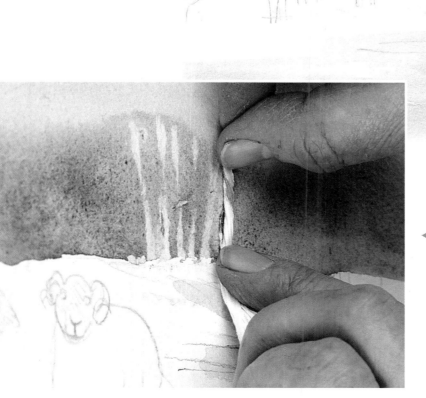

◄ 6 While your Step 4 wash is still damp, suggest some pale tree trunks by lifting out. Press a short piece of tightly twisted tissue vertically into the wash and lift it off to give a natural-looking tree trunk. Use the same press-and-lift motion to create more tree trunks, singly and in groups, across the background.

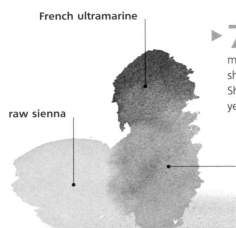

French ultramarine

raw sienna

yellowish-grey sheep colour

▶ **7** Mix a pale wash of raw sienna, adding a hint of ultramarine to make a dirty yellow. Use this to fill in the shapes of the sheep with the No.6 brush. Sheep are not white – their wool looks yellowish grey against the snow.

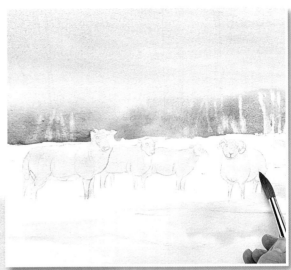

◄8 While the yellow wash is still damp, use the tip of the brush to touch in some diluted French ultramarine on the faces, necks and underbellies of the sheep. This creates shadows that define their rounded bodies. Notice how the paint granulates as it dries, suggesting the woolly texture of their coats perfectly.

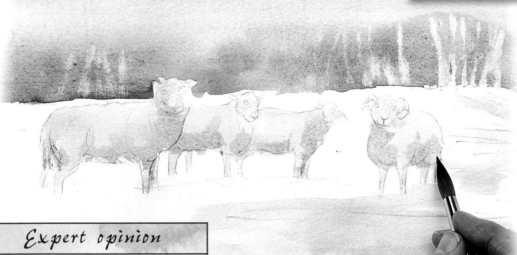

Expert opinion

Q When I try to paint winter trees they look stiff and clumsy. How can I make them more graceful?

A Don't attempt to paint every last twig. Pick out the main limbs and branches and merely suggest the smaller branches – the viewer's imagination will fill in the rest. Always work from the base of the trunk or branch upwards, gradually taking the pressure off the brush as you near the end of the stroke so it tapers off naturally and becomes paler at the tip.

French ultramarine

light red

◄9 Jot in the shadows cast by the sheep with diluted ultramarine. Then paint the trees: mix ultramarine and a touch of light red for the cool, bluish trees, and raw sienna with a hint of Winsor blue for the warmer-coloured trees. Vary the strength of tone to indicate how some trees are nearer than others and how some are partially obscured by mist.

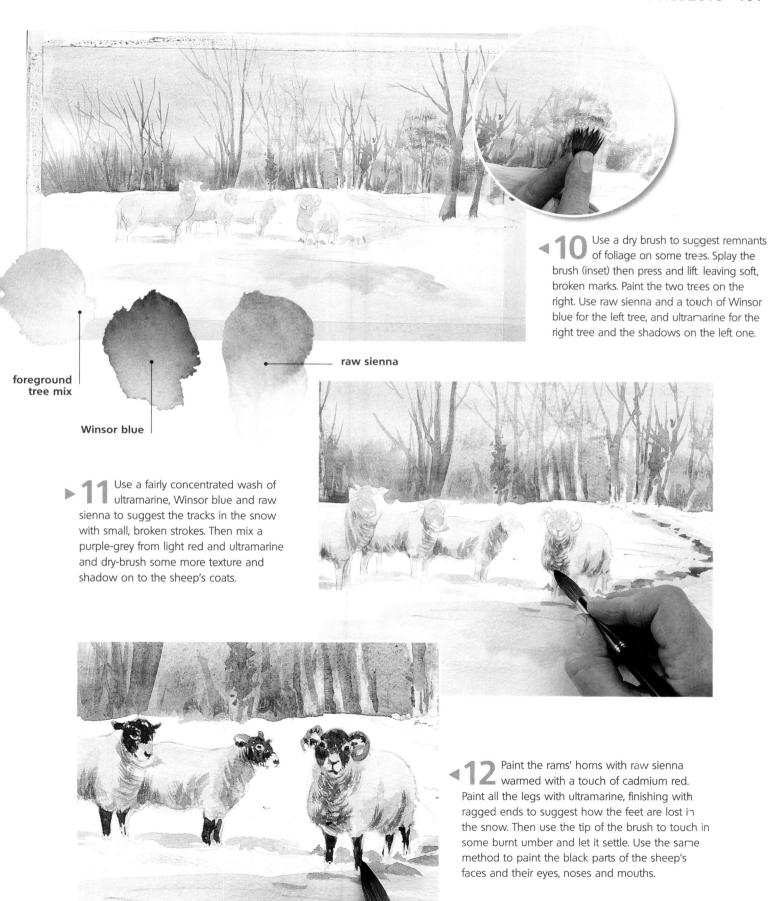

10 Use a dry brush to suggest remnants of foliage on some trees. Splay the brush (inset) then press and lift leaving soft, broken marks. Paint the two trees on the right. Use raw sienna and a touch of Winsor blue for the left tree, and ultramarine for the right tree and the shadows on the left one.

raw sienna

foreground tree mix

Winsor blue

11 Use a fairly concentrated wash of ultramarine, Winsor blue and raw sienna to suggest the tracks in the snow with small, broken strokes. Then mix a purple-grey from light red and ultramarine and dry-brush some more texture and shadow on to the sheep's coats.

12 Paint the rams' horns with raw sienna warmed with a touch of cadmium red. Paint all the legs with ultramarine, finishing with ragged ends to suggest how the feet are lost in the snow. Then use the tip of the brush to touch in some burnt umber and let it settle. Use the same method to paint the black parts of the sheep's faces and their eyes, noses and mouths.

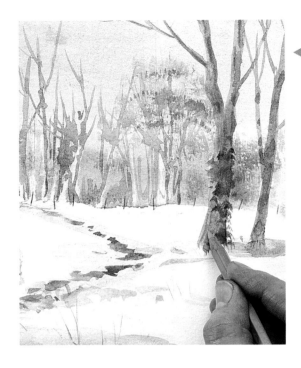

◀**13** Apply the ultramarine, Winsor blue and raw sienna mix on your palette to paint the ivy twining up the tree on the right. Then use the bright, leafy green coloured pencil to suggest lichen on the tree trunk and introduce a touch of warmer colour to the picture. Leave to dry.

▲**14** Use a scalpel or craft knife to scrape into the paper surface to suggest falling snowflakes. Use the tip of the blunt edge of the blade and scrape very quickly with a light, flicking movement – enough to scrape off the paint without digging into the paper.

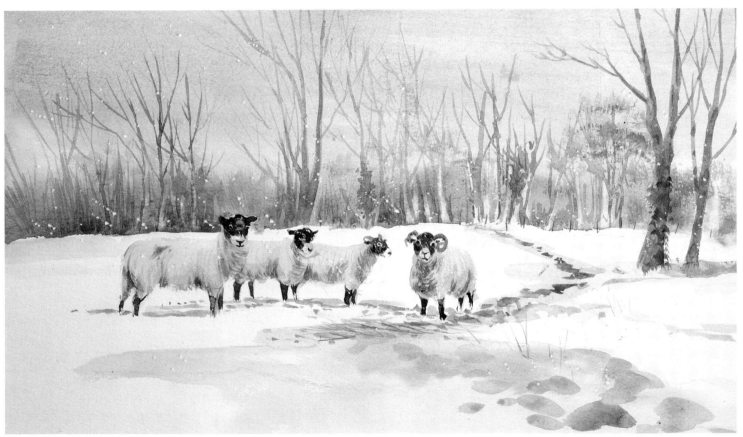

▲**15** To finish the picture, add a few more shadows on the snow with quick, light strokes of dilute ultramarine. Then paint the straw in the foreground with raw sienna and a little grey from the palette.

FINISHED PICTURE
The small touches of warm colour in the painting nicely offset the cool, neutral colours that capture the atmosphere of a snowy winter's day.

Sheep in the snow
by *Linda Birch*

Harbour wall

Ingenuity is needed to convey the texture of the stones in this dramatic painting. Using sponges, among other things, is a good way to build up variety and interest.

Brushes are by no means the only items you can use to apply paint to paper. There is a vast range of other objects available for creating texture, and a variety of informative, descriptive marks that give liveliness and interest to your painting. A subject such as this harbour wall is perfect for trying out different ways of applying paint. The scene has lots of craggy texture – the weathered stones from which the harbour wall is built, for instance, the path on top, the sand and the surrounding cliffs, the boat shed and other buildings.

To depict these textures, use several different sponges, both natural and synthethic, plus masking fluid and masking tape, some small pieces of cardboard – even an old credit card!

Tip

It's common practice to use Chinese white on top of transparent watercolour to put in whites or lights, and to introduce opaque texture and 'body'. The secret is not to overdo things. Just add a little here and there as you think necessary.

The set-up

Find the position that gives the most interesting view. Here, from the far end of the harbour wall, the cliffs rise up majestically from the sea, and the scene offers many different textures and vital contrasts between the path, cliffs, sea and sky.

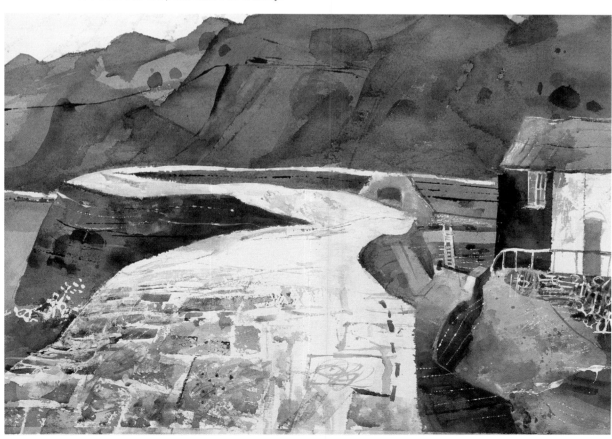

◀ FINISHED PICTURE
The sinuous, twisting line of this harbour wall is a naturally picturesque feature – the patchwork pathway leads the eye into the painting and entertains the viewer with its rugged textures and patterns.

What you need

- A 50 x 36 cm (20 x 14in) sheet of stretched 300gsm (140lb) NOT watercolour paper
- Large and small natural sponges and wedges of synthetic sponge
- Masking fluid, masking tape
- HB pencil
- Scissors and small pieces of cardboard
- Seven watercolours: Payne's gray, alizarin crimson, cadmium yellow, cobalt blue, Hooker's green, raw sienna, Chinese white
- Two brushes: No.6 to apply the masking fluid and No.12, both round synthetic
- Two jars of water
- Mixing palette

▲ **1** Draw your subject with the HB pencil on the stretched paper. The artist made only very sketchy outlines to give the main shapes and structure of the composition. Then use masking tape to mask off the path, boat shed and sky. Apply masking fluid with the No.6 brush to protect the finer details such as the sea splashing against the lower wall, the ladder, the railings and the grout in the wall. Leave to dry.

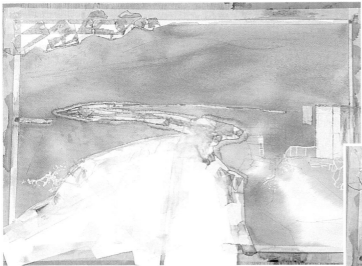

▲ **2** Wet the paper with the dampened natural sponge. Using the same sponge, apply a wash of Payne's gray to the wet paper. Cover all the paper, including the masked sky, leaving only the path and the sandy area on the right. Let the paint seep under the masking tape – it all helps to create texture. Leave to dry.

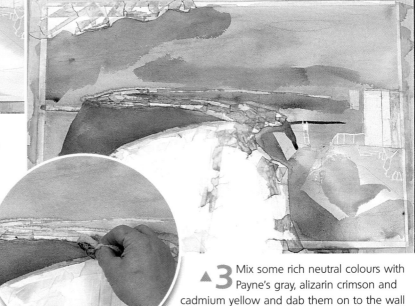

▲ **3** Mix some rich neutral colours with Payne's gray, alizarin crimson and cadmium yellow and dab them on to the wall with the small natural sponge to create a softly mottled effect (inset). Mix a variety of blues, greens and golden yellows from combinations of cobalt blue, Hooker's green, raw sienna, alizarin crimson and cadmium yellow and apply them to the sky, hill, wall and right side of the wall. Allow the colours to melt into one another to create a variety of tones and textures. Leave to dry.

Expert opinion

Q If I find at a fairly late stage that I want a couple of extra light or white areas in my painting and I've forgotten to mask them off, what can I do?

A You can – carefully – scratch in highlights with the tip of a craft knife. This works particularly well with linear highlights. Don't dig into the paper too much or you'll ruin the surface; and don't overdo the scratching or the result will not look fresh.

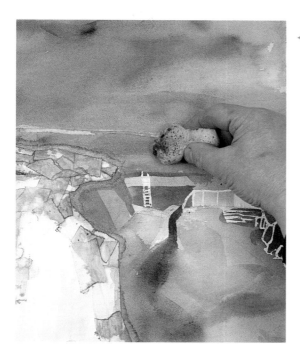

4 Using the small natural sponge, apply rich golden tones to the sand area. Mix Payne's gray and cobalt blue and use to add darker neutral tones and textures to the hill and cliff by dragging the sponge across the paper and dabbing paint on to produce a slightly mottled effect.

Payne's gray

cobalt blue

neutral grey tone mix

5 Now sponge in the darker tones on the hills, the wall and the clifftops with the blue and green mixes from Step 3. Squeeze colour on to the paper and work with the sponge wet in wet. Leave to dry. For extra texture spatter paint on to the lower right area. Add linear details on to the hills and cliffs with the edge of a piece of card dipped in paint.

6 Remove the masking tape (inset). Lift it without tugging, so you don't tear the paper. Rub off the masking fluid with your fingers. Paint seeping underneath the tape has produced jagged lines of colour and texture on the path and sky. Tone these down with a little Chinese white and the No.12 brush. Use the Chinese white to add texture and highlights here and there, using a piece of card rolled up and dipped in the paint.

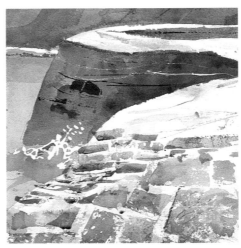

▲**7** Use various bits of synthetic sponge to print different colours and textures on the stone path with the greens, ochres and blues you mixed earlier. Either dip the sponge into a single colour wash or, for a more mottled effect, select several colours and apply them to the sponge with the No.12 brush.

▲**8** Stand back to assess your work so far, then add details as necessary. Notice how the squares of colour get smaller as the eye travels into the scene, creating an accurate sense of perspective. The sponge markings help to offset the flat surface of the path, adding contrast and providing depth..

▲**9** Use a piece of synthetic sponge loaded with cadmium yellow to add linear effects and smudged blobs to the sandy area to create light patches. Then, working wet on dry, use small wedges of synthetic sponge to add detail to the wall – and also to lift off colour from it.

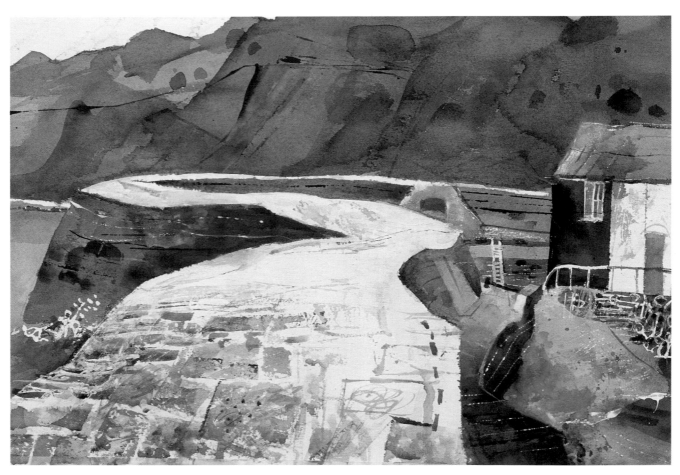

▲**10** Continue developing the textures on the harbour wall using combinations of sponging, printing, scratching and spattering techniques.

FINISHED PICTURE
The dark background emphasizes the wall's light serpentine shape, which pushes forward, seemingly coming out of the picture, and creates a jigsaw of shapes and patterns.

**The Cobb
by Stan Smith**

Summer landscape

This peaceful rural scene is a joy to paint. It relies for its effect on subtle colour, carefully observed details and meticulous handling of the watercolour washes.

This complex composition aims to fit a lot of detail into a small space. It calls for good organization and for the use of a wide range of different watercolour techniques.

To create the illusion of depth, the artist used small variations of colours. He mixed a range of warm and cool tones to pull some elements forward and push others back, and made the tiniest of colour adjustments to his washes in order to give objects form. He knocked back some colours by lifting them out to create a sense of distance, and also used dry-brush, wet-on-dry, scratching out and overlaying wash techniques to achieve plenty of texture and tone in the painting.

Tip

Clean all your brushes regularly as you go along so your colour stays pure. Use two jars of water – one for cleaning brushes, the other for mixing washes. Change the water frequently. Keep scrap paper handy for testing different mixes. Remember that for landscapes, you start with pale misty colours in the far distance and gradually mix stronger colours as you come forwards.

The set-up

On-the-spot sketches are especially useful for a painting with this much detail. Here, the artist used a 2B pencil to make one detailed and one rough sketch, annotating the rough one with notes on colours and weather conditions. He worked directly on to the detailed sketch, using the rough one for reference.

◀ FINISHED PICTURE
The focal point of the church (inset) draws the eye with two tiny touches of cerulean – on the clockface and the spire – the only places in the entire picture where this colour is used.

What you need

- A 35 x 25cm (14 x 10in) sketchbook with 300gsm (140lb) NOT acid-free watercolour paper
- 2B pencil
- Craft knife
- White scrap paper
- Sheet of blotting paper
- 13 paints: cadmium yellow, yellow ochre, raw sienna, burnt sienna, cadmium red, light red, alizarin crimson, Payne's gray, viridian, cerulean, ultramarine, cobalt blue, Prussian blue
- Three round brushes: No.4, No.6, No.10
- Two jars of water
- Large mixing palette

▲**1** Make a watery mix of cobalt blue/ultramarine and use to sweep in the sky, starting a third of the way down the page and moving up towards the top right. Use the tip of the No.10 brush and make the blue stronger at the top of the page.

▲**2** Turn the picture upside down and, using the same brush, wash a band of yellow ochre/cadmium red straight across the horizon to suggest the sun setting beyond the hills and trees. Dilute the mix until it's quite watery and wash it from the horizon into the sky, merging it with the blue. Turn the page right way up.

Payne's gray

ultramarine

pale blue-grey mix

▲**3** Mix a pale blue-grey with ultramarine/Payne's gray for the silhouettes of the distant hills and trees – use the No.4 brush. Wash the grey up and down the tree trunk to avoid sharp edges. Blot excess paint to keep the area pale and misty.

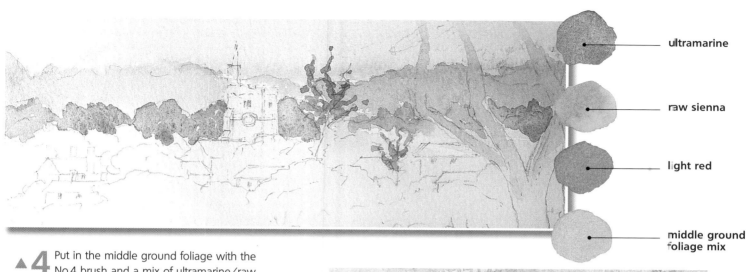

ultramarine

raw sienna

light red

middle ground foliage mix

▲**4** Put in the middle ground foliage with the No.4 brush and a mix of ultramarine/raw sienna/light red. Add other washes for variety – blue-grey, greeny-blue and yellowy-green. Fill in the different trees, however small, with the point of the brush. Paint the lower parts of the foliage darker so the tops appear to catch the light.

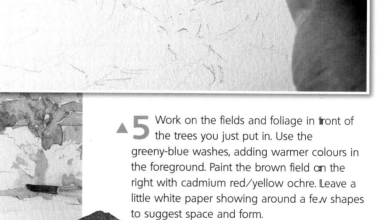

▲**5** Work on the fields and foliage in front of the trees you just put in. Use the greeny-blue washes, adding warmer colours in the foreground. Paint the brown field on the right with cadmium red/yellow ochre. Leave a little white paper showing around a few shapes to suggest space and form.

alizarin crimson

ultramarine

▲**6** Paint the grey roofs, the church, its buttress and spire in dilute cobalt blue/Payne's gray. Apply the same wash for shadows in the trees in front. Use a warmer grey mix of yellow ochre/burnt sienna/ultramarine on the church front. Make a plum mix with burnt sienna/alizarin crimson/ultramarine for the other cottage roofs. Add more diluted alizarin and yellow ochre for the walls and road next to the fields.

burnt sienna

plum mix

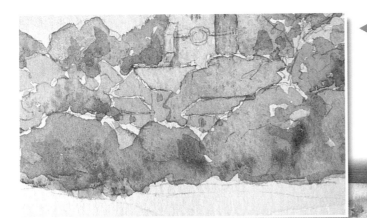

◄ **7** Mix cadmium yellow/yellow ochre/cobalt blue for the lightest tones near the top of the line of trees in front of the cottages. Add viridian and more cobalt blue for a stronger green in the centre of the trees. Add raw sienna and lay your wash over the grey for the deepest shadows at the bottom.

▶ **8** Mix yellow ochre/raw sienna for furrows on the brown field. Dilute this wash and add cadmium yellow for the cornfield. Paint the purple field with alizarin crimson/cobalt blue, then deepen the mix for furrow texture. Apply this wash in places in the foreground. Mix cadmium yellow/yellow ochre/cadmium red/ viridian and use with the No.6 brush for the leaves against the sky.

Tip

The artist used tubes of paint, squeezing yellow through red, brown and green to blue on to a large palette. This paint order is important. If you raise your palette at a slight angle as you mix the colours, the excess paint runs down into three compartments, making a blue/grey mix, a plum mix and a green/brown/yellow mix.

◄ **9** Use the plum mix from Step 6 for the gnarled tree trunk. Dilute the mix for the lighter left side. Build up the shadows on the right to a dense plum colour. Mix burnt sienna/viridian for the darker clumps of leaves. Add cadmium yellow and cobalt blue here and there to build up strong leafy clusters full of light and shade.

yellow ochre

burnt sienna

Prussian blue

mix for dark green bush

▶ **10** Add more fine twigs and branches to the tree with the No.4 brush. Paint the dark green bush on the left with a Prussian blue/burnt sienna/yellow ochre mix. Change to the No.10 brush and lay a loose wash in the foreground of a watery light red, adding viridian as you go.

◀ **11** Splash a greenish yellow mix across the foreground, then break it up with touches of Prussian blue and burnt sienna. The artist invented a path winding up past the tree. Use a damp brush to lift out some of the colour you just put on. Mix a strong wash of ultramarine/ alizarin crimson/burnt sienna and sweep it over the foreground with the No.10 brush. Use blotting paper (inset) to lift out paint so some of the underlying colours reappear. Redefine the path in this way.

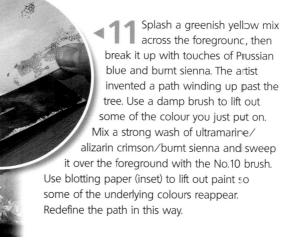

▶ **12** Put in clouds on the horizon with a wash of ultramarine/Payne's gray and a dry brush. Use the same wash to strengthen the trees on the horizon and put shadows on the sides of the cottages on the right. Use the No.4 brush to add a touch of cerulean blue to the clockface and spire on the church to make them stand out.

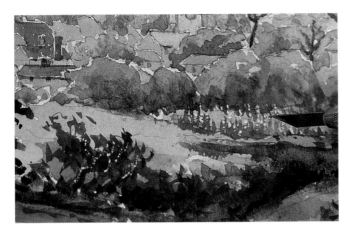

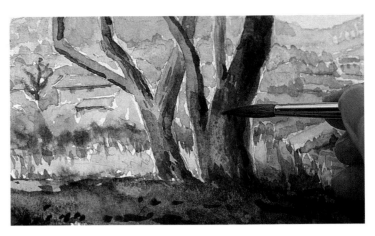

▲**13** Use the craft knife to scratch off some colour carefully from the middle ground trees and bushes to add texture. This also puts more white back in the picture without the need for too much white paint.

▲**14** Put a wash of light red on the tree trunk, then dab on a few patches of the plum mix to give the bark texture. Add more layers of dense plum and cobalt blue to the trunk under the leaves for the strongest shadows.

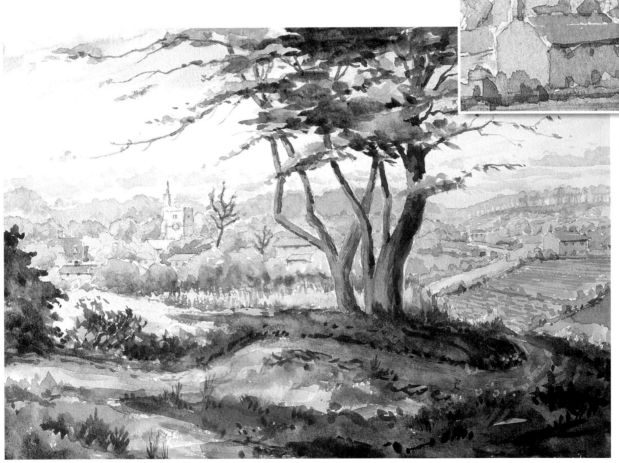

▲**15** Put in a line of shadow under the roofs, and dab another layer of tiny shadows behind the hedges around the fields. Also put a few shadowy blades of grass in the bottom left corner. Finally, add two minute figures and their shadows on the road.

FINISHED PICTURE
The final painting shows that every detail has been carefully observed. You can tell the time of day by the shadows, and the season of the year by the flowers and crops. It is *this combination of attention to tiny details and controlled handling of watercolour that captures the calm atmosphere of a tiny village nestling in a sunlit valley.*

Summer landscape
by *Dennis Gilbert*

Grand museum

For any large and complex building such as this, an accurate sketch is a prerequisite for capturing its character and texture.

The first stage in producing a likeness of a building is to study the structure carefully and record it as precisely as you can. Once you've put the structure down on paper, you have more freedom to think about other matters – conveying colour and form, bringing out different textures within the building and contrasting it with the textures of any surrounding buildings or vegetation.

In order to capture the character of the lovely golden stone of this gallery, the artist chose a slightly textured neutral grey NOT paper. He brought out the warmth of the stone by playing up the violet of the road – this is the complementary colour of the yellow stone and has the effect of enhancing it. Finally, he contrasted loose washes in the trees with tighter work on the building itself to help draw the eye.

Tip

If you choose to work on small sheets of paper such as the one used for this painting – it measures 230 x 305mm (9 x 12in) – some precise work is necessary when it comes to details. Try using a large goat-hair hake brush for general washes, and a No.3 round brush for putting in the small, but telling, details.

The set-up

The building with its beautiful classical embellishments is the focus of this painting. It has been given a slightly old-fashioned appearance by ignoring most of the paraphernalia of modern life such as cars and buses, as well as the crowds of people.

▼ FINISHED PICTURE

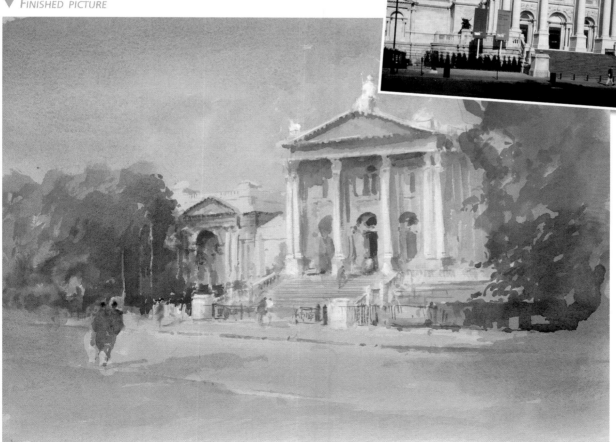

▲ REFERENCE PHOTOGRAPH
This will help you make an initial sketch for your painting. Remember that you need to reproduce the structure of the building but there's no need to copy all the details. What you're after is an accurate impression, not an architect's drawing.

What you need

- A 23 x 30cm (9 x 12in) sheet of neutral grey NOT watercolour paper
- 2B pencil
- Seven paints: yellow ochre, vermilion, cobalt blue, Hooker's green medium, permanent violet, burnt sienna, Vandyke brown
- Chinese white
- Three brushes: a hake (very large goat-hair flat); No.3 and No.6 rounds
- Two jars of water
- Mixing palette

▲**1** Loosely plot the scene with the 2B pencil, working very lightly over the paper so the marks won't stand out too much in the finished painting.

Now warm up the buildings, steps and street with thin washes of yellow ochre and burnt sienna. These help to give an initial impression of the bulk of the building.

burnt sienna

Vandyke brown

soft warm brown mix

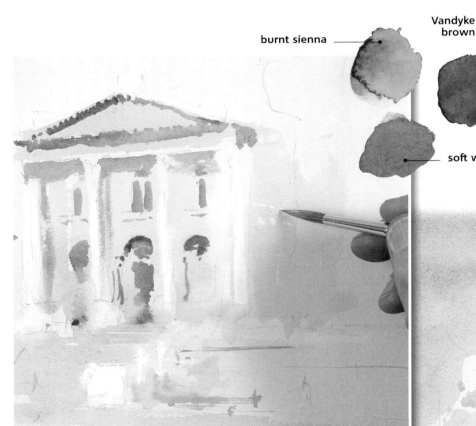

▲**2** Model the pillars and indicate the hollows in the windows and door arches with a darker wash of burnt sienna with a touch of Vandyke brown. Use the No.6 brush, switching to the small round for tiny touches of colour.

The coloured paper means you can't leave areas blank for whites. Instead, apply a little Chinese white for the brightest whites.

▲**3** Wash in the sky with cobalt blue and the hake brush, switching to the round brushes to work neatly around the buildings. You don't need to skirt around the tree canopies since the green washes can be worked on top of the blue.

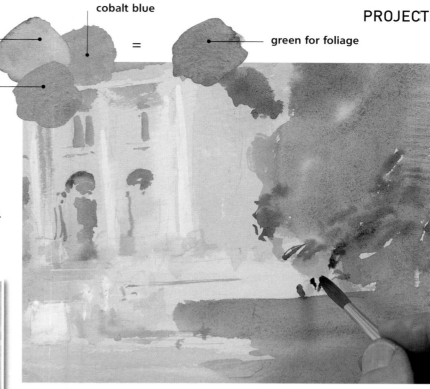

Hooker's green medium

cobalt blue

Vandyke brown

=

green for foliage

▶ **4** Sweep in the road in permanent violet. Then use the No.6 brush and a wash of Hooker's green medium tinged with Vandyke brown and cobalt blue for the trees on either side of the building and the grassy area on the right. Wet the paper first so the colour spreads. Strengthen the wash for the darker undersides of the tree canopies.

◀ **5** Lightly indicate some of the people nearby. Put in the darker shadows on the road with more permanent violet, working wet on dry to give crisp edges. Add a more brightly clad figure with a little vermilion. Touch in the figure at the front entrance in a mix of cobalt and white (inset).

permanent violet

▶ **6** Stand back and assess your progress. Notice how the trees frame the building and enclose the composition to hold the viewer's gaze.

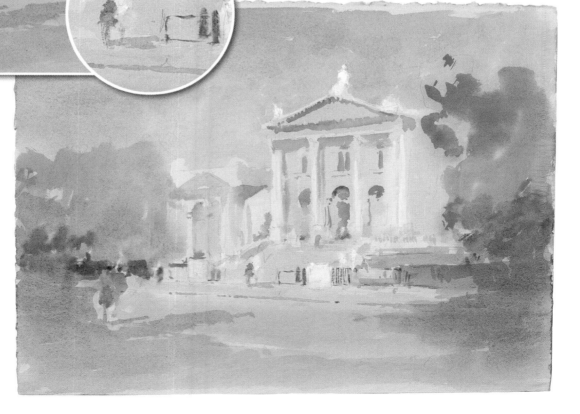

▲ **7** Use Vandyke brown mixed with cobalt for the railings, the steps and the shadows on the road, applying the colour quite dry with the very tip of the No.6 brush to give additional texture.

◀ **8** Enrich the shadows in the portal of the main building with vermilion, then add a little Vandyke brown to shade the right side of the building.

Now darken some of the shadows on the building and steps by applying a second wash of the same colour. This produces more subtle tonal variations than mixing a darker wash.

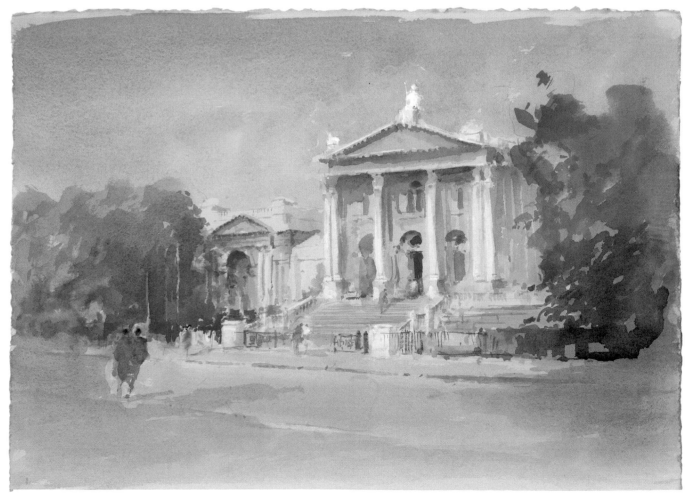

▲ **9** To finish the painting, add more highlights and deep shadows to bring out the contrasts of tone typical of a sunny day – to the main entrance for example, and under the arch of the second building. Add a few extra figures, or develop the existing ones as necessary.

FINISHED PICTURE
Note how the building attracts and holds the attention. The dark trees enclose the scene, while the violet shadows seem to make the building glow with an inviting warmth.

The Tate Gallery, London
by Roy Hammond

Fishing village

In order to paint a misty seascape, a number of variegated washes are used. The secret is to control the different colours in the fluid washes.

In order to convey the atmosphere of this seaside village, the broad plan is to work in very wet washes in the early stages, allow the washes to dry, then build up structure by working wet on dry. The key to this approach lies in the washes. You need to apply them quickly but thoughtfully – be ready to respond immediately if a new colour suggests itself and apply it while the paper is still wet enough to move the paint about easily. It pays to prepare all your washes in advance.

As the paper starts to dry, the paint becomes harder to manipulate – so, in a sense, water is your ally. But if the paper becomes too waterlogged, you'll find the paint almost impossible to control. It's all a matter of striking the right balance.

Tip

Although you can mix a great range of greens from the colours on your palette, it is sometimes helpful to keep a few palette greens handy. For this painting, for example, you could use viridian as a short cut to a clean, bluish-green.

The set-up

A small village in the shadow of rugged cliffs, with the sun just breaking through, presents an interesting prospect for the painter, and a chance to practise technique with washes.

▶ REFERENCE PHOTOGRAPH
In this case, a view from above is an excellent aid for colour and composition.

▼ TRACE TEMPLATE

▲ FINISHED PICTURE
Flat areas, such as the sea, and large expanses, such as the cliffs, are obvious candidates for rendering wet in wet, but the more definite, precise forms of the buildings may also be successfully depicted using this technique.

What you need

- A 50 x 100cm (20 x 40in) sheet of 640gsm (300lb) NOT watercolour paper
- 3B pencil
- Sponge
- Masking fluid
- Four brushes: No.12, No.8, No.5 rounds; old brush for applying masking fluid
- Nine paints: cerulean blue, cobalt blue, cobalt violet, yellow ochre, raw sienna, permanent magenta, light red, Indian yellow, cadmium red
- Two jars of water
- Mixing palette

1 Make a pencil drawing of the scene. Mask out the areas you want to keep white – a few of the walls, chimney stacks, window frames, distant figures and boats and flecks of rock along the waterline. Keep the edges straight and crisp. Leave to dry completely.

yellow ochre

beach colour mix

cerulean

2 Wet the paper with the sponge. Prepare your washes, then use the No.12 brush to apply them, working from the top. For the sea, use cerulean/cobalt violet. For the cliffs and beach, use yellow ochre/cerulean. For the warm shadow in the sea, drop in a little raw sienna.

3 For the pantiles on the roofs, apply yellow ochre/cerulean (the roof on the left), and raw sienna/permanent magenta (the roof in the middle). For the cool shadow, dip in a little cobalt blue here and there.

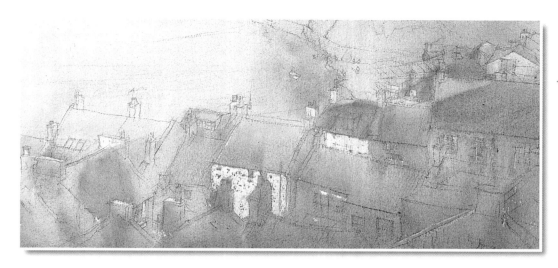

▲4 As the paint dries, revisit some areas with another wash – a blue green (either mixed or viridian) on the roof on the right, for example. You can already see the shadow starting to develop across the foreground. Leave to dry.

▲5 Rub off the masking fluid. You'll see that your washes have dried a much lighter colour. The pencil drawing still appears satisfyingly crisp and light enough to hold together the washes (right).

Expert opinion

Q How can I achieve a good balance between wet-in-wet and wet-on-dry work in my painting?

A Try the following exercise. Use good-quality, heavy watercolour paper (as here, 640gsm/300lb) and prepare all your washes beforehand – you need to paint your washes as quickly as possible. In the early stages, apply the paint with reckless abandon. For this you have to be mobile and you might find it helpful to stand up. For the wet-on-dry stages, you can move at a much more sedate pace, and since you require a steady hand, it may be better to sit down.

▶6 Using the cerulean and cobalt violet mix, work back into the sea with the No.12 brush. Grade the tone from light at the top to dark at the bottom, leaving a few breaks so the first wash shows through. These provide crisp shapes for the waves. Drop in some raw sienna for the warm reflection of the cliffs.

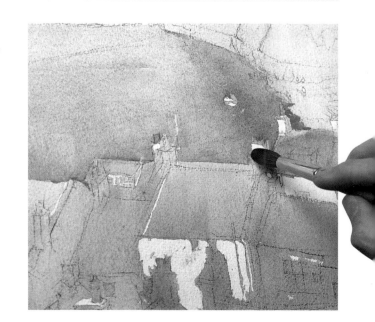

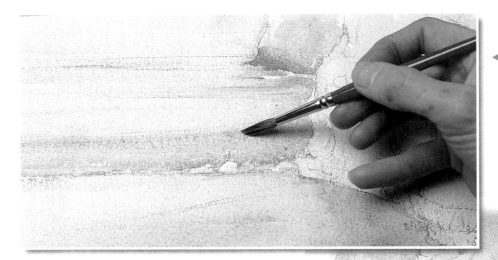

◄ **7** Let your previous wash dry completely. Change to the No.8 brush and stroke a little cobalt violet on to the sea – this is dry-brush work.

► **8** Mix a natural-looking green from yellow ochre/cerulean and apply it for the grass on the crumbly rocks. Apply a blue-green mix plus raw sienna for the darker areas on the cliffs. Pick out the crevices in the rocks with a plummy mix of raw sienna/permanent magenta/cobalt blue.

raw sienna

cobalt blue

permanent magenta

plummy mix for rock crevices

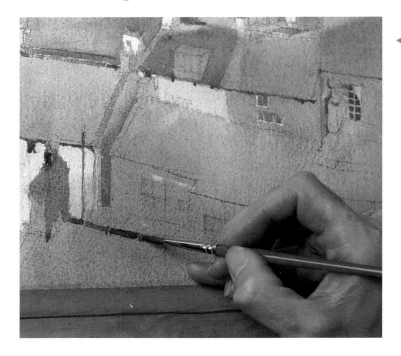

◄ **9** Apply a steely blue wash right across the foreground diagonal shadow – use a mix of cobalt blue/raw sienna/light red. Crisp up the edges of the roofs by painting in the ridge tiles and gable ends in a mix of cobalt blue/raw sienna/permanent magenta – use the No.5 brush for this. Also paint in a few of the windows.

Tip

The mixes used by the artist for this painting are almost all variations on a theme – often containing one or more of the same colours. This means that the colours blend together naturally, none of them jumping out – something to bear in mind when you are mixing washes for your own subjects.

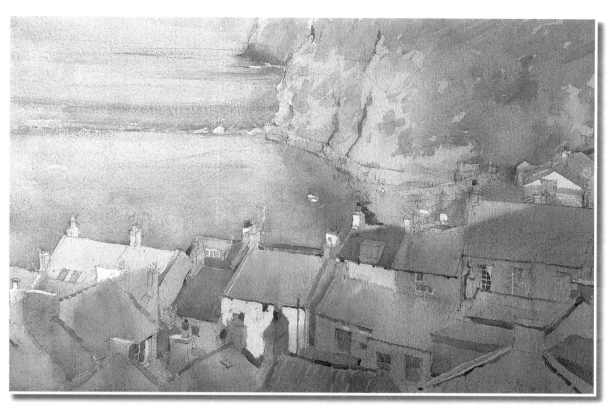

10 Stand back and take an overview. The tones have darkened, but the darks in the buildings in the foreground are stronger than those in the sea and cliffs. The lightest tone – the wall of the house – is also in the foreground. The greatest tonal contrasts are in the foreground.

cobalt blue

mix for amber roof

11 For the amber roof, mix Indian yellow, cadmium red and a tiny touch of cobalt. For the roof behind, add more cadmium red and a little more cobalt blue to the same mix.

cadmium red

Indian yellow

12 Paint the roof next to the amber roof in raw sienna/permanent magenta. Then paint the roof next to it – which is the same colour, but in shadow – in the same mix, adding a little cobalt blue to darken and cool it.

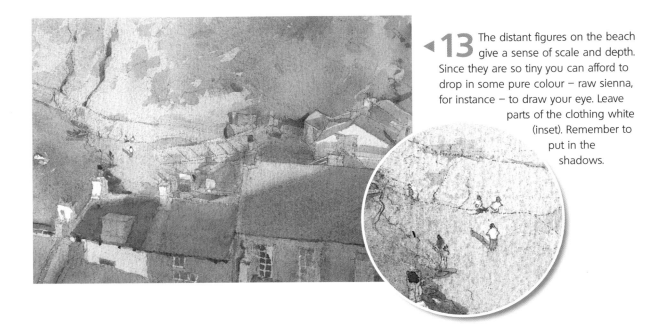

◀**13** The distant figures on the beach give a sense of scale and depth. Since they are so tiny you can afford to drop in some pure colour – raw sienna, for instance – to draw your eye. Leave parts of the clothing white (inset). Remember to put in the shadows.

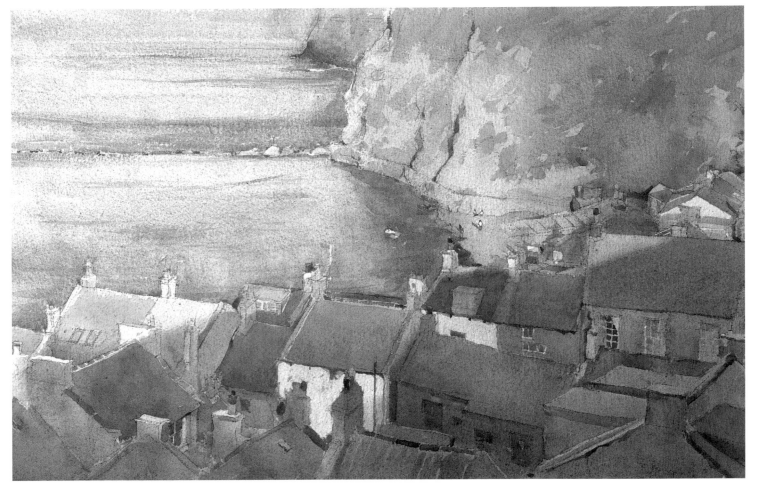

▲**14** To complete the painting, use cobalt blue to put on another glaze – a transparent wash – over the shadow in the foreground. Cobalt is fairly transparent so it cools the colours underneath without muddying them.

FINISHED PICTURE
By using variations of a few basic mixes all over the picture, the painting has inherent harmony, all the colours blending and merging in a pleasing way. The wet-in-wet approach conveys a soft, misty atmosphere typical of a coastal area.

Fishing village
by *David Curtis*

Leafy garden

The flowers and foliage in this shady corner give an overall impression of minute detail, but you don't have to paint every leaf and petal to achieve this realistic effect. Skilful technique is required.

Gardens are a glorious subject to paint, but the details often cause dilemmas. What should you leave in and what should you leave out? The secret is to concentrate on the overall effect and not get bogged down in minute detail.

Start with a pencil drawing of the main shapes. Then approach each plant or cluster of foliage by painting the spaces between them in dark green, so the leaves themselves remain as unpainted white shapes. When this dark tone is almost dry, apply water or a wash of very diluted colour over the entire plant. This lifts some of the dark green, causing it to run into the wet shapes, creating paler green leaves with soft, natural-looking edges.

Watercolour becomes lighter as it dries, so as the painting progresses, you must keep going back to strengthen the darkest tones. Paint the foliage rapidly – a single brushstroke can represent a leaf. Suggest stalks, branches and other linear shapes equally quickly, using the tip of a No.4 brush.

With deft brushwork, you can create effective flower and leaf shapes. Also,

by building up the colour in small strokes, you can leave small flecks of white paper showing between the brushmarks, giving an overall effect of dappled light and shade.

The set-up

A quiet corner of the garden is the inspiration for the painting, but artistic licence can be taken with the flowers and plants.

▼ WATERCOLOUR SKETCH
Before embarking on the painting, try out the light and dark foliage tones on a pencil sketch (see inset bottom left).

▶ PENCIL SKETCH
A preliminary pencil sketch, made on the spot, helps you to decide the final composition of a painting. Here, three silver birch trees are central and a wicker chair is placed just left of centre.

▲ REFERENCE PHOTOGRAPH
A photo provides the detailed information needed to paint the shapes and tones of the flowers and foliage.

What you need

- A 38 x 28cm (15 x 11in) sheet of 640gsm (300lb) NOT watercolour paper
- Drawing board
- Masking tape to fix paper to board
- 2B pencil
- 10 paints: sap green, cadmium yellow pale, cadmium orange, Winsor blue, ultramarine, cadmium red, alizarin crimson, Vandyke brown, burnt sienna, Winsor violet
- Two brushes: No.4 and No.6 round
- Two jars of water
- Mixing palette

◄1 Make a light outline drawing of the subject with the 2B pencil. Using the No.4 brush, start to paint the spaces between the trees in diluted sap green. Add tiny amounts of burnt sienna and ultramarine to create patches of warmer and cooler colour.

sap green

sap green + burnt sienna

sap green + ultramarine

sap green + cadmium yellow pale

►2 Paint the background plants in sap green, varying the mix with small amounts of cadmium yellow pale, burnt sienna or ultramarine. First paint the spaces between the leaves in strong colour. When dry, wash over each plant with dilute green mixes to create pale green leaf shapes.

►3 Continue painting the foliage spaces around the chair in sap green, ultramarine and Vandyke brown. Paint the spaces in the wickerwork in sap green. When dry, paint the wickerwork in mixes of cadmium yellow pale, burnt sienna and alizarin crimson. Add Winsor violet to these for the shadow on the chair back.

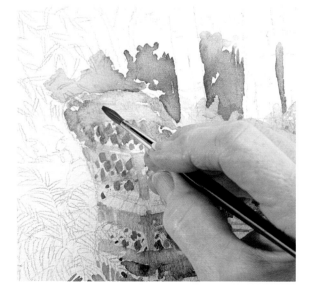

Expert opinion

Q Every plant and tree is a different green. How can I use so many greens yet retain an overall sense of harmony in a painting?

A Use just one green and add small amounts of other colours to this to get different colour variations. Add touches of yellow for bright spring foliage; burnt sienna or red for a warmer green; and blue or purple for a cooler colour. This simple technique gives infinite variety but, because the basic green is the same, your painting retains a sense of integrated colour.

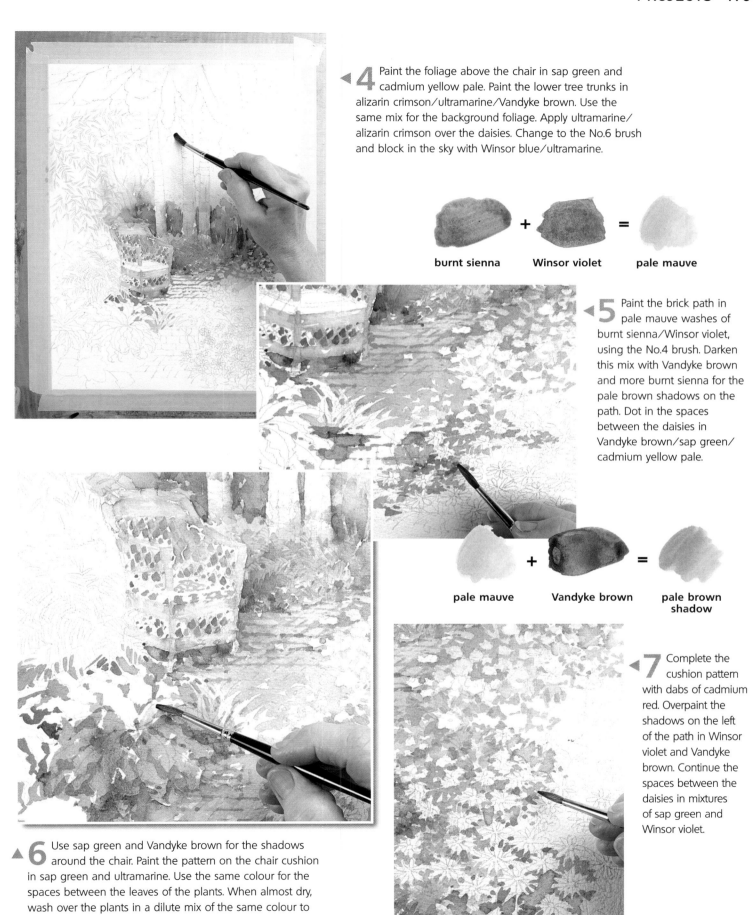

4 Paint the foliage above the chair in sap green and cadmium yellow pale. Paint the lower tree trunks in alizarin crimson/ultramarine/Vandyke brown. Use the same mix for the background foliage. Apply ultramarine/alizarin crimson over the daisies. Change to the No.6 brush and block in the sky with Winsor blue/ultramarine.

burnt sienna + **Winsor violet** = **pale mauve**

5 Paint the brick path in pale mauve washes of burnt sienna/Winsor violet, using the No.4 brush. Darken this mix with Vandyke brown and more burnt sienna for the pale brown shadows on the path. Dot in the spaces between the daisies in Vandyke brown/sap green/cadmium yellow pale.

pale mauve + **Vandyke brown** = **pale brown shadow**

6 Use sap green and Vandyke brown for the shadows around the chair. Paint the pattern on the chair cushion in sap green and ultramarine. Use the same colour for the spaces between the leaves of the plants. When almost dry, wash over the plants in a dilute mix of the same colour to establish the paler green leaves.

7 Complete the cushion pattern with dabs of cadmium red. Overpaint the shadows on the left of the path in Winsor violet and Vandyke brown. Continue the spaces between the daisies in mixtures of sap green and Winsor violet.

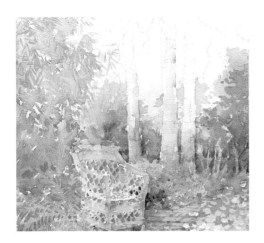

▲8 Paint the tree trunk shadows in diluted Vandyke brown/ultramarine, then wash burnt sienna/cadmium yellow pale into the base of each tree. When dry, apply diluted sap green/ultramarine on the background shrubs. Leave to dry. Use the same colours for the leaves on the left shrub.

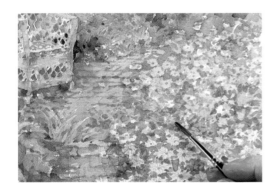

▲10 Use alizarin crimson/cadmium red for the red flowers. Dot in the centres of the daisies with cadmium orange/cadmium yellow pale mix. Strengthen the dark tones and paint a wash of ultramarine/Winsor violet over the farthest daisies.

▶11 Paint the branches and the markings on the tree trunks in Vandyke brown. Curve the lines around the trunks to suggest their solidity and cylindrical form.

FINISHED PICTURE
The many greens are mixed from sap green with the addition of small amounts of other colours. Splashes of bright red and yellow bring the painting to life.

The artist's garden
by *Shirley Felts*

◀9 Paint the branches behind the chair in Vandyke brown. Paint the tree foliage in loose dabs of sap green and ultramarine. Allow flecks of white to show between the strokes to convey an impression of sunlight and dappled shade.

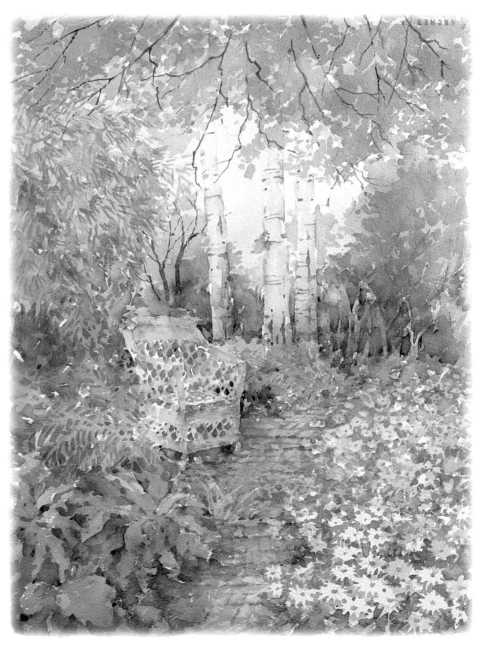

Meandering river

In this glowing woodland scene, layers of spattered paint contrast with blended wet-in-wet colours to produce an almost photographic image – but without the fuss of painting every detail.

To achieve a natural-looking scene, you must paint what you see rather than what you think is there. In this painting, the artist used spattering for a highly textured surface, creating the illusion of foliage layers in perspective. Starting with the palest colour, overlay darker tones – contrasting denser areas of colour with lightly spattered areas – letting the paper shine through to give the impression of dappled sunlight.

In contrast, the water is painted wet in wet to continue the natural look. To achieve reflections in the shadow areas, work the paint quickly into wet paper coated with gum arabic, which slows the drying process, depicting the reflections with vertical strokes and lines overlaid with horizontals. This produces wet, blurred, colour blends; the horizontals give the effect of surface interruptions in a stream of moving water.

The set-up

A slow stream winding through woodland is a popular subject and provides the opportunity to use several different techniques in the same painting.

▲ REFERENCE PHOTOGRAPH
When composing a scenic painting in the studio, spend time studying your chosen landscape from photos taken at different angles. Becoming familiar with the various elements of the scene helps you determine composition, technique and colour range.

▲ ▶ PENCIL SKETCH AND OUTLINE DRAWING
For a scene like this, start by making an energetic rough composition drawing (right). Overlay the sketch with tracing paper and, refining the lines, transfer it to the painting support within a ruled pencil border (above).

◀ TRACE TEMPLATE

What you need

- A 51 x 37cm (20 x 14½in) sheet of Whatman 425gsm (200lb) NOT watercolour paper
- Cartridge paper for masking
- Tracing paper
- Staple gun and staples
- Drawing board
- 2B pencil
- 14 paints: cadmium yellow, lemon yellow, Naples yellow, light red, alizarin crimson, cobalt blue, cerulean blue, indigo, turquoise, cobalt green, phthalo green, burnt sienna, burnt umber, titanium white
- Five brushes: No.2, No.4, No.8, No.10, No.16 sable or sable/synthetic
- Masking fluid plus paint shaper and toothbrush
- Gum arabic, saucer and brush
- Two jars of water
- Mixing palette
- Hair drier
- Paper towel

1 Apply masking fluid to selected areas, using both the paint shaper (shown) and the toothbrush. Contrast strong lines for the bridge and trees with clusters of small dots and flicks for the cow parsley on the right bank of the river and the sunlight glistening through the trees on the opposite bank.

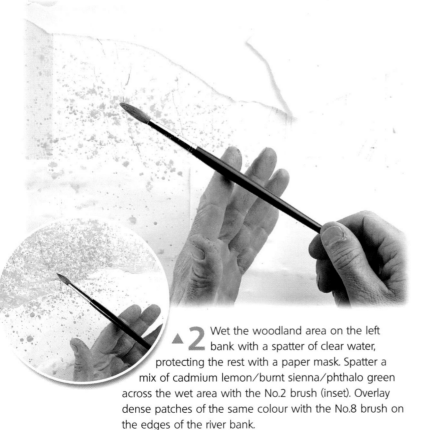

2 Wet the woodland area on the left bank with a spatter of clear water, protecting the rest with a paper mask. Spatter a mix of cadmium lemon/burnt sienna/phthalo green across the wet area with the No.2 brush (inset). Overlay dense patches of the same colour with the No.8 brush on the edges of the river bank.

3 Continue spattering with the same mix on the right bank, alternating brushes for variety of tone and texture. Adjust the paper mask as necessary and blend the colours by spattering clear water over them. Use the No.8 brush to describe the edge of the riverbank. Leave to dry.

◄ **4** Add cobalt green to the mix and mask off the foreground. Then, interchanging the No.16 and the No.8 brushes, intensify the texture and tones of the foliage. Blend with spatters of clean water.

► **5** Mask the top area. Then use the No.8 brush to spatter an open ragged texture on the right bank, flicking clean water in criss-cross movements. Work from the bottom up, making the drops smaller and denser towards the back. Use the same action to overlay greens already mixed on your palette.

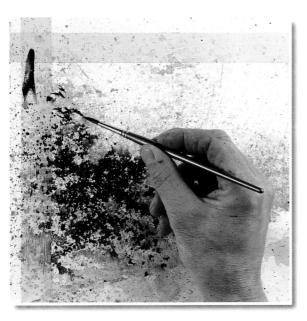

▲ **6** Return to the wooded area on the left. Mix burnt umber with your greens, and spatter in dark shaded tones with the No.8 brush, varying the density and allowing the background colour to show through in places. Use the No.4 brush to drag out a few foliage shapes.

Expert opinion

Q How can I create a variety of different marks using spattering techniques?

A Always use brushes with a fine point. To create a sense of perspective, start with the biggest brush and scale downwards, testing the paint load on a piece of spare paper first. For tiny droplets, spatter from a small brush on to dry paper with a sharp tap of your hand. Larger marks can be achieved with a watery solution on a bigger brush. Spatter on to wet paper to create soft blends. To preserve highlights, spatter masking fluid on to a dry surface – as in Step 1.

▶**7** The illusion of thick, deep woodland is created by the overall variety of spattered and blended paint. Highlights of spattered light red and turquoise add texture, while a small patch of phthalo green brushed on a wet surface at the far end of the river suggests a grassy glade.

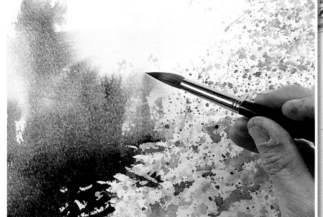

▲**8** Wet the river area to help the colour spread. Mix phthalo green/indigo and paint the reflection of the sky in the water with the No.10 brush, laying vertical strokes over horizontal. Work the brushstroke from the bottom upwards. Leave to dry.

Tip

Stapling the paper to the board along each edge provides a good support and avoids the need to stretch the paper in advance.

▶**9** Working quickly into a wet surface and allowing the paint to blend creates the impression of a quivering reflection on water. The illusion of depth is enhanced by intensity of tone against the tiny dots of masking fluid.

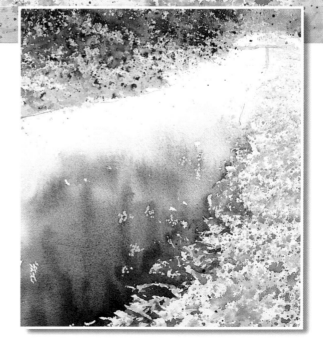

▶**10** Use a mix of greens and alizarin crimson and the No.4 brush to darken the foliage, adding bright marks in pure turquoise and light red. Define the river edge in palette colours overpainted with turquoise and cadmium yellow. Use dark palette mixes for the main tree trunk (inset), wetting the paper first. Then drag out the colour of the branches with the tip of the brush.

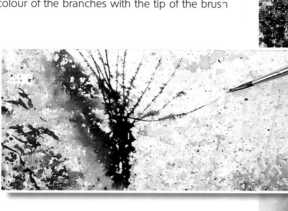

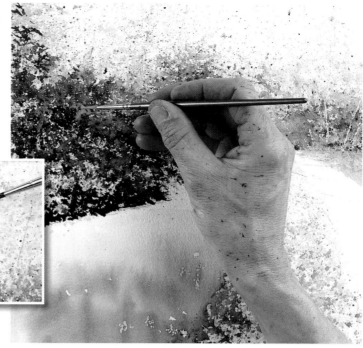

◀**11** Paint the thinner tree trunks right at the back with the No.4 brush and a mix of cobalt green, light red and cobalt blue, working the colour from the bottom upwards. Blend the trunks into the foliage with a wash of clear water. Indicate the branches with fine sweeping strokes.

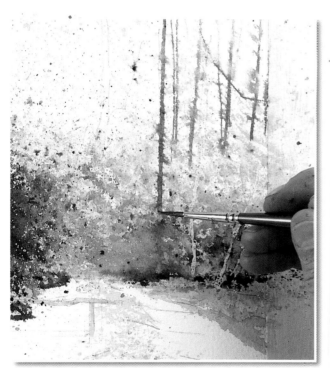

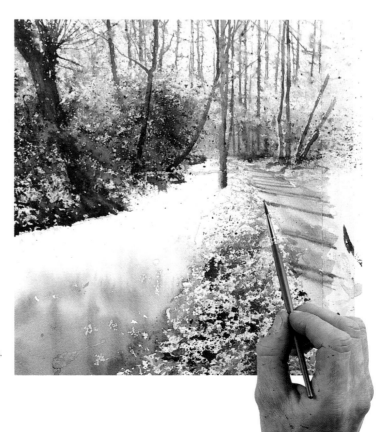

▶**12** Paint in the tall thin trees in front of the background ones, adding shadows to the trunks with the No.4 brush and a mix of light red and cobalt green. Dilute the mix to wash in the path, adding in darker palette tones for the shadows. Darken the verge with a spatter of green.

◀**13** Make a strong mix of cerulean for the water by the bridge. Wet the paper first and apply gum arabic – pour a little in a saucer and brush on with a clean brush. Use vertical strokes of the No.4 brush to paint the water. Now paint in the water by the left bank in cadmium lemon/Naples yellow, letting the background colour show through. Add in strong contrasting lines of crimson and green.

▲**14** Alternating the No.4 and No.16 brushes, paint in tree reflections with a mix of crimson and green, keeping the paper wet. Accentuate bands of colour under the bridge, and paint vertical zigzag lines in Naples yellow. Use a dark palette mix to create horizontal shimmer lines.

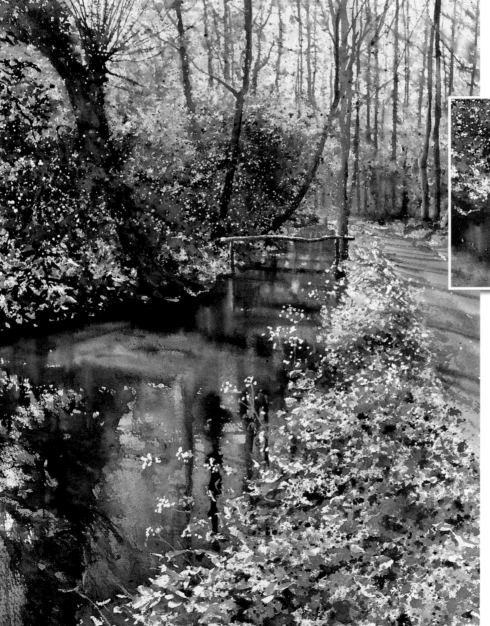

▲**15** Lift out flashes of light reflections in the water with the clean No.4 brush and water. Adjust the colour tones in the landscape as required. When the painting is dry, rub off the masking fluid with your fingers.

◀**16** Stand back and assess your work for tone and contrasts. Then, using the No.4 brush, lightly paint in the cow parsley stems in a mix of lemon yellow/titanium white.

FINISHED PICTURE
Notice how effective the contrast is between the crisp spattered areas and the parts painted softly wet in wet. The bright highlights left by the masking fluid give sparkle and create the appearance of sunlight filtering through the trees.

Meandering river
by *Joe Francis Dowden*

Farmyard scene

To paint a scene like this successfully requires careful observation of the landscape, the farm buildings and the animals – all of which require different skills to portray convincingly.

When faced with a composite scene with several different elements, under constantly changing light, it pays to reduce the features to their essentials, and to use simple painting techniques. For example, a piece of farm machinery can be successfully painted using just a few economical brushstrokes. Here the artist used the traditional watercolour method of working from light to dark, and from the broad to the detailed. The result of working methodically and simply in this way is a painting that seems both effortless and exhilarating.

The cows and chickens weren't actually there, but were added to bring life and character to the picture. The artist used his imagination, and existing sketches as reference, and took care to draw the animals in correct proportion to their surroundings.

Tip

French ultramarine and raw sienna are good colours for painting cloudy skies. Interestingly, the two colours don't turn green – as you might expect – even when applied wet in wet.

The set-up

This project provides the opportunity to explore the contrasts between the organic forms of the sky and trees and the hard-edged shapes of the man-made structures.

▼ Trace template

▲ Pencil sketch
The finished painting is loosely based on this sketch, but the cows have been moved back into the middle distance in order to present a more cohesive design.

What you need

- A 56 x 39cm (22 x 15in) sheet of 640gsm (300lb) Saunders Waterford Rough watercolour paper
- Drawing board
- HB pencil
- 10 paints: French ultramarine, raw sienna, burnt sienna, burnt umber, alizarin crimson, light red, cadmium yellow, Winsor red, Winsor blue (red shade), Payne's gray
- Four brushes: No.16 and No.8 rounds; No.3 rigger; 5cm (2in) flat
- Two jars of water
- Mixing palette
- Paper tissues

▲**1** Draw the buildings and animals with the HB pencil, using the sketches as a guide. In separate wells of the palette, mix three washes: raw sienna; ultramarine with a touch of alizarin crimson; and a dark blue mixed from ultramarine/burnt umber. Dampen the lightest part of the sky and touch in some raw sienna with the edge of the flat brush.

◀**2** Paint the blue sky from the top with the ultramarine/alizarin mix. Use the tip and body of the No.16 brush to make ragged strokes, leaving patches of underwash for the light clouds. Make the wash paler towards the horizon, and the marks smaller, to create recession in the sky.

ultramarine

sky wash

alizarin crimson

▶**3** While the blue wash is still wet, dab the edges with crumpled tissue to soften them and blend them naturally into the raw sienna wash.

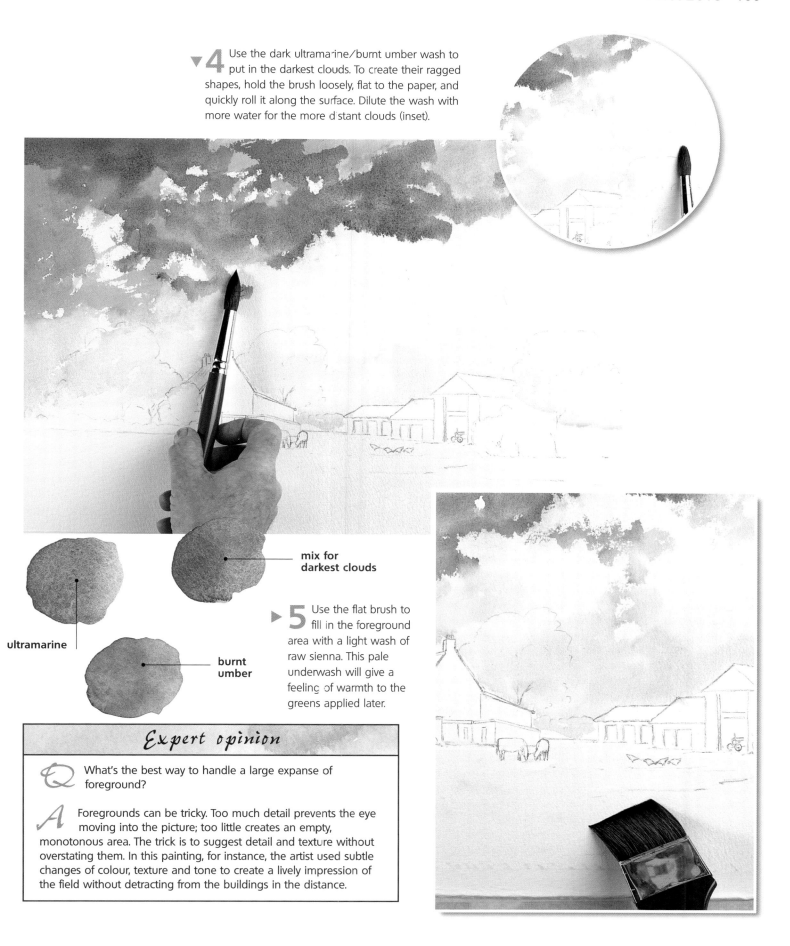

4 Use the dark ultramarine/burnt umber wash to put in the darkest clouds. To create their ragged shapes, hold the brush loosely, flat to the paper, and quickly roll it along the surface. Dilute the wash with more water for the more distant clouds (inset).

ultramarine

mix for darkest clouds

burnt umber

5 Use the flat brush to fill in the foreground area with a light wash of raw sienna. This pale underwash will give a feeling of warmth to the greens applied later.

Expert opinion

Q What's the best way to handle a large expanse of foreground?

A Foregrounds can be tricky. Too much detail prevents the eye moving into the picture; too little creates an empty, monotonous area. The trick is to suggest detail and texture without overstating them. In this painting, for instance, the artist used subtle changes of colour, texture and tone to create a lively impression of the field without detracting from the buildings in the distance.

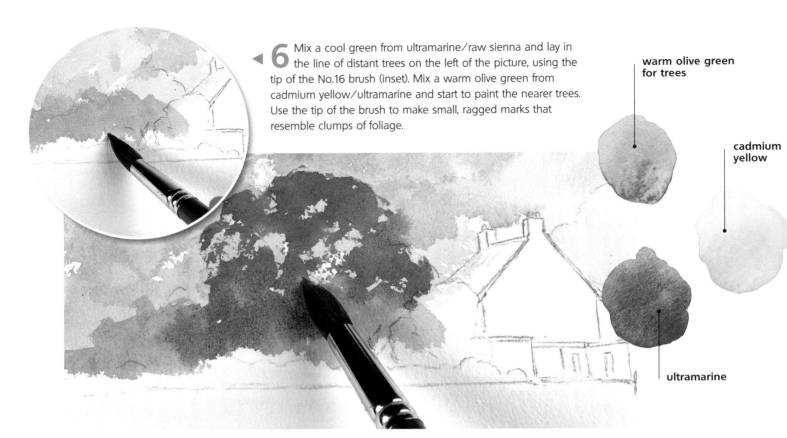

6 Mix a cool green from ultramarine/raw sienna and lay in the line of distant trees on the left of the picture, using the tip of the No.16 brush (inset). Mix a warm olive green from cadmium yellow/ultramarine and start to paint the nearer trees. Use the tip of the brush to make small, ragged marks that resemble clumps of foliage.

warm olive green for trees

cadmium yellow

ultramarine

7 To suggest shadows and darker clumps of foliage, add touches of Payne's gray wet in wet, using the tip of the brush. Make the middle tree slightly paler and bluer to push it farther into the distance. Put in the smaller trees, adding some cadmium yellow to the mix for the golden foliage and some Winsor blue for the dark, warm greens.

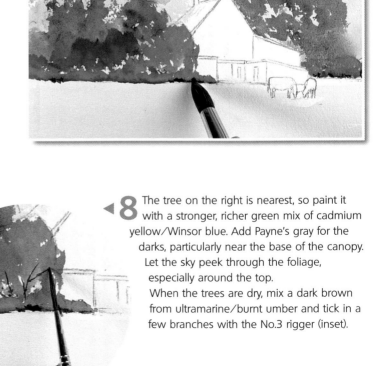

8 The tree on the right is nearest, so paint it with a stronger, richer green mix of cadmium yellow/Winsor blue. Add Payne's gray for the darks, particularly near the base of the canopy. Let the sky peek through the foliage, especially around the top.
When the trees are dry, mix a dark brown from ultramarine/burnt umber and tick in a few branches with the No.3 rigger (inset).

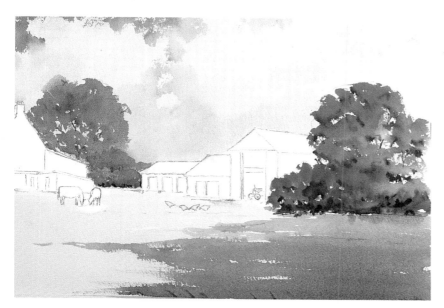

◄9 Mix a warm green from cadmium yellow and Winsor blue and dilute it to a thin wash. Put in the shadow on the grass in the foreground with the edge of the flat brush. To give the effect of perspective, make the wash weaker in the distance and strengthen it with a little ultramarine/burnt umber in the front.

shadows on the grass mix

cadmium yellow

Winsor blue

ultramarine

burnt umber

►10 Mix a dark green from cadmium yellow and Payne's gray and use with the No.8 brush to paint some dark tree foliage behind the farmhouse roof. This will bring the house forward and accentuate the red of the roof. Paint the roof with light red, then float on some ultramarine to give it an aged look.

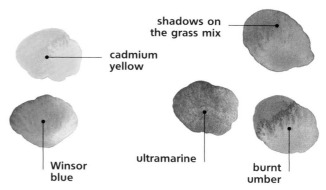

◄11 Use light red to paint the walls and roofs of the barns, weakening the tone and cooling the colour with a hint of ultramarine as they go back in space. Add burnt umber/burnt sienna to the mix and suggest the roof tiles with the rigger. Use Payne's gray and the No.8 brush for the corrugated iron parts of the barn.

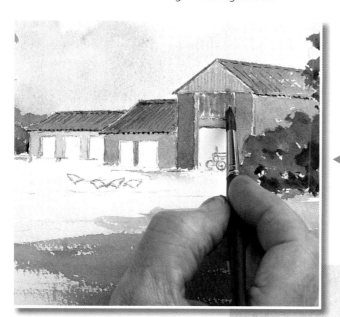

►12 Suggest just a few bricks on the nearest barns. Mix ultramarine/burnt umber for the barn interiors, adding a stronger tone for the deeper shadows. Add touches of yellow and the brick colour to suggest straw spilling out of the doorways.

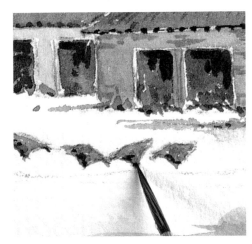

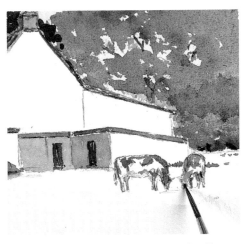

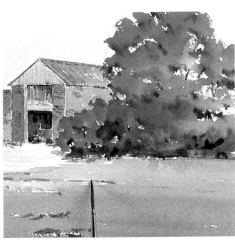

▲**13** Paint the tractor with Winsor red and Payne's gray, leaving flecks of white paper for highlights. Use the rigger to paint the hens in the brick colour. Add Payne's gray shadows to hint at their form. Make the cockerel darker, and put in his red comb.

▲**14** Mix ultramarine and a touch of burnt umber for the shadows on the walls of the house. Darken the mix with more burnt umber for the doors. Use the rigger brush to paint the brown patches on the cows, using the same mix as for the hens.

▲**15** Strengthen the foreground with raw sienna, adding streaks of brown and grey. When dry, mix the green used in Step 11 to extend the grassy area right across the immediate foreground. Tick in patches of mud and clumps of grass with the rigger.

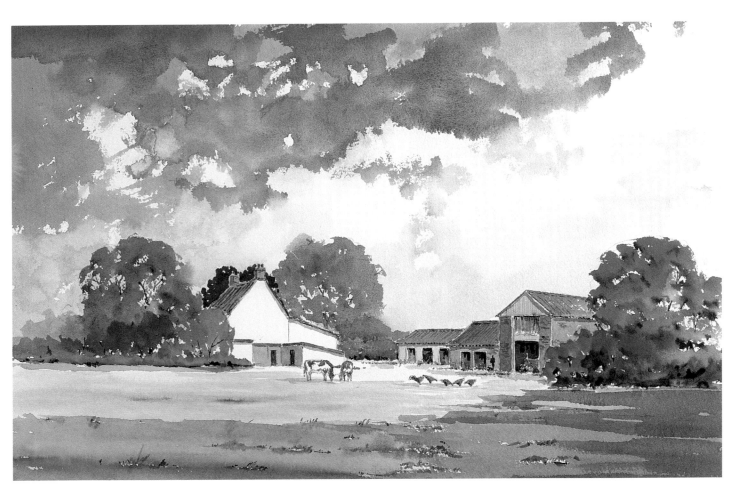

▲**16** To finish off, use ultramarine/burnt umber and the No.8 brush to put in shadows on the grass on the right. Dilute the wash and put in the shadows under the eaves and those cast by the barn, the cows and the hens. Add a touch of colour with a tiny figure in front of the barn, using Winsor red and Payne's gray.

FINISHED PICTURE
This shows how useful shadows can be in a composition. The shaded foreground frames the view and gives depth to the scene.

Church Farm
by *Frank Halliday*

Lakeside landscape

Use graded washes to capture the progression of colour from sky to horizon to foreshore. The wet-in-wet approach produces smoothly blended brushstrokes and, where two colours meet, soft blurred lines.

The sweeping expanses of water and sky in this picture (see page 192) are painted in graded washes, that is washes that change gradually from dark to light, or from light to dark, or are laid in two or more colours.

Working down from the top of the paper, the areas of sky were applied in broad, overlapping strokes, starting with a diluted blue/green. A little more paint was added to the wash mixture for each fresh stroke, making the colour progressively brighter and stronger towards the horizon. The water was painted light in the distance where it reflects the sky, and increasingly darker towards the foreground shoreline as it picks up shadows and reflections from the surrounding landscape.

The colours in the sky and water also vary markedly from top to bottom. Add ultramarine to the wet blue/green sky at the horizon and a strong, dark indigo to foreground water.

▼ *REFERENCE PHOTOGRAPH*
A photograph of a crofter's cottage provided ample information and architectural detail to create the cottage in the landscape.

The set-up

The lakeside view was painted from an on-the-spot sketch, but the artist felt a more specific reference – borrowed from a photograph – was needed for the whitewashed cottage.

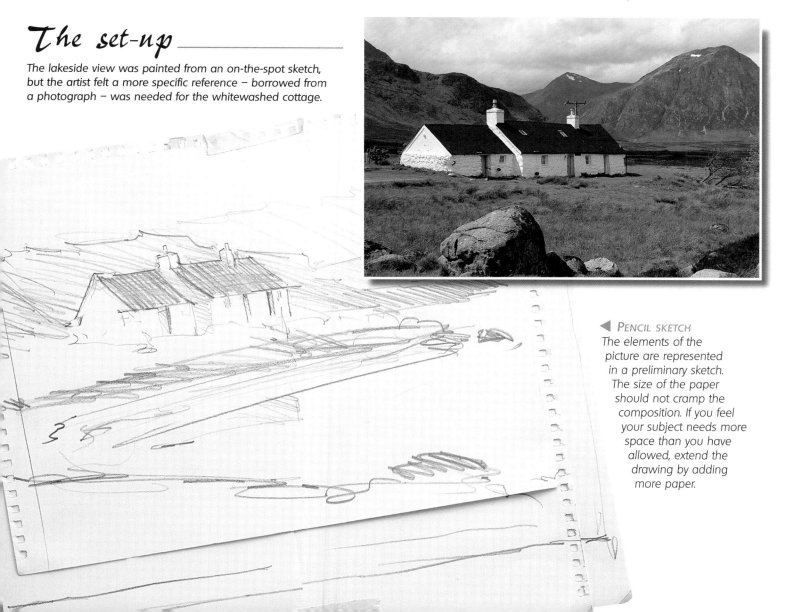

◄ *PENCIL SKETCH*
The elements of the picture are represented in a preliminary sketch. The size of the paper should not cramp the composition. If you feel your subject needs more space than you have allowed, extend the drawing by adding more paper.

What you need

- A sheet of stretched 38 x 50cm (15 x 21in) NOT watercolour paper
- Staples and staple gun for stretching paper
- Tracing paper
- Masking tape
- Drawing board
- B and 4B pencils
- Eight paints: cobalt blue, burnt sienna, Winsor blue, Winsor green, indigo, ultramarine, cadmium lemon, quinacridone red
- Three brushes: No.4, No.8, No.16 round sable
- 50mm (2in) soft flat brush for wetting the paper
- Two jars of water
- Mixing palettes

1 Make an outline drawing of the subject on tracing paper with the B pencil. Turn it over and scribble over the drawn lines on the reverse side of the tracing paper with the 4B pencil. Place the trace, right side up, on the stretched watercolour paper and tape it down with masking tape. Pressing firmly, go over the lines of the original drawing (inset right) with the B pencil.

2 Peel back the tracing paper to reveal the outline drawing of the subject on the watercolour paper (inset right). If the drawing is very pale, lightly redefine the lines with the B pencil so you can see them clearly.

3 A good technique if your paper is large and heavy is to staple it firmly to a board. Then, to ensure a crisp edge to the painting, stick masking tape around the picture area (inset far right). Press the tape down firmly to prevent the watercolour seeping underneath.

quinacridone red

burnt sienna

cobalt blue

4 Working around the gables of the cottage, wet the picture area with clean water using the flat brush. Leave a few flecks of dry paper on the far shoreline to indicate distant buildings. Mix a cool grey-purple wash from cobalt blue, burnt sienna and quinacridone red. Use the No.16 round brush to apply the wash in overlapping horizontal strokes, allowing the colour to run freely into the wet areas. Remove the masking tape (inset). Let the painting dry; then renew the tape before moving on. This prevents a build-up of dark colour around the edge of the painting.

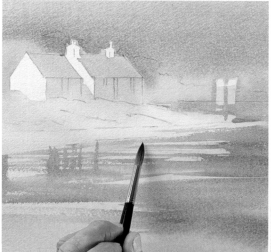

5 Wet the sky and lake areas with clean water. Apply a wash of Winsor blue and Winsor green to the sky with the No.8 brush. Strengthen the colour as you near the horizon. Add a little indigo to the mix and paint the water, leaving streaks of unpainted undercolour to indicate reflected light. Add a few vertical strokes, lining these up with the cottage for the reflection of the building.

ultramarine

indigo

blue/green sky mix

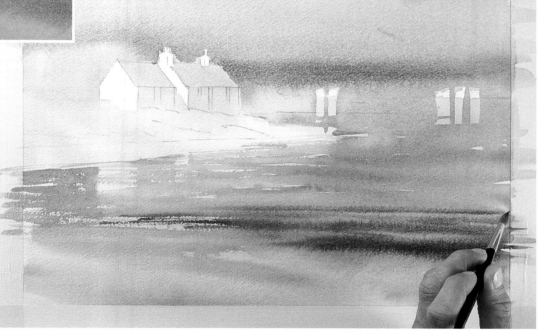

6 While the paint is still wet, add a little ultramarine to the sky just above the horizon line. Then add a little indigo to the lake colour and paint a few horizontal streaks on the surface of the water. Increase the indigo for the darker foreground water.

Expert opinion

Q What should I do when I am working from more than one reference and the light in the various sketches and photographs is coming from different directions?

A The light source in your painting must be consistent, otherwise the composition will look odd and the subject appear unconvincing. Choose your source of light before you start work and stick to it. In this painting the direction of sunlight on the cottage was changed from that in the photograph in order to establish a strong light source from the left-hand side of the picture.

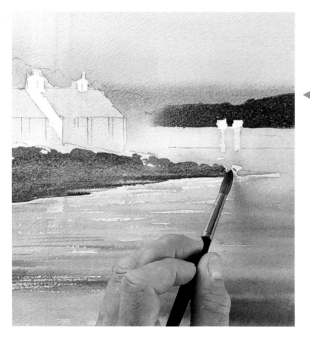

7 Wet the horizon of the distant hill. Paint the hill in a mixture of ultramarine and burnt sienna, allowing the colour to flood into the damp horizon line.

Paint the land immediately in front of the cottage in ultramarine and cadmium lemon with a touch of burnt sienna, leaving it jagged along the upper edge.

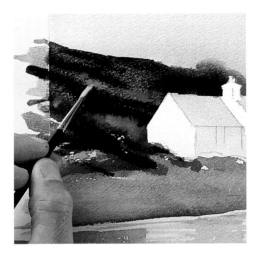

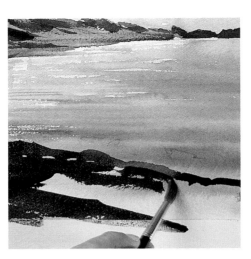

▲**8** Wet the sloping hill behind the cottage. Paint the wet area in a mix of deep burnt sienna/cadmium lemon/indigo. Drop a few streaks of cadmium lemon into the wet painted colour. Extend streaks of the same mix in front of the cottage.

▲**9** Paint the foreground in mixes of burnt sienna and indigo. Use the No.4 brush to define the roofs, windows and doors with a fine indigo line. Make a pale mix of cobalt, quinacridone red and burnt sienna and block in the windows and doors.

▲**10** Darken the roof with diagonal strokes of cobalt blue/burnt sienna. Make sure the roof is paler than the background. Still using parallel strokes, add flecks of burnt sienna and lemon yellow to represent the lichen on the roof tiles.

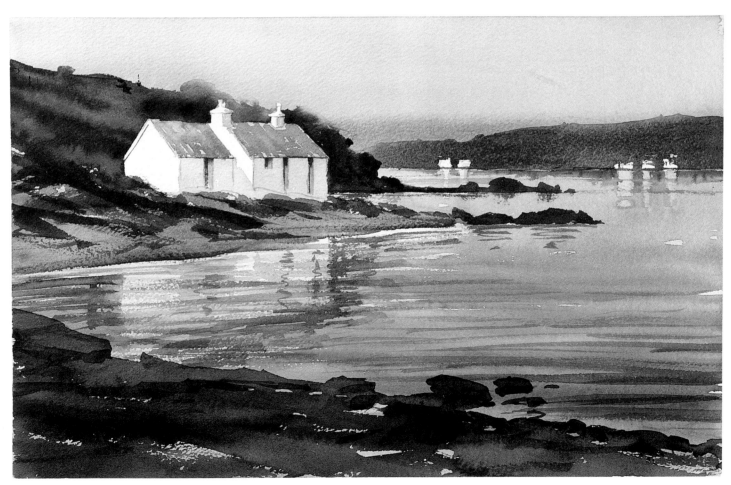

▲**11** To finish the picture, add some dark horizontal and zig-zag shadows to the water in indigo with a touch of burnt sienna. Use broad strokes for the foreground shadows and narrow ones for the distance.

FINISHED PICTURE
Note how the blurred contours of the distant hills contrast with the sharp brushstrokes and clearly defined shapes of the middle and near distance. The difference between the two effectively conveys a feeling of space and atmosphere.

Lakeside cottage by *Joe Francis Dowden*

Topiary garden

A group of clipped box hedges standing in rough meadow offers a wealth of intriguing shapes and natural textures.

Topiary is often associated with neat, well-tended flowerbeds and manicured lawns, but in this scene there is a charming contrast between the formal precision of the trees and the rough meadow-like grass in which they stand. With its strong, geometric shapes and crisp, graphic outlines, topiary is the visual antithesis of all that is graceful and flowing in nature.

In this painting, the artist used loose, free brushstrokes to depict the softness of the long grass – a perfect foil for the hard-edged trees, which he rendered with more precision and control. He made skilful use of a limited palette to create a harmonious range of greens, while the addition of gum arabic to the washes helped the paint to flow, creating convincing foliage textures.

▲ FINISHED PICTURE
The picture exploits the vibrant complementary pairing of red and green – among so much greenery, the warm red-brown of the house draws the eye.

The set-up

After choosing the viewpoint for this composition, the artist exercised discretion to omit some tousled shrubs, leaving the long grass as the only untamed element in the orderly scene.

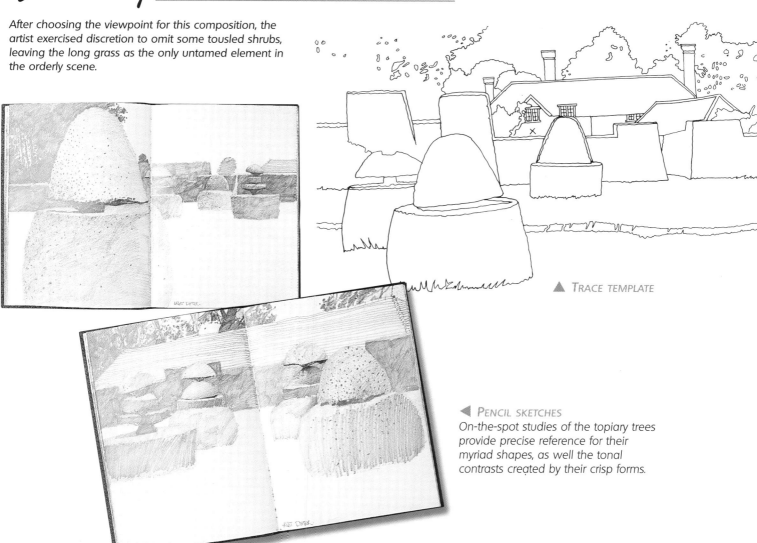

▲ TRACE TEMPLATE

◀ PENCIL SKETCHES
On-the-spot studies of the topiary trees provide precise reference for their myriad shapes, as well the tonal contrasts created by their crisp forms.

What you need

- A 55 x 36cm (21½ x 14¼in) sheet of Bockingham 425gsm (200lb) NOT watercolour paper, stretched on to a drawing board with gummed brown paper tape
- Spare sheet of watercolour paper, measuring approximately 55 x 25cm (21½ x 10in)
- HB and B pencils
- 10 paints: phthalo blue, sap green, yellow ochre, cadmium yellow, Payne's gray, sepia, burnt sienna, brown madder alizarin, raw umber, black
- Five brushes: No.1, No.4, No.6, No.12 round; 13mm (½in) flat
- Gum arabic
- Two jars of water
- Mixing palette

▲**1** Sketch the outlines of the subject lightly on to the stretched paper with the HB pencil. Mix a very dilute wash of phthalo blue and block in the sky with the No.12 round brush, working round the topiary trees, the roof and the chimneys.

◀**2** Use the No.12 brush and a light mix of sap green/yellow ochre for the hedge, trees and grass in front of the house. Wash over the entire area with loose, free brushstrokes, keeping the foreground open. Don't worry if the wash bleeds into the sky a little – the distant trees will hide that. Leave to dry.

hedge and grass colour

yellow ochre

sap green

burnt sienna

Payne's gray

colour for buildings

▶**3** Use a loose grey-brown mix of burnt sienna/Payne's gray and the No.12 brush to paint the buildings. Paint round the shrubs at each end of the building, and reserve the whites of the eaves, windows and the white weatherboard wall. Allow the paint to dry.

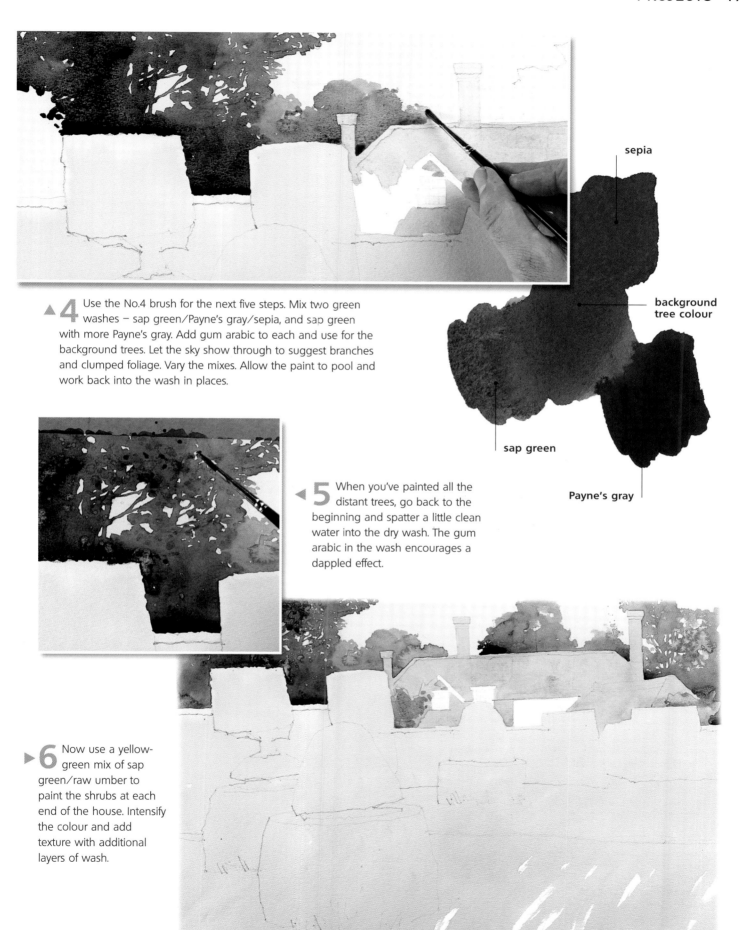

4 Use the No.4 brush for the next five steps. Mix two green washes – sap green/Payne's gray/sepia, and sap green with more Payne's gray. Add gum arabic to each and use for the background trees. Let the sky show through to suggest branches and clumped foliage. Vary the mixes. Allow the paint to pool and work back into the wash in places.

sepia

background tree colour

sap green

Payne's gray

5 When you've painted all the distant trees, go back to the beginning and spatter a little clean water into the dry wash. The gum arabic in the wash encourages a dappled effect.

6 Now use a yellow-green mix of sap green/raw umber to paint the shrubs at each end of the house. Intensify the colour and add texture with additional layers of wash.

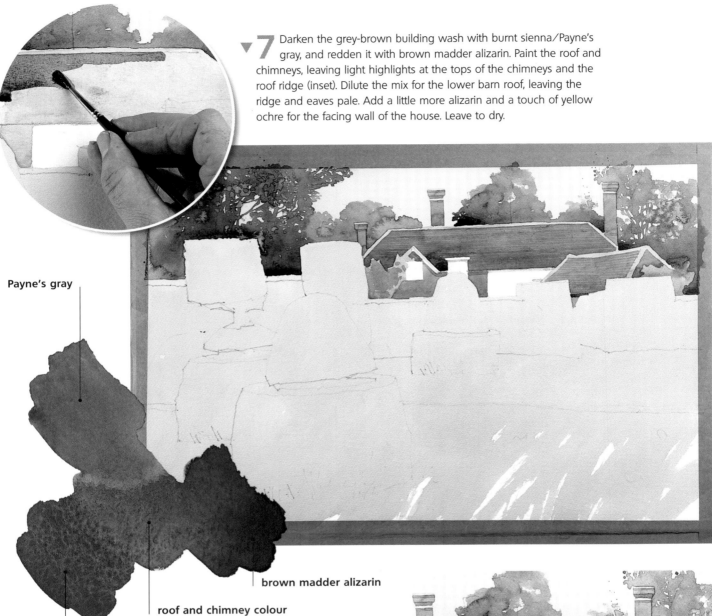

▼7 Darken the grey-brown building wash with burnt sienna/Payne's gray, and redden it with brown madder alizarin. Paint the roof and chimneys, leaving light highlights at the tops of the chimneys and the roof ridge (inset). Dilute the mix for the lower barn roof, leaving the ridge and eaves pale. Add a little more alizarin and a touch of yellow ochre for the facing wall of the house. Leave to dry.

Payne's gray

brown madder alizarin

roof and chimney colour

burnt sienna/ building wash

Tip

Grass is never flat – long grass especially has depth and texture. To render it sensitively, you need to create an internal dynamic with your brushstrokes to give it movement. Echo the direction of growth or the way the wind is blowing it, building up tone and texture with overlaid brushmarks for depth but not solidity.

▶8 Add a touch of black to the building wash and use the tip of the brush to suggest the rows of roof tiles. Paint the shadows under the eaves in Payne's gray. To add the final details to the building, change to the No.1 brush, and paint the window panes with black/Payne's gray. Use the B pencil to draw the weatherboard lines.

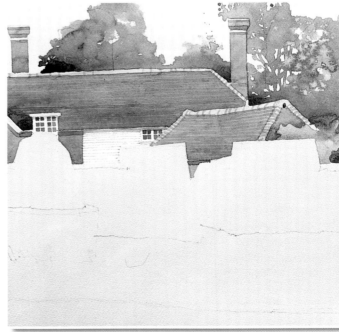

◄**9** Return to the foreground. Go back to the first sap green/yellow ochre wash and add plenty more yellow ochre. Use the No.6 brush to paint the long grass with loose, energetic strokes. Keep the brushwork free and open, changing the direction of the marks slightly from time to time. Leave to dry.

▶**10** Build up the texture of the long grass with a second layer of the same wash. Use the edge of the flat brush, and spatter a little wash here and there for varied effects. When dry, repeat the process a third time, deepening the texture still more. Finally soften the brushmarks in places with clean water and the No.12 brush to suggest the haze of feathery grasses.

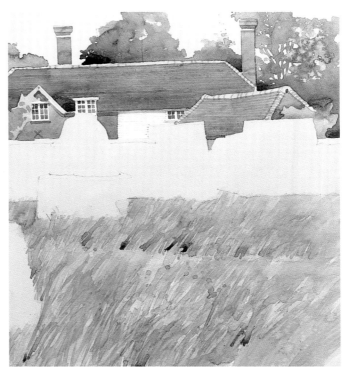

▶**11** For the path across the long grass, tear the spare sheet of paper in half lengthways. Place the two halves across the support with a small gap between. Darken the grass wash and brush vertically across the gap with the flat brush (inset above). Leave it for a minute, then lift off the masks (inset right). This creates a soft, expressive edge for the mown pathway.

▲ **12** Use the No.4 brush for the rest of the painting. Make a bright green mix of sap green/cadmium yellow and paint the topiary and hedge. Use a wetter wash in some places so it dries unevenly, hinting at the texture of the clipped foliage.

▲ **13** Mix sap green/raw umber/sepia and gum arabic. Paint the hedge first, then the trees in front. Leave highlights on the horizontal surfaces and create broken textures to suggest the foliage. Let the paint pool in places to create varied tones.

▲ **14** Darken the green mix with sepia and touches of brown madder alizarin/Payne's gray. Paint the long hedge first to separate it from the trees. Depict the texture of the hedge with broken colour, and spatter on clean water to open up the wash.

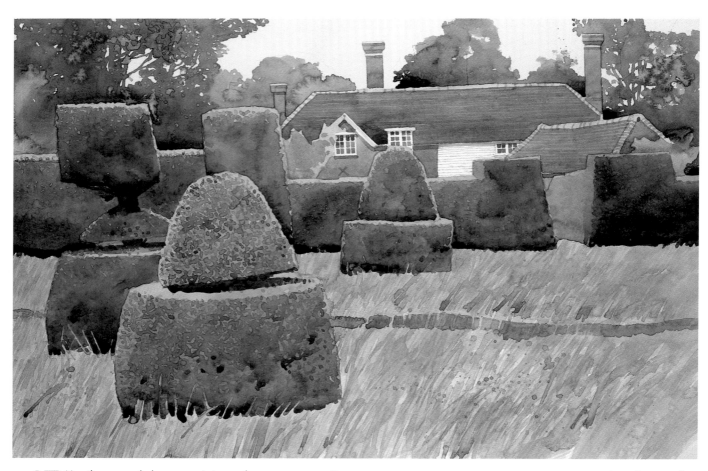

▲ **15** Use the same dark green mix to work up the topiary trees, adding raw umber and black to the wash for the areas of deepest shadow. To advance the nearest tree, bring the foliage detail into focus with small individual leaf-shapes, dabbing with the tip of the brush.

FINISHED PICTURE
Notice how the gum arabic helps to deepen the textural effects, emphasizing still more the contrast between the soft, long grass and the crisply trimmed small leaves of the topiary.

**A topiary garden
by Ian Sidaway**

Harbour steps at low tide

Versatile yet subtle, delicate earth-colour mixes are ideal for capturing this harbour scene, rich in ochres, umbers and browns.

Earth colours are complex – often slightly muted versions of primaries or secondaries. Yellow ochre is a neutralized yellow-orange, for example, while Venetian red is a soft brownish red. They are wonderful colours to use. Intense but never garish, they can produce some highly useful mixes.

Here the artist began with watery washes of raw sienna with a little blue, green or red added. These knocked back the white of the paper and made a good base for the colours laid on top. He used Rough paper with a slightly waxy surface that resists the water and allows the paint to create pools of colour. These dry with crisp edges, while the pigment often separates and tiny particles settle in the indents of the paper to create a grainy texture.

Tip

If you stick some tracing paper to the board all around the watercolour paper, you can use it to try out the hue and intensity of each colour before you apply it to the actual support.

The set-up

Earth colours are perfect for this scene. The artist worked on a slightly raised board, so the paint ran down the paper and pooled at the edge of each brushstroke.

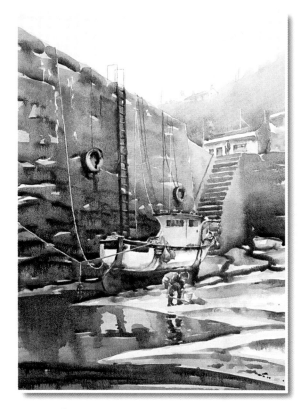

▲ FINISHED PICTURE
The painting was done on a cold morning in March, when the colours of nature appear rather muddy – perfect for a palette of earth colours.

◄ TRACE TEMPLATE

What you need

- A 55 x 38cm (21½ x 15in) sheet of 300gsm (140lb) Rough NOT watercolour paper
- Drawing board
- 2B pencil; putty rubber
- Masking fluid
- 12 paints: olive green, raw sienna, burnt sienna, burnt umber, Indian red, rose madder alizarin,
- Winsor blue, cobalt blue, cerulean blue, French ultramarine, cadmium red deep, cadmium yellow
- Seven brushes: 22mm (⅞in) flat; No.2, No.4, No.5, No.6, No.12 round; old No.1 for masking fluid
- Two jars of water
- Mixing palettes
- Tissues

▶ **1** Sketch the composition with the 2B pencil. Mix Indian red/cobalt blue/raw sienna and wash over sky, houses and hill with the No.12 brush. Change to the flat brush, add more raw sienna/cobalt blue to the wash and brush over the walls. Apply cerulean over the boats. Add more raw sienna/cobalt blue/olive green for shadows on the seabed.

◀ **2** Dab off paint from the houses with tissue. Leave to dry. Apply masking fluid with the old brush to the boat ropes and those on the wall to the left of the ladder (leave the ones on the right unmasked), the tyres, ladder, flagpoles and masts on the angling shop. Leave to dry.

▶ **3** Paint the chimneys, roof and windows of the house in cobalt/Winsor blue with the No.4 brush. Paint the house front in raw sienna/Indian red. Let the wash spread on to the hillside. Add more of this and cobalt/olive green along the top – let it spread into the sky. Moving down the hillside, drop in cobalt and Indian red separately. Apply burnt sienna/olive green over the shop roof, leaving some speckles of white. Leave a white strip and add raw sienna under it along the wall. Darken this wash for the side of the building and use a raw sienna/ultramarine wash on the windows.

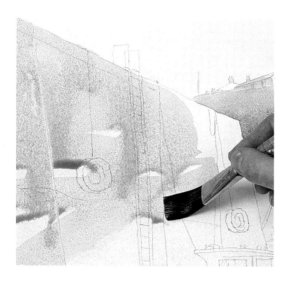

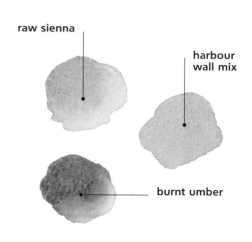

raw sienna

harbour wall mix

burnt umber

4 Use the flat brush with a very loose wash of raw sienna and a touch of burnt umber for the harbour walls. Let it run down and collect in pools at the edge of the brushmarks, leaving flat breaks like slits here and there to suggest old stones. Run a darker streak over the ladder.

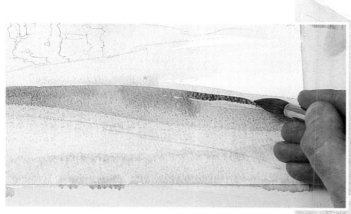

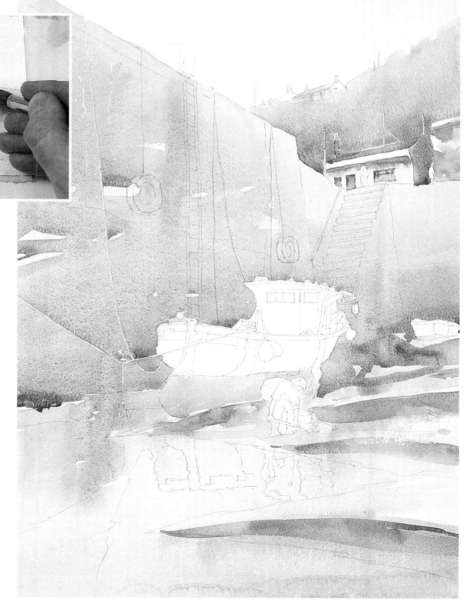

5 Dash some horizontal washes of the previous mixes on to the sandy bed on the foreground right, adding more cobalt along the top edges and letting it spread down to suggest the effect of the water on the seabed with tidal movement.

6 Paint the walls and foreground with mixes of raw sienna/olive green. Add burnt umber/cobalt to darken the foot of the wall on the left, and more cobalt with burnt umber for a bluer wall at the back right. Let this wet paint run down and pool to create edges with denser pigment. Use the No.5 brush to paint around the boat and figure. Paint the keel and build up the shadow under it. Leave to dry. Apply masking fluid on the ropes to the right of the ladder and in a few places from the top of the wall.

7 Paint the stones at the top of the left wall with the No.12 brush and burnt umber/cobalt/raw sienna. Work down, adding more cobalt or burnt umber. Leave some strips bare; let other areas run and spread. Drop in Indian red or raw sienna for rusty tones. Suggest the tidemark in ultramarine and burnt umber. Use the No.5 brush to paint around the boat.

8 Paint the steps in burnt sienna/raw sienna/cobalt. Drop Indian red/cobalt into the wet colour on the right wall – adding burnt umber farther down. Wet the muddy trails, then paint them with this mix. Wash raw sienna on the wheelhouse. Drop in rose madder alizarin/cerulean to suggest the sun on white paintwork. Paint parts of the roof in cerulean/raw sienna. Paint the deck on the right in cobalt/rose madder/burnt sienna.

9 Use the No.4 brush and burnt umber/cobalt for shadows on the wheelhouse roof. Carry on with these colours for the windows – add cadmium yellow for the wheelhouse curtains. Paint the stern with cobalt/raw sienna/burnt sienna. Use cobalt and burnt umber for the rudder blade and raw sienna for the rust on the hull. Paint the keel with a mix of palette colours. Model the boat by layering the shadows and rust. Let the paper dry between each layer.

olive green

burnt sienna

mix for tyres

ultramarine

raw sienna

10 Rub off the masking fluid. Paint the tyres with olive, burnt sienna, ultramarine and raw sienna, building up the shadows underneath to help place the tyres against the wall. Let some colour bleed down the wall and lift out colour from the tyres with a wet brush to model their form. Paint the ladder in the same way with a similar colour mix. Lift off paint for the highlights on the rungs.

◄11 Using the No.12 brush, wash in wet layers of cerulean, cobalt, raw sienna and rose for the foreground water. Paint a darker wash at the foot of the side wall with raw sienna/cobalt and add burnt sienna for the shadows under the boat. Use the No.4 brush for the smaller boat, with washes of raw sienna and cobalt. Apply cobalt for the stripe around the top, going over it with rose and then burnt sienna.

►12 To work up the murky foreground, loosely wash in a very wet mix of raw sienna/burnt umber/cobalt, allowing streaks to run down and form dark pools along the edge of the waterline. Paint around the edge of the reflections in the water, making them delicate and wobbly.

◄13 Apply wet washes to the foreground water. Use burnt umber/ultramarine for the darkest tones. Use sweeping, gestural brushstrokes for the dark areas on the left. Spatter the paint to suggest pebbles on the right (inset below). Back on the wall, put in the handrail at the top of the ladder with a neutral colour and the No.2 brush (inset top).

Tip

Watercolour dries naturally to a lighter hue, so to build up rich earth colours, apply several layers of wash. It's important to allow each layer to dry before applying the next to prevent the colours running into one another. If you use a hair drier to hurry things up, be careful not to scorch the paper or blow the wet paint out of place. Notice the way the paint granulates to create a mottled effect – this is typical of earth colours.

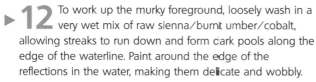

◄ **14** Rub off the rest of the masking fluid and put touches of colour on these exposed areas. Using the No.2 brush and raw sienna, cobalt and cadmium red, make the ropes dark where the background is light and vice versa. Note how the pigment has separated and settled in wet washes to create a textured effect that captures the pebbles, rock and masonry.

▲ **15** The figure digging worms is a focal point and needs fine details. For his skin, use the No.2 brush and cadmium red deep/cadmium yellow; use raw sienna/cobalt for the hair. Use cadmium yellow/raw sienna and cerulean/rose/cobalt for the shirt. Paint the trousers and boots in cobalt/olive/raw sienna. The bucket, spade and mud heap are in raw sienna/cobalt/rose.

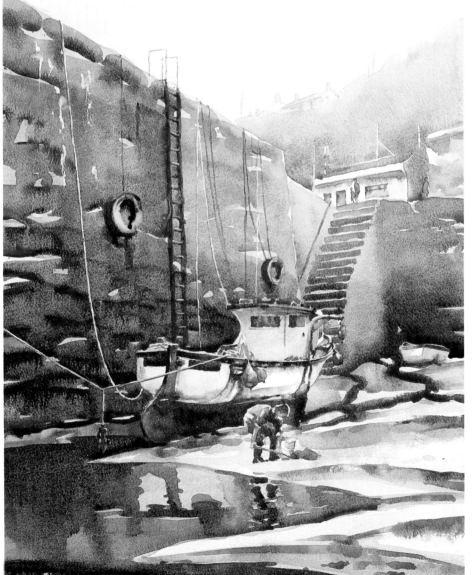

▲ **16** Use the No.6 brush to make a few big sweeps across the right foreground with a variety of earth colours. Keep the paint very wet and twist and turn the brush to make varied marks and create different textures.

◄ **17** Suggest the figures at the top of the steps with a pale, watery mix of rose/cadmium red/cobalt/raw sienna.

FINISHED PICTURE
This picture was painted with four main colours: raw sienna, burnt sienna, burnt umber and cobalt. Raw sienna predominates – it was used in nearly all the colour mixes, giving the painting its overall colour unity. There is a strong, three-dimensional quality to the picture, emphasizing light and space. The paint textures and tones convey a strong feeling of the damp, muddy scene – you can almost smell the sea.

Harbour steps at low tide
by *Keith Noble*

The Grand Canal

A classic view of the beautiful city of Venice requires careful technique and skilful use of watercolour to capture its romantic atmosphere.

In this painting of Venice's Grand Canal and the church of Santa Maria della Salute, the artist worked with veils of overlaid colour to capture the special ambience and reflected light. He started with an underpainting, plotting out the composition in washes of luminous colour. Unusually for watercolour, these early washes are complementary to the final colours. For example, the blue sky starts off as translucent pink and yellow, which glow through the final layers of colour and are visible in the completed picture. Off-whites and ochres in the church and surrounding buildings are first blocked in with complementary purples. Take care when doing this: complementary colours can combine to create a dull neutral.

The set-up

Venice's rich colours, elegant architecture and the light, make it irresistible for artists. It is one of the most painted cities in the world.

▲ TRACE TEMPLATE

▲ WATERCOLOUR SKETCH
Although photos are excellent for recording detail, they lack the luminosity of real light and colour. This on-the-spot watercolour sketch captured subtleties missed by the camera and reminded the artist of the scene as it really was.

▼ REFERENCE PHOTOGRAPHS
A series of photos taken from the same spot were put together to form a wide vista from which to select the composition.

Tip

Try starting the painting with some preliminary washes rather than a conventional line drawing. If you make the first washes very pale – just the basic shapes and forms – you can adjust the proportion and position of any element later on.

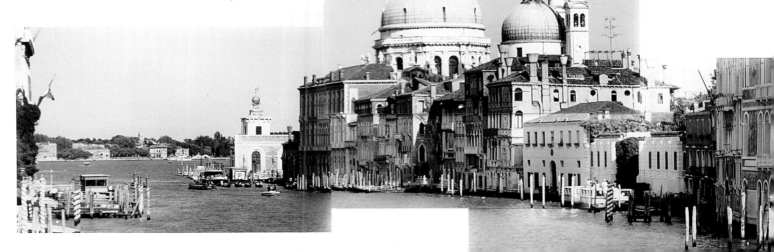

What you need

- A 20 x 28cm (8 x 11in) sheet of off-white, acid-free mounting card
- 15 paints: ultramarine, alizarin crimson, indigo, cadmium yellow, permanent rose, yellow ochre, cadmium red, cerulean, cobalt, cadmium orange, lemon yellow, viridian, Chinese white, burnt sienna, black
- Three brushes: No.14 and No.4 round sable or sable/synthetic; rigger brush
- Two jars of water
- Mixing palette

ultramarine

alizarin crimson

wash for canal water

▲1 Use the No.14 brush to make a light underpainting of the subject, establishing the position of the main dome and buildings. Paint the canal water in washy ultramarine/alizarin crimson, ready to receive the main colours, which will include complementary greens and ochres.

▲2 Paint the shaded side of the dome in washy indigo. While this is still wet, block in the rest of the dome in cadmium yellow. Use the tip of the brush to drag the mix along the roof, defining the top of the building.

▶3 Block in shady areas on the buildings in washy permanent rose/ultramarine. Suggest sunlit areas in dilute cadmium yellow/permanent rose. Paint the horizon of the water in dilute ultramarine. Establish vertical reflections in permanent rose/cadmium yellow with touches of ultramarine.

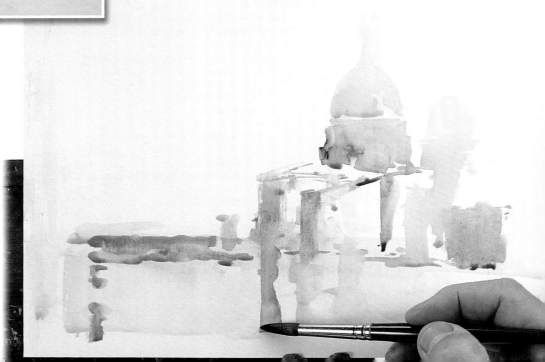

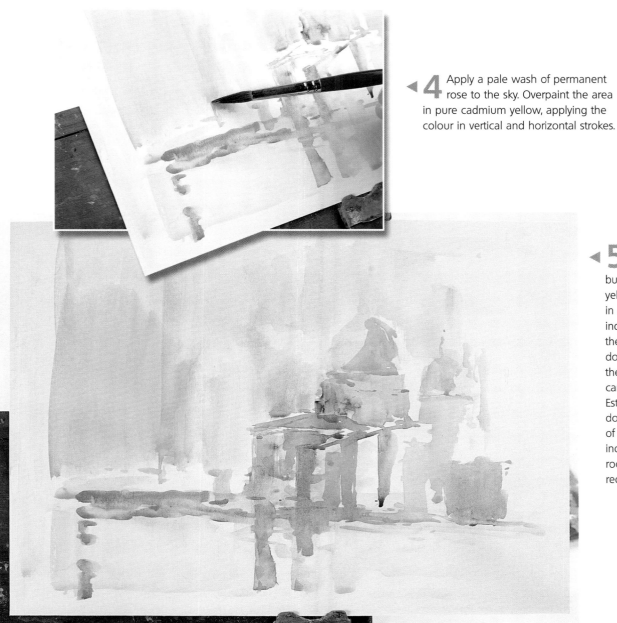

4 Apply a pale wash of permanent rose to the sky. Overpaint the area in pure cadmium yellow, applying the colour in vertical and horizontal strokes.

5 Paint the sunlit façades of the building in cadmium yellow/yellow ochre. Dot in architectural detail in indigo/ultramarine with the tip of the brush. Add dots of these colours to the reflections in the canal as you work. Establish the smaller dome in separate washes of cadmium yellow and indigo and paint the tiled rooftops in cadmium red/cadmium yellow.

6 Use light vertical strokes to overpaint the sky above the buildings in cerulean/cobalt blue. Blend this into the alizarin/yellow underpainting on the left side. Strengthen the blue mix to paint carefully around the dome, defining the shape with a clean, precise outline.

cerulean

sky colour

cobalt blue

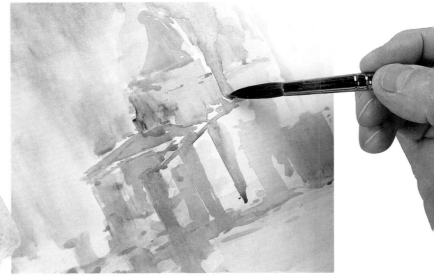

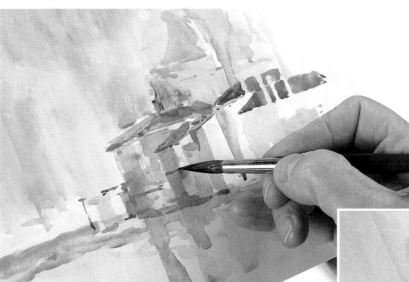

7 Develop the buildings, strengthening the rooftops in a darker mix of cadmium red/cadmium yellow. Work around the chimneys, leaving these as unpainted white shapes. Develop the buildings, dotting in windows and archways in ultramarine and cadmium orange. Add linear shadows in ultramarine with the tip of the brush.

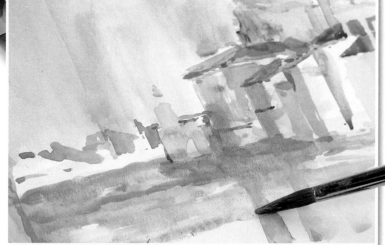

8 Paint the distant hills in a cobalt/viridian mix. Suggest the adjoining dome in diluted orange/ultramarine. Use burnt sienna/ultramarine to block in the edge of the building visible on the left side. Continue painting the water in cerulean, taking the colour across the vertical reflections.

lemon yellow

mix for distant buildings

cadmium red

Expert opinion

Q My initial washes are sometimes too dark because I find it difficult to judge how light or dark a colour will be when it dries. Is there a simple way of getting this right?

A The safest method is to start light and build up the washes in layers until you get the tone you want. This gives you control over the final result. In this painting, very pale washes were used tentatively at first to establish the composition and the position of the buildings. Tones were built up gradually in a series of loosely overlaid colours, allowing the early washes to show through.

9 Add a few broad strokes of viridian/cerulean to the water in the foreground, painting over the reflections. Add touches of pure cadmium red to the tiled roofs and block in the distant buildings in cadmium red/lemon yellow. Add a little of this mix to the water.

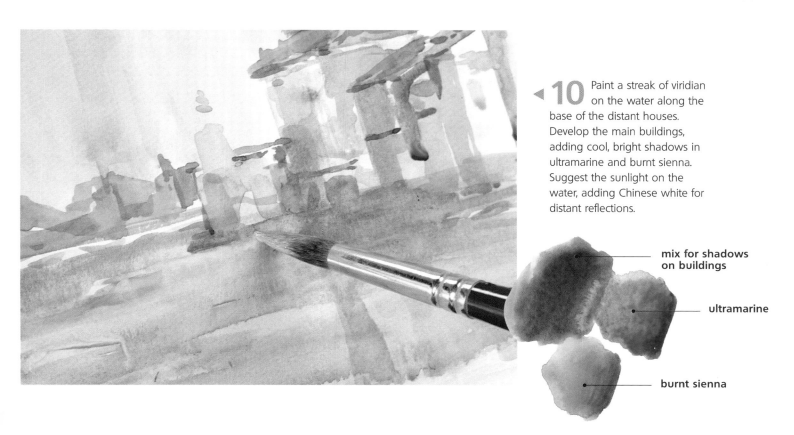

◄10 Paint a streak of viridian on the water along the base of the distant houses. Develop the main buildings, adding cool, bright shadows in ultramarine and burnt sienna. Suggest the sunlight on the water, adding Chinese white for distant reflections.

mix for shadows on buildings

ultramarine

burnt sienna

◄11 Introduce a little black into the painting to define the bell towers and the curves on the two domes. These details should be suggested rather than overstated, so use fine broken brushstrokes rather than heavy continuous lines.

►12 Strengthen any highlights and shadows in the architecture that now appear too faint compared with the surrounding tones. Add more highlights in yellow ochre/Chinese white, using the same colour to add small vertical reflections in the water.

◄13 Add further detail to the main building in black. Strengthen the roof tiles in bright cadmium orange. Use the rigger to define the shadows and shapes of the rooftops in burnt sienna. Add a few strokes of Chinese white to the water in the foreground.

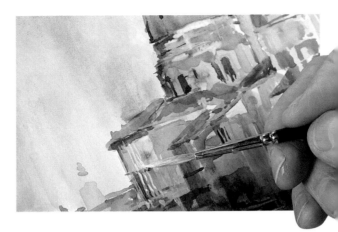

►14 Change to the No.4 brush and block in any unpainted shadows and gables in ultramarine and burnt sienna. Add more detail to the buildings on the right, picking out the sunlit areas on the dome and the façades in Chinese white/yellow ochre.

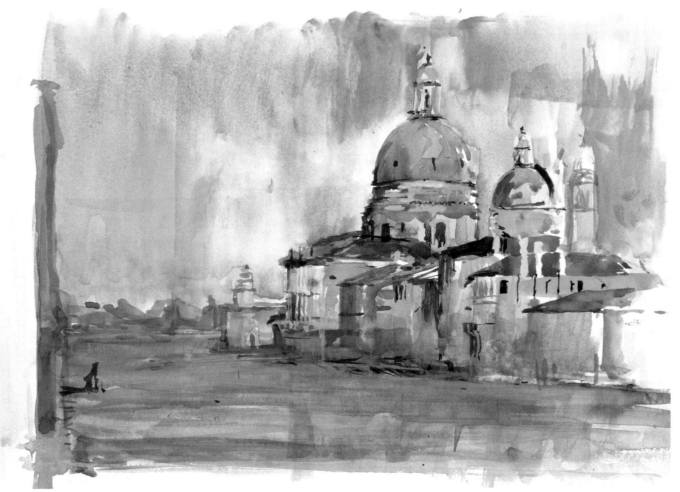

▲15 Define and darken the shadows on the tiled rooftops in burnt sienna. Dot cool shadows mixed from viridian/ultramarine on to the front of the building. Finally, dot in suggestions of carved stonework around the base of the dome.

FINISHED PICTURE
The sky and canal have been deliberately left as areas of loose, bright overlaid washes, which contrast very successfully with the more controlled brushwork and detail on selected areas of the domes, bell-towers and façades.

The Grand Canal, Venice
by *David Carr*

Indian market

A busy street market offers contrasts of colour, shape and tone – impose unity by developing the entire picture at the same time.

Exotic produce, billowing canopies and jostling shoppers provide a colourful, rewarding subject. With such complex material, it's important to simplify the subject, and to decide what the theme of the painting is to be. In this case, the artist focused on the pattern of lights and darks, the repeated curves of the baskets and the bright colours of the market-place. There are several tricks for giving such a colourful subject a sense of coherence. Use a limited palette of colours and mix washes in a big palette or in several mixing saucers. Eventually you produce a range of mixed palette washes – use these as a basis for your darkened tones and the colours will link together harmoniously.

Tip

When making a compositional sketch (such as the one shown below), try working with the photograph and sketch upside down. This means you won't be distracted by the subject matter and you'll be able to see it as an abstract pattern of tones and shapes.

The set-up

This painting is based on two photos taken in a busy market in Mysore in India. The composition is taken from the right-hand photo, but two figures from the left-hand photo are also included.

▶ *REFERENCE PHOTOGRAPHS*
There is plenty of pictorial potential to be found in a busy and colourful street scene – the generous curves of the baskets in which the produce is displayed, for instance, and the swooping shape of the canopies.

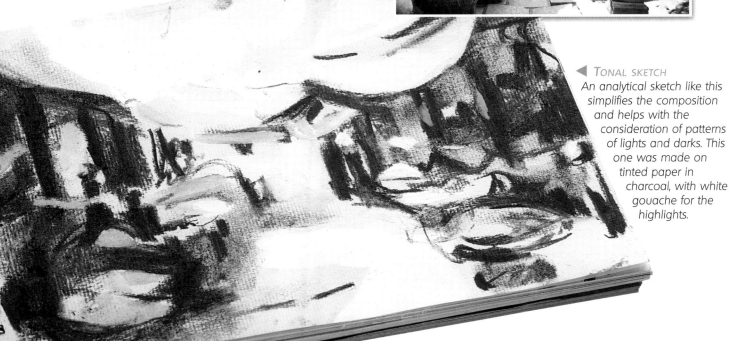

◀ *TONAL SKETCH*
An analytical sketch like this simplifies the composition and helps with the consideration of patterns of lights and darks. This one was made on tinted paper in charcoal, with white gouache for the highlights.

What you need

- A 50 x 38cm (20 x 15in) sheet of 300gsm (140lb) NOT Bockingford watercolour paper
- Masking tape
- Drawing board
- Soft carpenter's pencil
- Masking fluid and cotton bud
- 12 paints: cerulean, cobalt, Winsor blue, cadmium yellow, raw sienna, raw umber, yellow ochre, cadmium red, alizarin crimson, viridian, Winsor violet, Chinese white
- White gouache
- Two brushes: No.10 and No.12 round
- Charcoal
- Scalpel or craft knife
- Two jars of water
- Mixing palettes

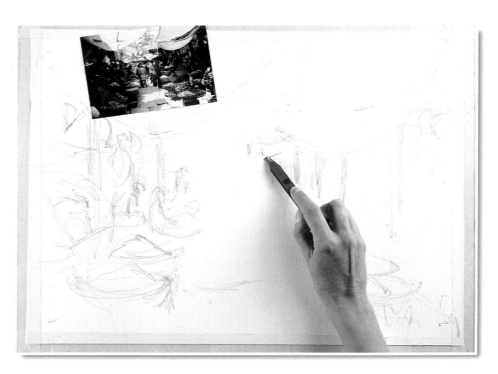

▲**1** Make an underdrawing of the subject with the carpenter's pencil. As the subject is complex, you can make the drawing more emphatic than usual. This won't be a problem because the pencil lines will disappear under the strong contrasting tones.

▲**2** Mask the highlights where the shafts of sunlight illuminate the heaps of fruit and vegetables. Use a cotton bud to apply the fluid.

Tip

Use a carpenter's pencil for tonal sketches. The broad tip gives quick and even coverage for areas of tone, and can be turned to give a narrow line.

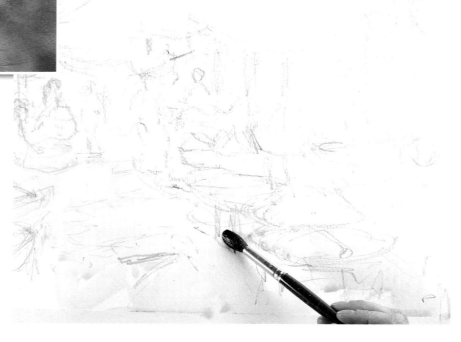

▲**3** Mix a pale wash of cadmium red with cadmium yellow to give a warm tone for the foreground. Using the No.12 round brush, apply this colour loosely, rolling the brush to get variegated coverage.

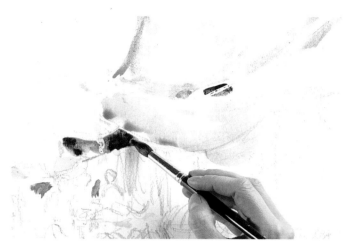

4 Block in the awnings. Use cobalt/cerulean for the large swathes of blue fabric – a pale wash where the light shines through, a darker tone where the fabric is bunched. Use raw sienna for the honey-coloured awning. Add dark shadows in yellow ochre, raw umber and Winsor violet – this helps establish a tonal range.

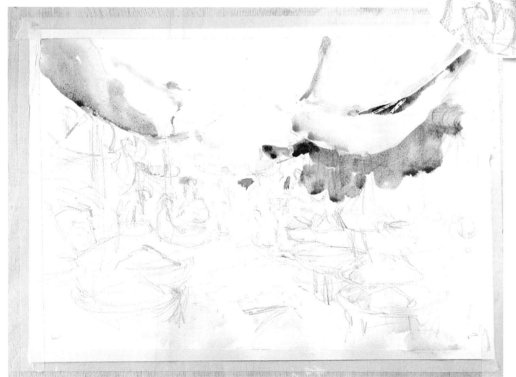

5 Mix cobalt, raw umber and Winsor violet – cobalt and raw umber granulate to give an interesting texture (inset). Using the No.12 brush, wash the mix over the shadowy area on the left. Then apply a paler wash of the yellow ochre/raw umber/Winsor violet mix under the honey-coloured awning on the right to give this area a sense of depth.

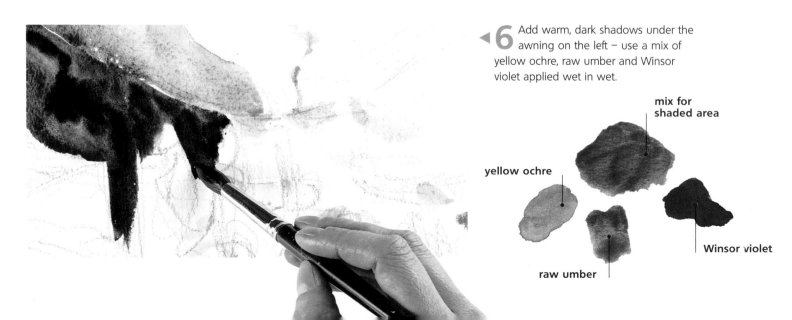

6 Add warm, dark shadows under the awning on the left – use a mix of yellow ochre, raw umber and Winsor violet applied wet in wet.

mix for shaded area

yellow ochre

raw umber

Winsor violet

◀ **7** Develop the shaded area in the left foreground, using the mix of yellow ochre, raw umber and Winsor violet. Then work into the shadows on the right with Winsor blue, raw umber and Winsor violet.

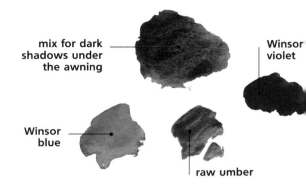

mix for dark shadows under the awning

Winsor violet

Winsor blue

raw umber

▶ **8** Use cobalt and alizarin crimson for the pavement shadows, applying the colour loosely. Mix yellow ochre and cadmium red and use this for the repeated curves of the baskets (inset). While the colour is still wet, drop in darker tones wet in wet – use the yellow ochre/raw umber/Winsor violet mix.

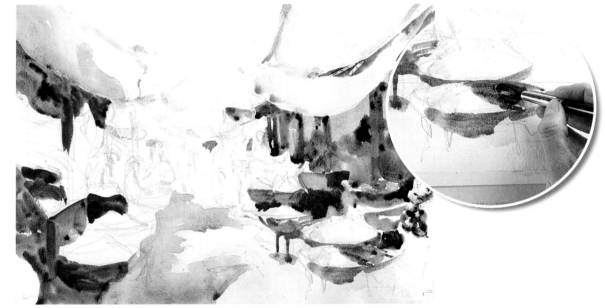

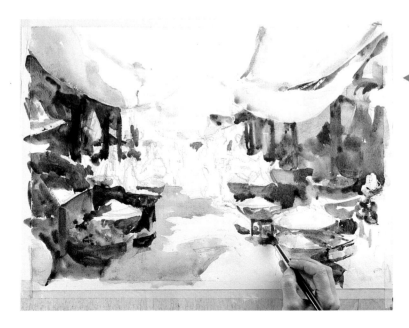

◀ **9** Add details to the left foreground. Use alizarin, raw umber and violet for the onions, viridian and cadmium yellow for the cool green, cobalt and cadmium yellow for the green peppers in the front, with cadmium yellow for the highlights. To keep the entire picture surface advancing, work on the right side too, adding touches of dark tone and local colour.

Tip

The figures give a sense of scale, recession and movement. If you paint them very simply as small patches of colour and light and dark tones, they will emerge from the patchwork of dabs of paint and be recognizable as figures. If they become too precise, smudge the paint with a tissue.

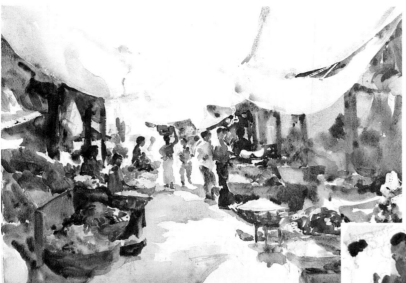

◄10 Render the stall holders on the left with a few strokes of the brush. The man in the red shirt draws the eye into the picture (inset left). The graceful woman with the basket on her head (inset right) and the boy in lilac are 'borrowed' from another photo. Add touches of burnt sienna in the background to close that area off.

◄11 Blob in a mix of cobalt and cadmium yellow for the foliage in the background, and cerulean for the blue sheeting. The blue melts into the background and draws the eye into the picture space.

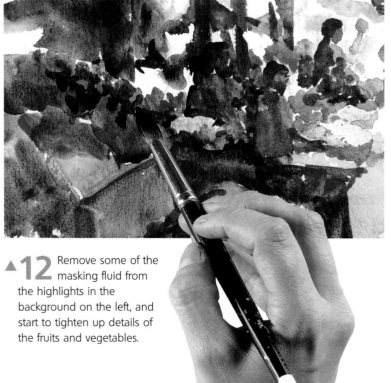

▲12 Remove some of the masking fluid from the highlights in the background on the left, and start to tighten up details of the fruits and vegetables.

Expert opinion

Q Sometimes I don't stretch my paper and it cockles – is there any way of flattening a finished painting?

A Once the painting is completely dry, lay it face down on a drawing board. Wet it evenly with a sponge then fix it with gum strip – as you would if you were stretching a clean sheet of paper. Leave to dry naturally and flat. When you remove it from the board it will be completely flat.

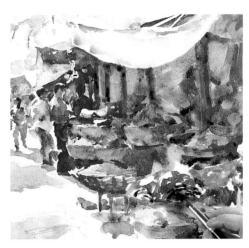

▲**13** Use Winsor blue/raw umber/Winsor violet for the watermelons at the back on the right. Add shadows to the awning. Remove the masking fluid from the peppers in the front, then add shadows with a mix of viridian/Winsor blue/alizarin.

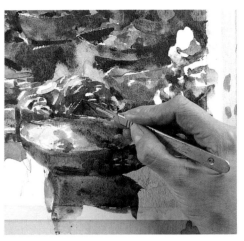

▲**14** Remove the final bits of masking fluid. Apply touches of light and dark tone here and there to pull the image together – a pale blue wash over the peppers, for example. Use the scalpel or knife to scratch highlights into the peppers.

▲**15** Scratch in highlights on the fruits and the baskets. Use watercolour plus Chinese white to bring light into the shade under the awning: Winsor blue/cerulean/Chinese white for the melons; alizarin/Winsor violet/raw umber/Chinese white for the struts.

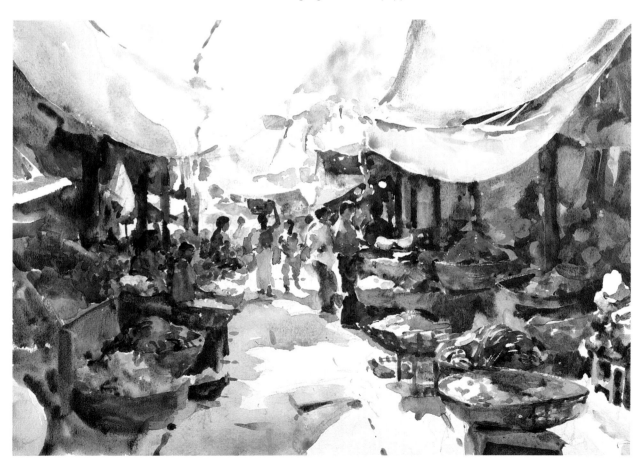

▲**16** To finish, use the tip of the No.10 brush to lay in the shadows on the edges of the paving stones in raw sienna/raw umber. The lightly indicated perspective lines draw the eye into the market and underline the sense of recession.

FINISHED PICTURE
The painting captures the rich colour and pattern of this cheerful market scene, and the play of light and shadow that binds the complex and varied surfaces together.

Market in Mysore, India
by *Abigail Edgar*

Index

Page numbers in *italic* indicate illustrations

Illustrations

Paul Banning 25; Chris Beetles (Roy Hammond) 19, 83, 163; (Charles Knight) 37; Linda Birch 3(l), 38, 60, 63–64, 147–152; Bridgeman Art Library (Trevor Chamberlain/Private Collection) 15, (Izabella Godlewska de Aranda/Private Collection) 51, (Lesley Fotherby) 49, (Patrick Procktor RA/Redfern Gallery, London) 95; David Carr 99(br), 111–116, 205–210; Trevor Chamberlain 31; John Cleal 87; David Curtis 167–172; Derek Daniells 117–122; Peter Davey 17; Joe Francis Dowden 3(cr), 9(tl,br), 23–24, 30, 32, 34, 36, 50, 52, 56, 101–104, 177–182, 189–192; Eaglemoss 21–22, 68–70, 72–74, 76–78, 80–82, 84–86, 88–94, 96–98; Patrick Eden/Isle of Wight Photography 133(b); Abigail Edgar 211–216; Eye Ubiquitous/W. McKelvie 189(t); Shirley Felts 99(bl), 173–176;

Peter Folkes 79; 183–188; Dennis Gilbert 11, 99(tr), 157–162; Kate Gwyn 12, 20; Frank Halliday 105–110, 183–188; Robert Jennings 45, 67; Brian Lancaster 39, 53; John Lidzey 13; Ronald Maddox 55; Mall Galleries/Andy Wood 29; Peter Marshall 9(tr), Sally Michel 59; Keith Noble 3(cl), 18, 91, 199–204; Kay Ohsten 127–132; John Raynes 99(tl), 141–145; Polly Raynes 40, 61–62, 137–140; Darren Rees 57–58; Royal Watercolour Society/Michael Whittlesea 33; Ian Sidaway 3(r), 16, 26(l), 27–28, 193–198; Adrian Smith 123–126, Stan Smith 153–156; Hazel Soan 47; Tate Britain/Mark Heathcote 163(t); Jenny Wheatley 71, 75; Albany Wiseman 9(bl), 14, 26(tr), 41–44, 46, 48, 54, 133–136.

Thanks to the following photographers:
Edward J Allwright, Simon Anning, Paul Bricknell, Mike Busselle, Mark Gatehouse, Brian Hatton, Peter Marshall, Graham Rae, Nigel Robertson, Steve Shott, John Suett, Steve Tanner, George Taylor, Mark Wood.

Challenge your watercolour skills further with this range of official Watercolour Challenge books

Painting With Watercolour Challenge

Hardback priced £16.99

The first ever *Watercolour Challenge* book is an aspirational companion to the popular TV show with hints and tips to starting your own watercolour practice.

Watercolour Challenge: Practical Painting Course

Paperback priced £12.99

A complete painting course featuring projects for budding artists.

Watercolour Challenge

Paperback priced £9.99

An accessible, practical guide to watercolour painting, including guidance on getting started, detailed descriptions of techniques, with helpful hints and tips from the experts.